E TEAMWORK PERFECTI
ROWESS DEDICATION TRAINING
RAL ETHICS DESIRE TO WIN SPE
EVEMENT CADET EXCELLENCE PE
NDITIONING HEROISM PHYSICA
CHAMPION GROWTH DEMONST
OTIVATION HARMONY RIGOR GL
F-CONFIDENCE BRAVERY COURAC
ECT SPIRITUALITY SPORTSMANSH
N GALLANTRY MILITARY SCIENCE
ITY LOYALTY SUCCESS GLORY MC
HONOR **ATHLETE/WARRIOR** CH
EARNING LEADERSHIP DEDICATIC
VALUE DIGNITY ABILITY STRENGT
NOWLEDGE CHARACTER EDUCAT
SURVIVAL TRUST CADET STAMIN

ATHLETE / WARRIOR

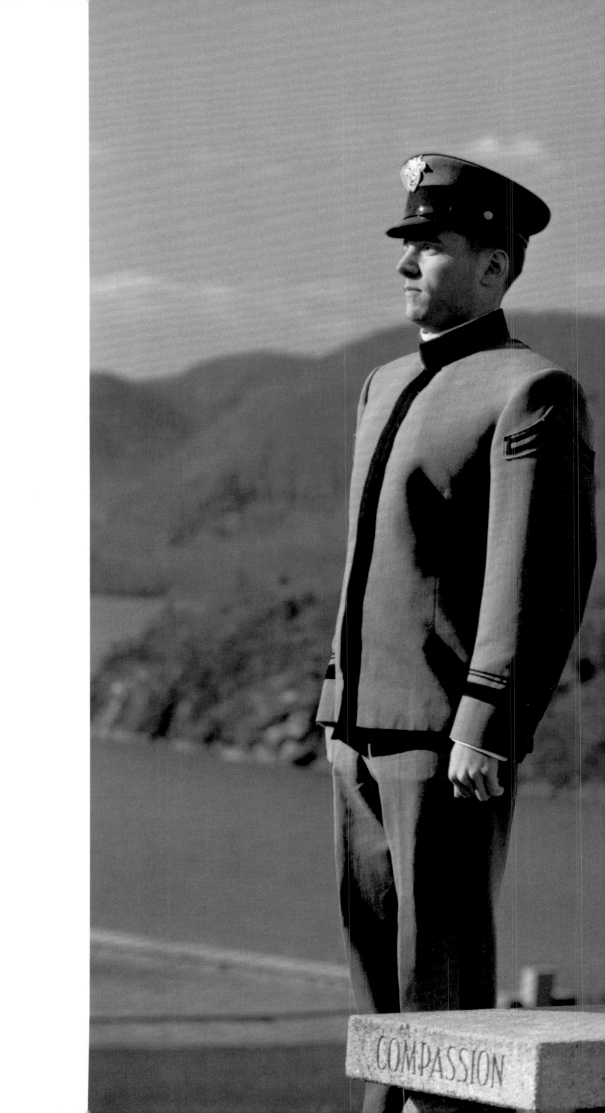

COMPASSION

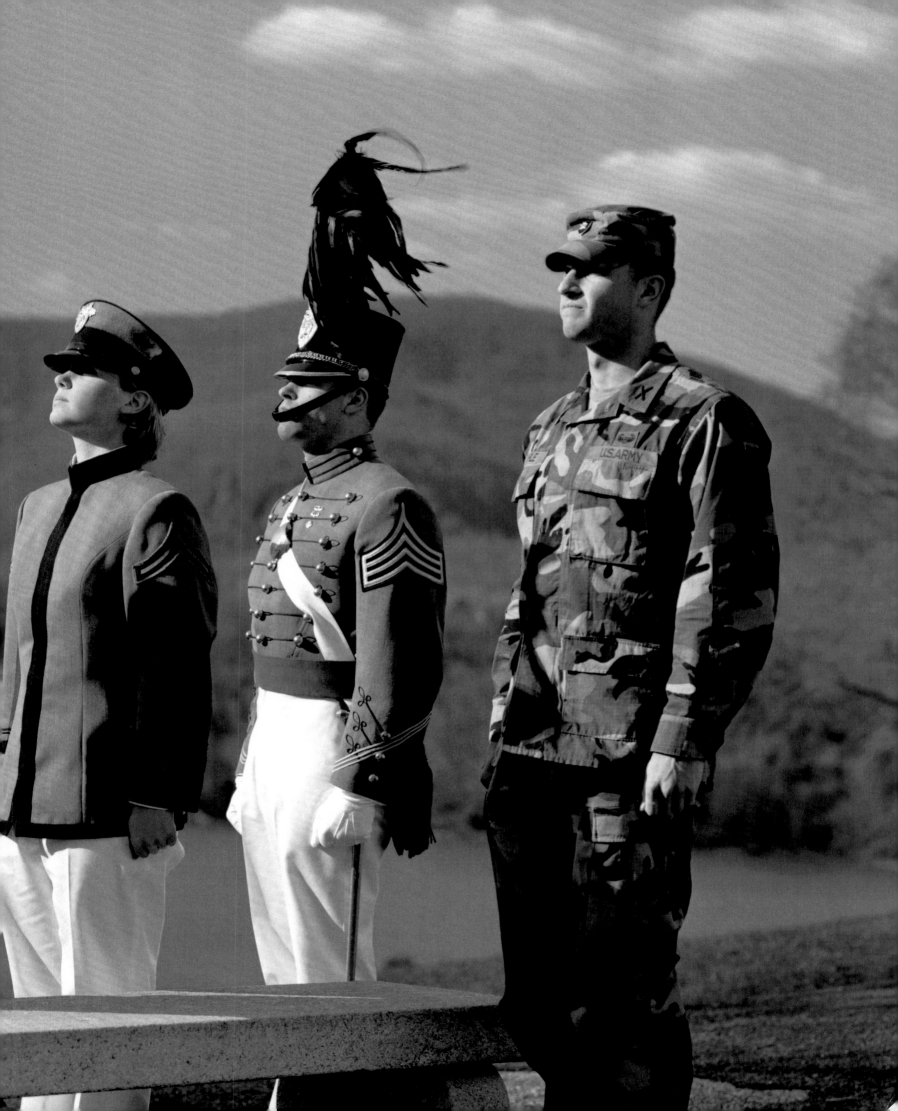

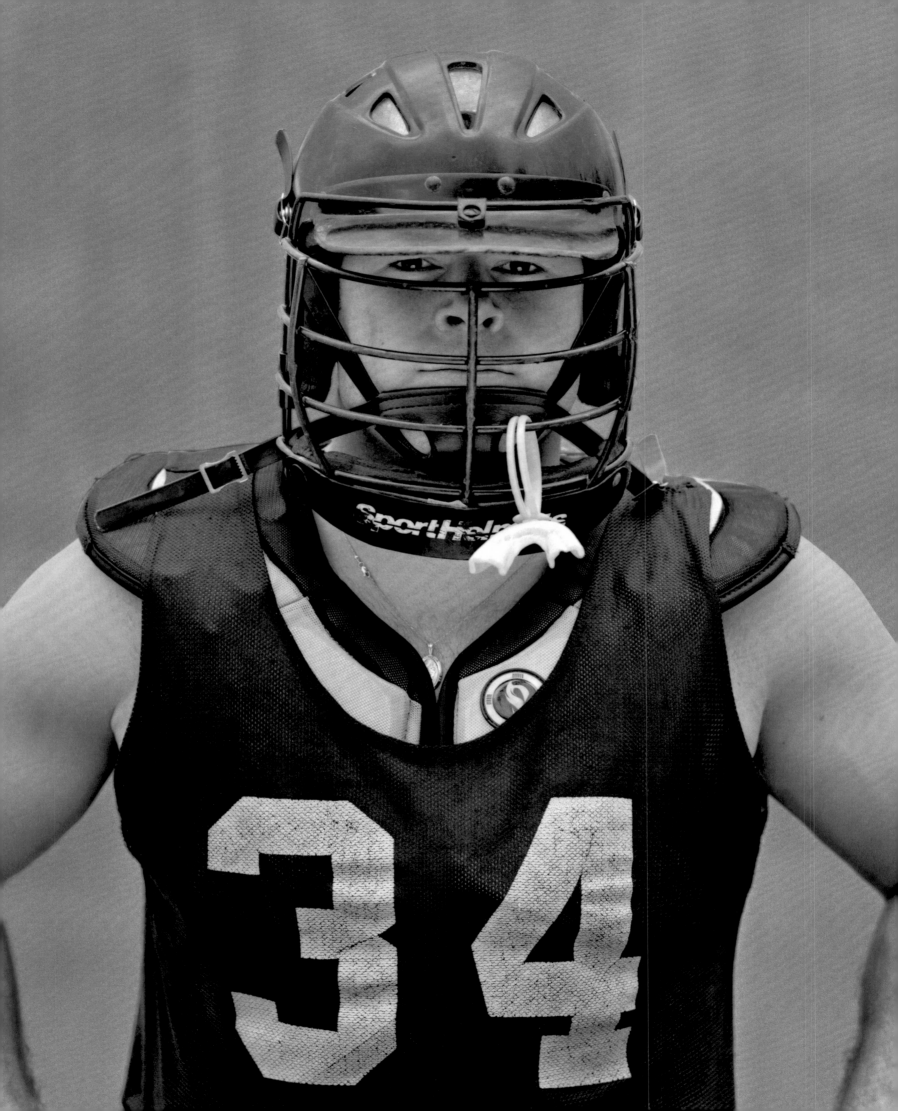

ATHLETE / WARRIOR

ANDERSON & LOW

MERRELL
LONDON · NEW YORK

ATHLETE / WARRIOR

Track shoes and combat boots. Baseball bats and assault rifles. Athletes and warriors. Do they belong in the same book? Is there enough in common between their very different pursuits to warrant such a pairing? Probably not. At least, not when glimpsed with an ordinary eye.

In these pages, Anderson & Low find the perspective that confirms the extra-ordinary, that helps us understand the incomprehensible. They have discovered a level photographic ground upon which to depict those preparing for both the athletic field and the battlefield. It's a place beyond the US armed forces academies in Annapolis, Maryland, West Point in New York State, and Colorado Springs, Colorado, where these photographs were taken.

The community embodied by the subjects of *Athlete/Warrior* is one of stunning duality: toughness, both physical and mental; discipline, from inside and outside; honor, for country and for team. The photographers were amazed at how a single person could put forth such different guises. The change was only in part caused by the change in uniform. Look closely and you, too, will see the emotional and psychological transformation.

For all of the fascinating duality in these pages, there is an unmistakable sameness here that gives the images their unique power. The men and women dressed in military uniforms and athletic jerseys share a commitment revealed in their stares. In fact, they even share the stares. The eyes. The fire.

To note the complexities that result when the same person fills the roles of both athlete and warrior, it's best to observe the cadets not only in their uniforms, but also in their day-to-day activities. For weeks at each academy, Anderson & Low moved among their subjects, observing practice sessions, military drills, trips to the cafeteria.

When the time came to pose the athlete/warriors, a trust had been built between them and the lens. The rapport is immediately apparent. Viewers who don't know a soldier or an athlete personally will meet many here. And don't be surprised if those relationships stay with you long after you have closed the book's cover.

The decision to forgo the controlled environment of the studio and shoot instead in the grounds of the academies, among their dramatic nineteenth- and twentieth-century architecture, contributes to the classicism of many of the portraits. Stone pillars, ornate archways, and grand colonnades frame some of the photographs. You'll be forgiven if you find yourself thinking that they were taken decades or even a century ago.

In fact the project began in the spring of 2001, at the United States Air Force Academy in Colorado, where coaches from myriad sports requested that Anderson & Low photograph their athletes. Before long, a vision for the project emerged and

took the photographers to America's other armed forces academies: the US Military Academy at West Point and the Naval Academy at Annapolis.

The settings, coupled with classic poses, underpin one of the collection's central themes: that of the hero. The iconic figure of the hero has evolved, from the warrior who fought with handheld weaponry to today's sports star who dazzles with physical artistry. Anderson & Low offer both, often in the same person.

While the environments for many of the photos may seem idyllic, the images are set in more than a physical location; they occupy a significant place in history as well. Though Anderson & Low completed the majority of the project prior to September 11, 2001, it has acquired an unmistakable poignancy in the wake of the terrorist attacks and subsequent military action. One can only imagine the weight on a soldier's mind—in a soldier's heart—in a time of war.

Recent history has also given us less heroic depictions of both athletes and warriors. Scandals in sport and the military force us to reconcile the ideal reflected in these images with the reality of the behavior detailed in disturbing stories and photographs from the media.

However disappointing, the juxtaposition is important. Indeed, the discrepancy becomes an issue to consider. We are reminded that although all the subjects strive for the ideals of the hero, it is easy, and utterly human, to fall from heroic heights. And while none of these images suggests such a fall, they are nonetheless filled with humanity, with possibility.

Diptych and triptych presentations challenge us to consider our own notion of the hero. Should we honor the determination of an athlete any less than we do the commitment of a soldier? Any more? And when the athlete and warrior are one, should we divide our admiration?

Anderson & Low are too skillful to offer answers. Instead, they do what all artists should—they bring the enlightening details into focus. Light falls masterfully on an officer's medal. A strand of hair escapes from beneath a camouflage cap. These photos will speak to you. Listen. There are clues in these whispers.

STEVE ANDERSON

Steve Anderson is a writer and poet based in Minneapolis, Minnesota. His features, profiles, and poetry have appeared in publications in the USA, the UK, Australia, and Southeast Asia. He has previously collaborated with Anderson & Low in a variety of media, including books, magazines, and materials for international exhibitions.

THOUGHTS OF DUALITY

Images from the past, ideals of the noble athlete, the noble warrior, are embedded in the history of most cultures. A maelstrom of references, partly subconscious, partly articulated, swirl in our heads as we photograph this project. We are at the same time apart from these ideals and these people, and at some level at one with at least some of their aspirations.

At times as we photograph, the environment feels overwhelming. Walls steeped in tradition, history, and regimentation. Sporting facilities so expansive as to be almost beyond comprehension. Memories from history, from books, from the media, jump into our heads as we proceed through the academies, juxtaposed with the evident humanity and humanism of people we encounter. The sporting ideal, the image of the noble warrior, set against these real athletes and warriors—and both expressed in each individual. An impossible reality presents itself to us.

Though we had been photographing athletes for many years when coaches and cadets asked us to photograph those at US military academies, we recognized a unique opportunity in the invitation: a chance to concentrate on these people's duality—as athletes and cadets. Thus the *Athlete/Warrior* project was born. Shooting between spring 2001 and spring 2002 on many trips to the academies in West Point, Colorado Springs, and Annapolis, we had many encounters and experiences that have intrigued us, adding to the project and to our understanding of the subjects.

Photographing at the academies and getting to know many of those studying there has been a journey of unexpected complexity and mystery. Getting to know these individuals, seeing them switch from one guise to another, has forced us to reconsider much. In their cadet uniforms, the regimentation and discipline is unmistakable, but it is edged with real introspection and reflection; it is a very different picture from the broad brush-stroke image of a soldier that is usually evoked. In sporting costume, we found the sense of toughness with a raw physical edge frequently apparent. Some of the emotions projected by the subjects in these two guises were similar, but so many were different. We were always left with the recurring paradox: it is the same person, but it is not the same person. How can this be?

These are also images of preparation. The subjects are preparing, both as athletes and as cadets. Perhaps we found greater purity here than at any other time in life for these people: a sense of the heroic ideal that should be striven for, of high standards of behavior, both sporting and military, of personal goals, of breaking one's limits. A sense of struggle, tempered with the frail humanity of these people, in both military and sporting costumes.

The humanity of athletes and of soldiers is rarely contemplated in any depth. Both

are held up as two-dimensional images, devoid of any more than the most rudimentary character traits to separate one person from another; they are then worshiped, and on occasion reviled. Interviews with sportspersons rarely reveal much beyond a publicist's yarns—trivial details held up as shining truth. Meaningful interviews with soldiers are even thinner on the ground. And yet both these groups of people occupy so much of our attention. We are bombarded with images of their successes, and sometimes their failings, both professional and personal.

Both these guises can be deemed heroic, but is a hero one who wins, or one who is noble in defeat? Perhaps a hero need not be involved only in conflict between people; on occasion the avoidance of conflict could be an equally heroic aim. Heroism implies a sense of nobility, a sense of struggle, but this can apply to the loser as well as to the victor, so what sort of behavior can be deemed heroic? Compassion—a word implying sympathy, concern, kindness. Where should this notion be placed in relation to either the athlete or the warrior?

And what else do the two have in common? The element of competition is shared, but the expression of that concept is so different. The psyche emanating from each shares little common ground—the same person, in different attire, not only appears to be a different person, but feels like a different person. Does this imply that the personality, the humanity of the individual is in part shaped by attire? What do these divergent roles mean for the individual, or for society?

Tradition, rules, regulations, all tumbling down upon us: the rules of the game, the rules of engagement—where does the institution end and the individual begin? What does it mean to be in a team? It is impossible for most of us, with our partially structured but nevertheless fluid lives, to imagine how it might be to dedicate one's life either to the pursuit of a single sporting goal, or to being a warrior—to accept that degree of regimentation. And yet we acknowledge the results of such focused dedication every day; indeed, some people demand these results of their heroes, who must satisfy these demands either as individuals or as a group.

What then does it mean to be an athlete or a warrior? Perhaps there is no answer. The former celebrates all that the human body can achieve, the latter runs the risk of death. Eros versus Thanatos. The paradox reveals itself in classical terms, yet is embedded in the present. We advance, yet we are bound to repeat the struggles of olden times. The ideals of achievement combined with compassion and respect for others are eternal. The hero remains. Humanity remains.

JONATHAN ANDERSON & EDWIN LOW

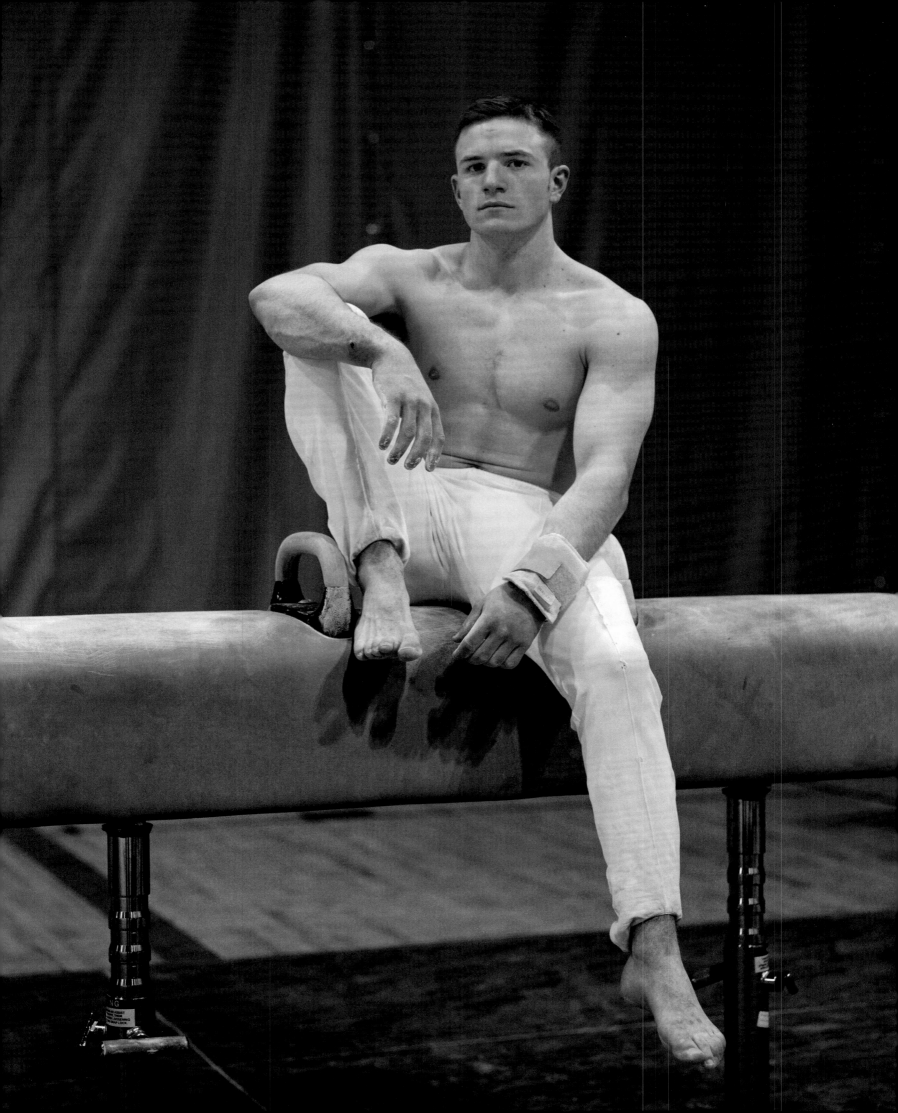

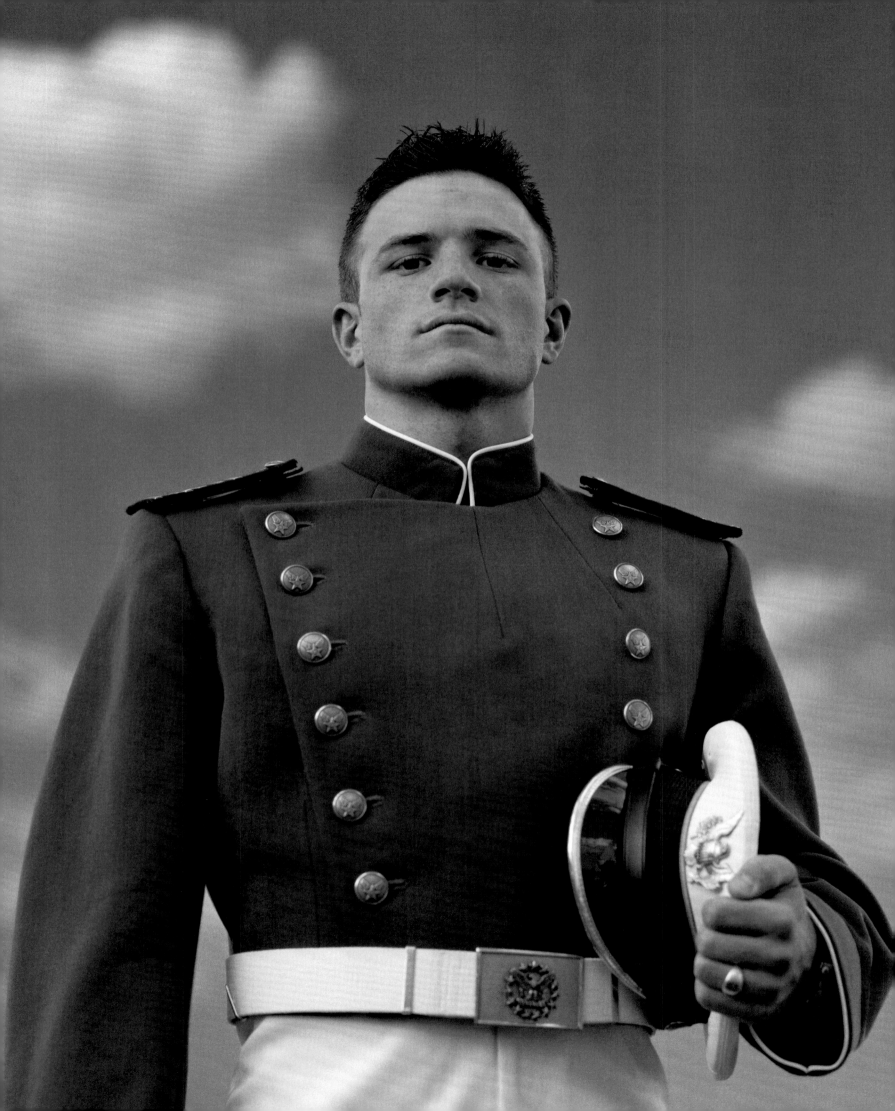

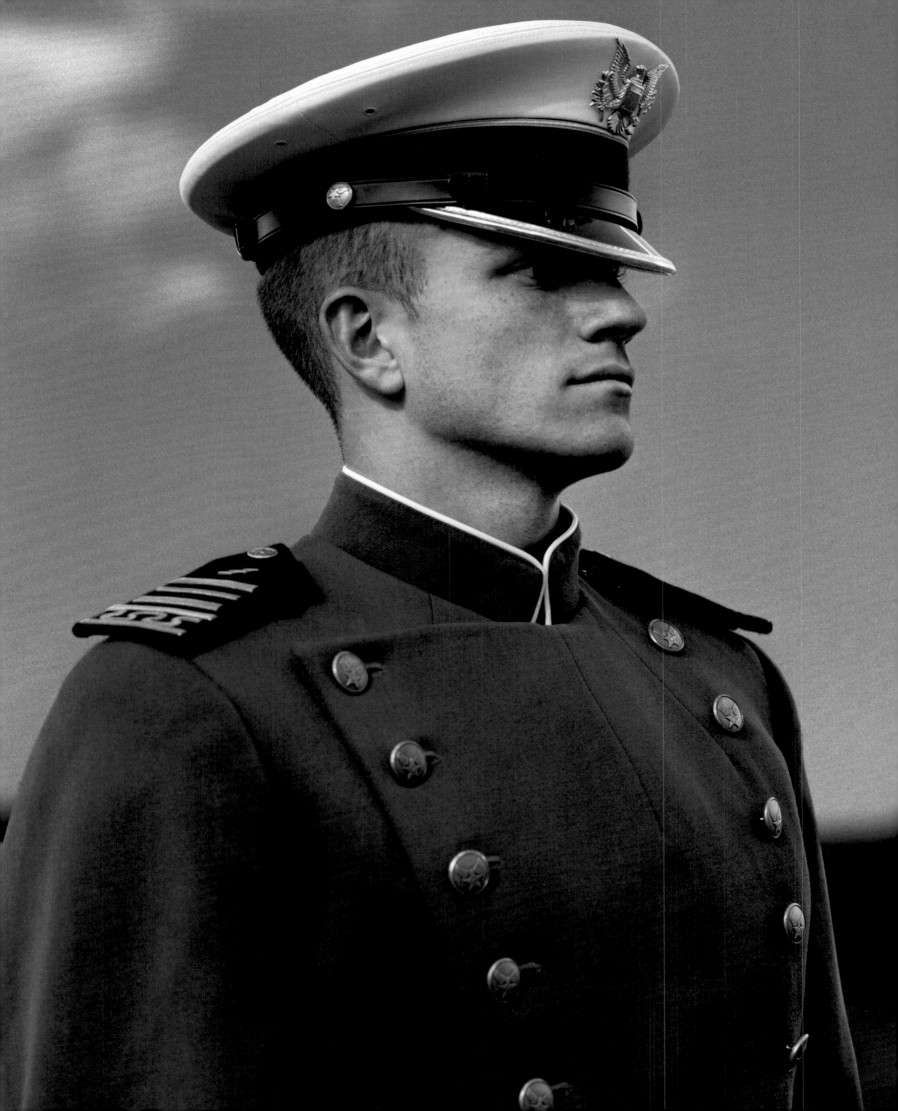

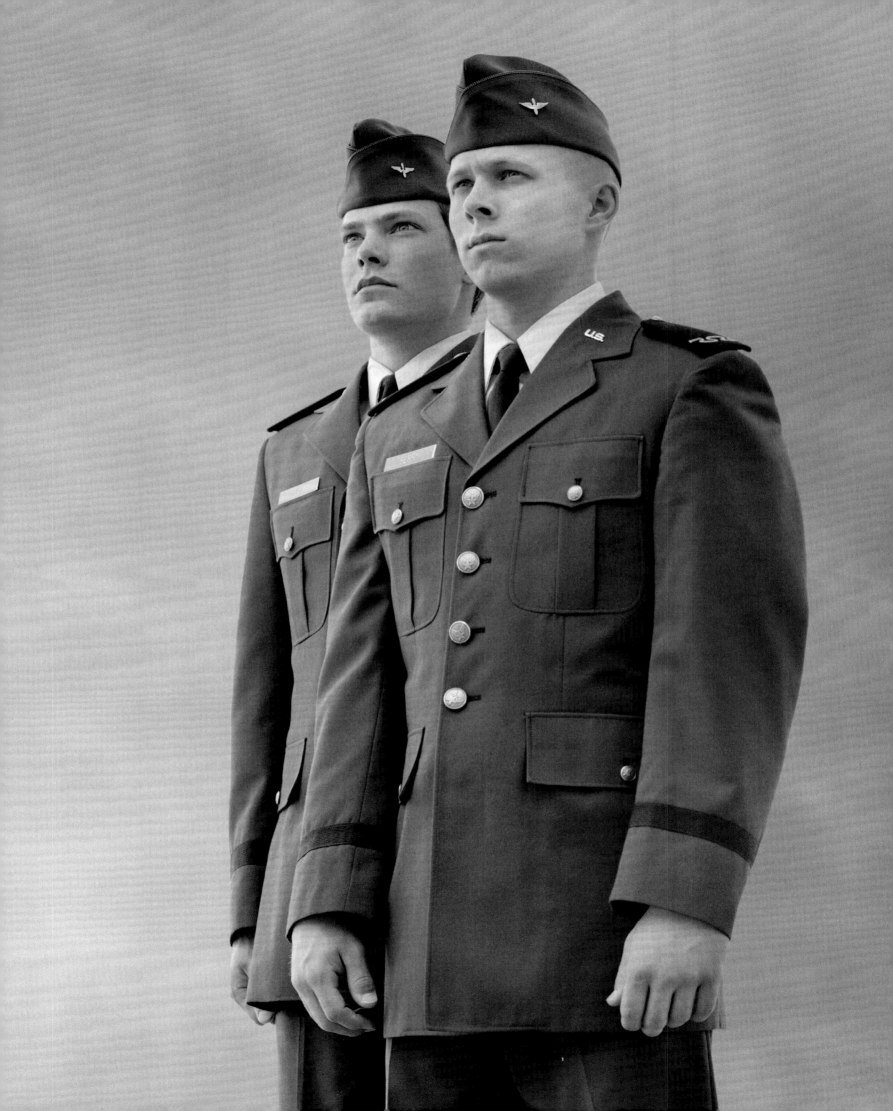

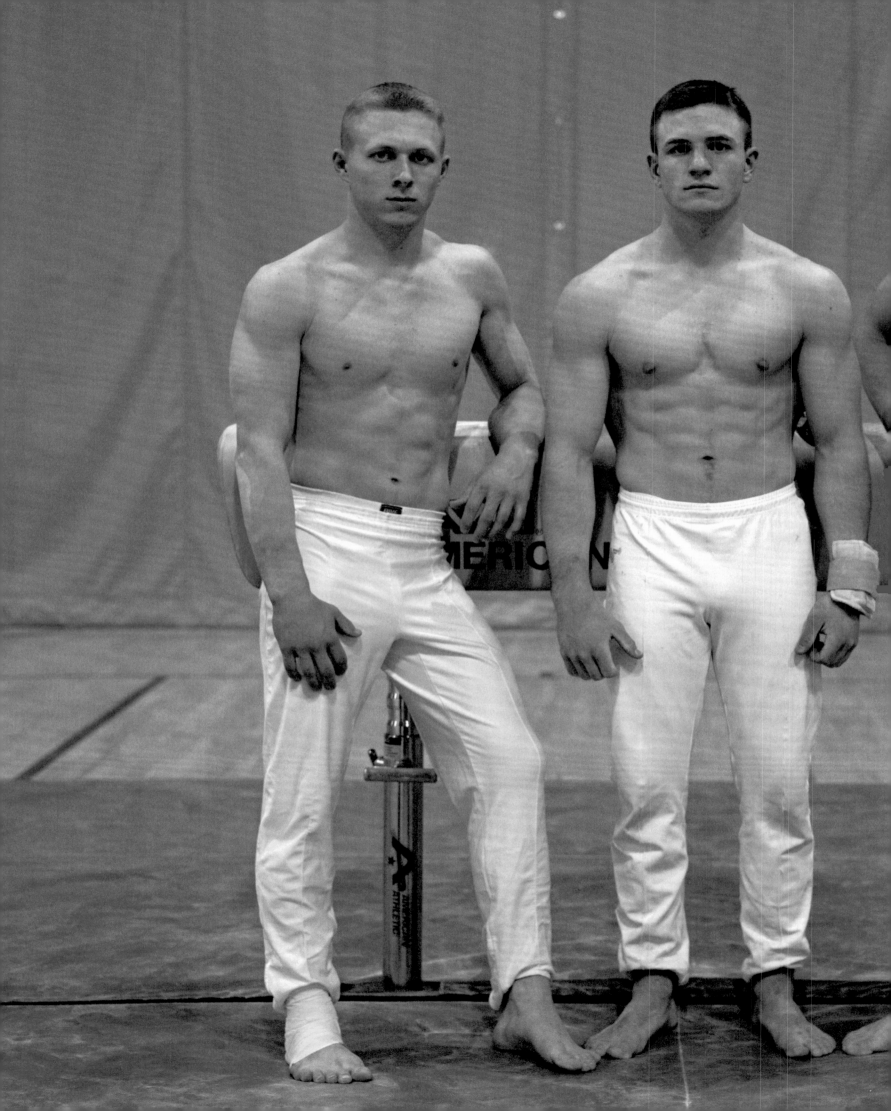

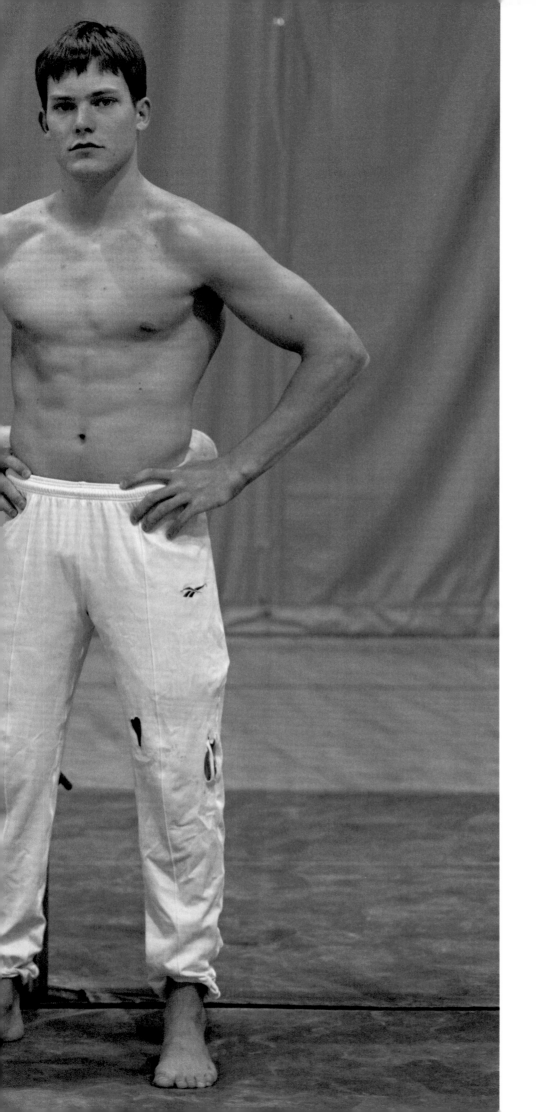

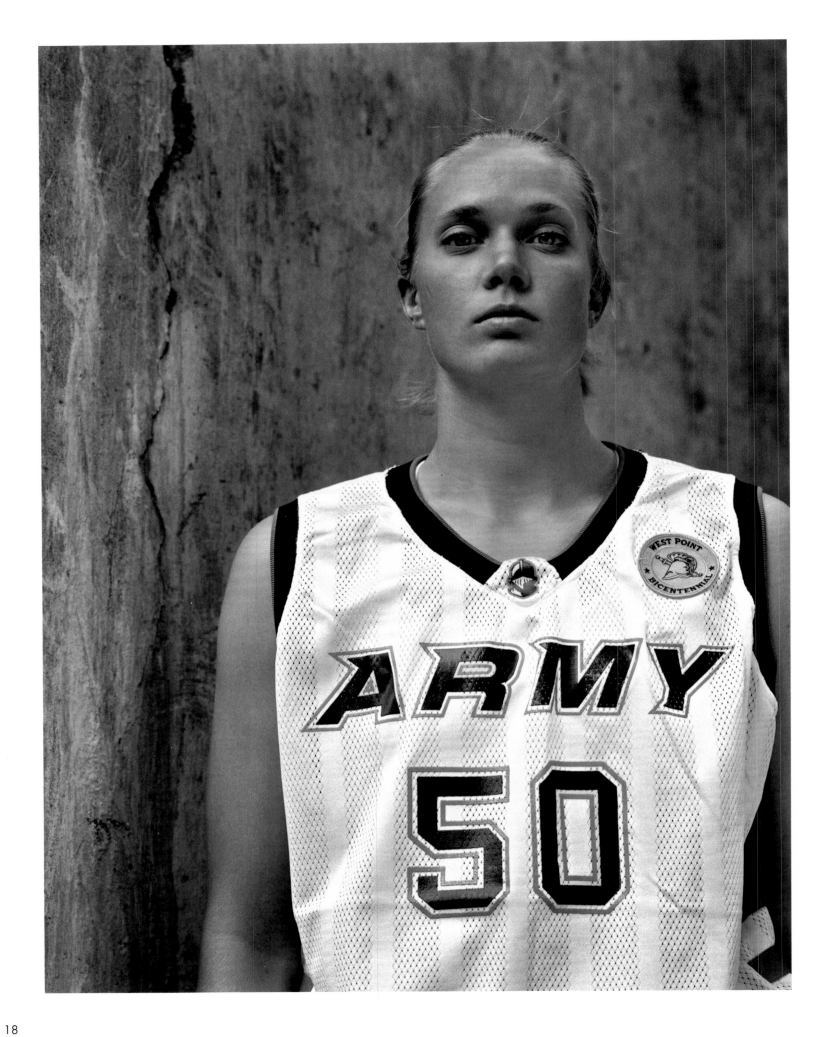

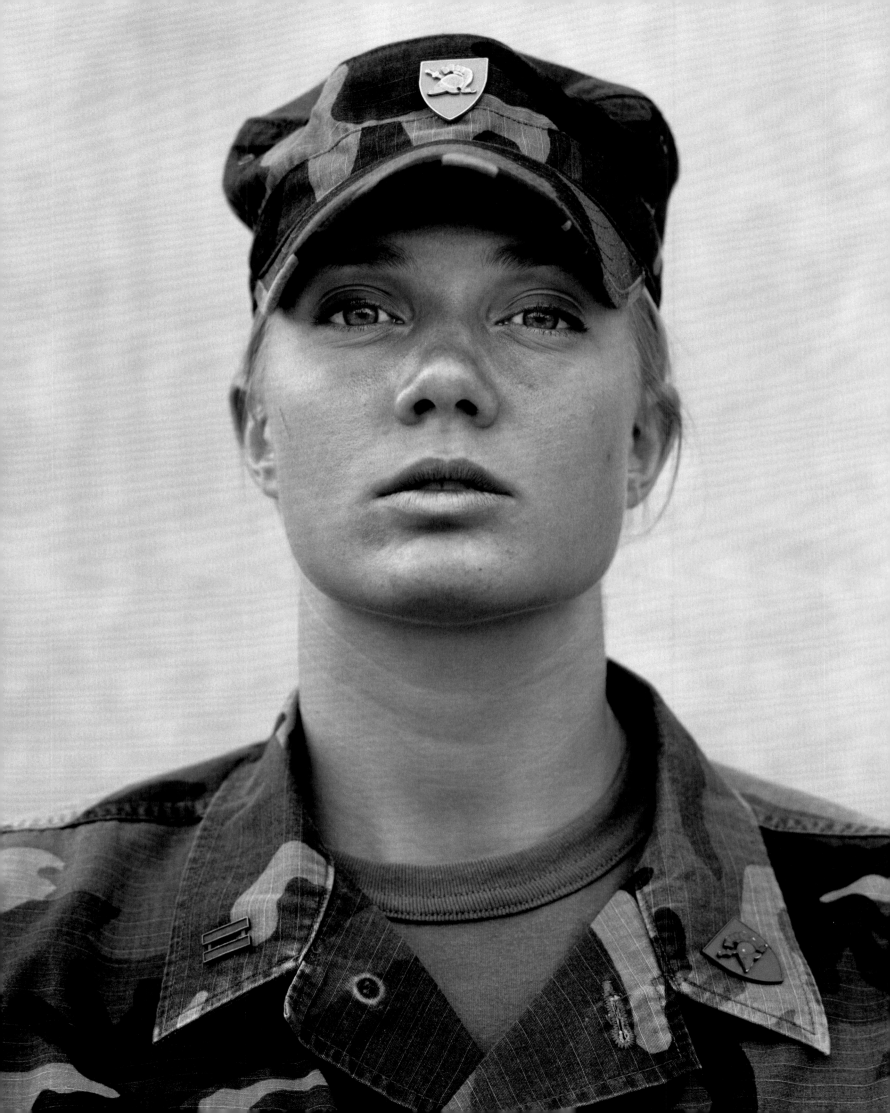

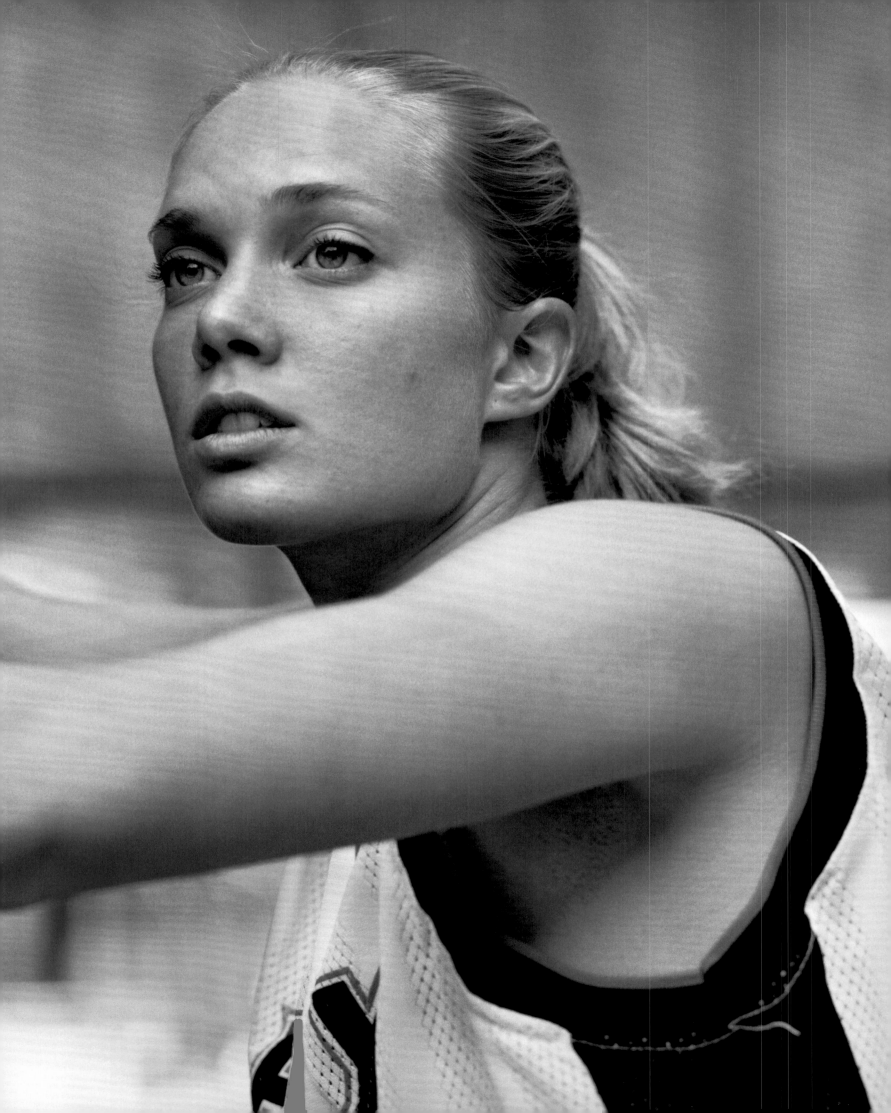

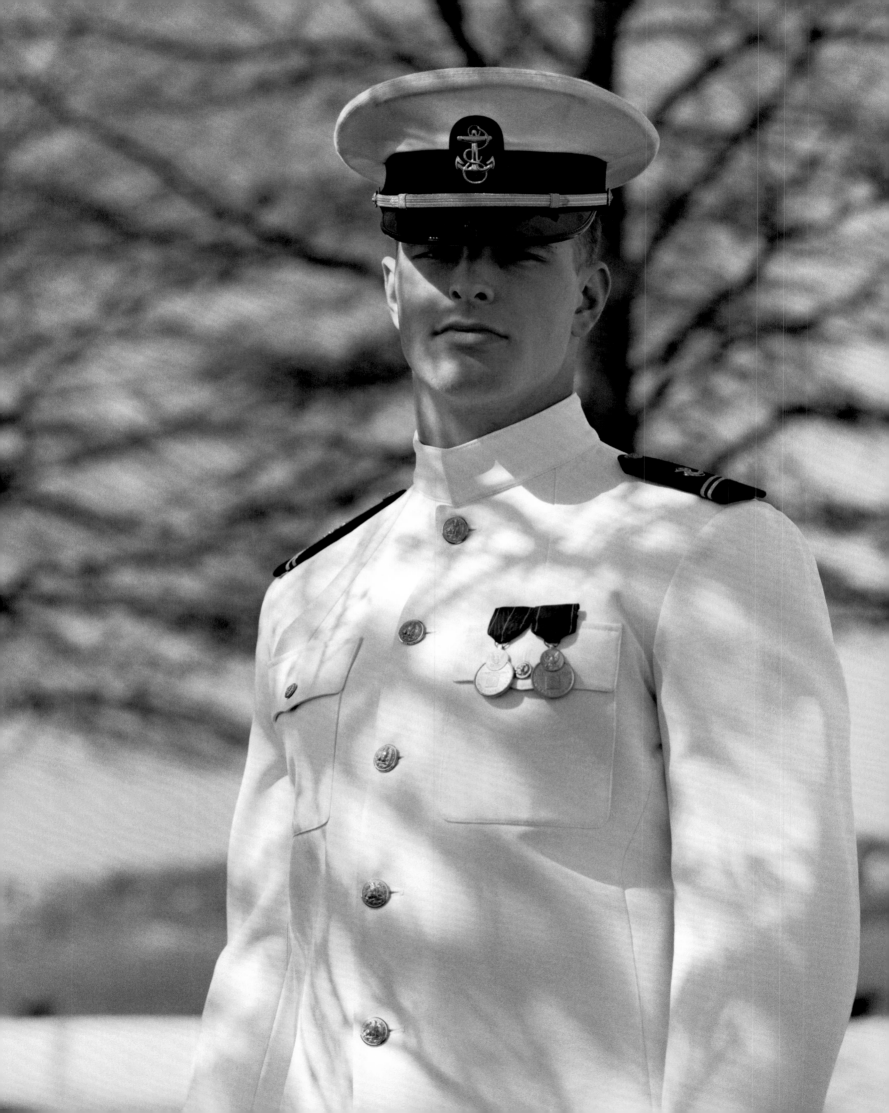

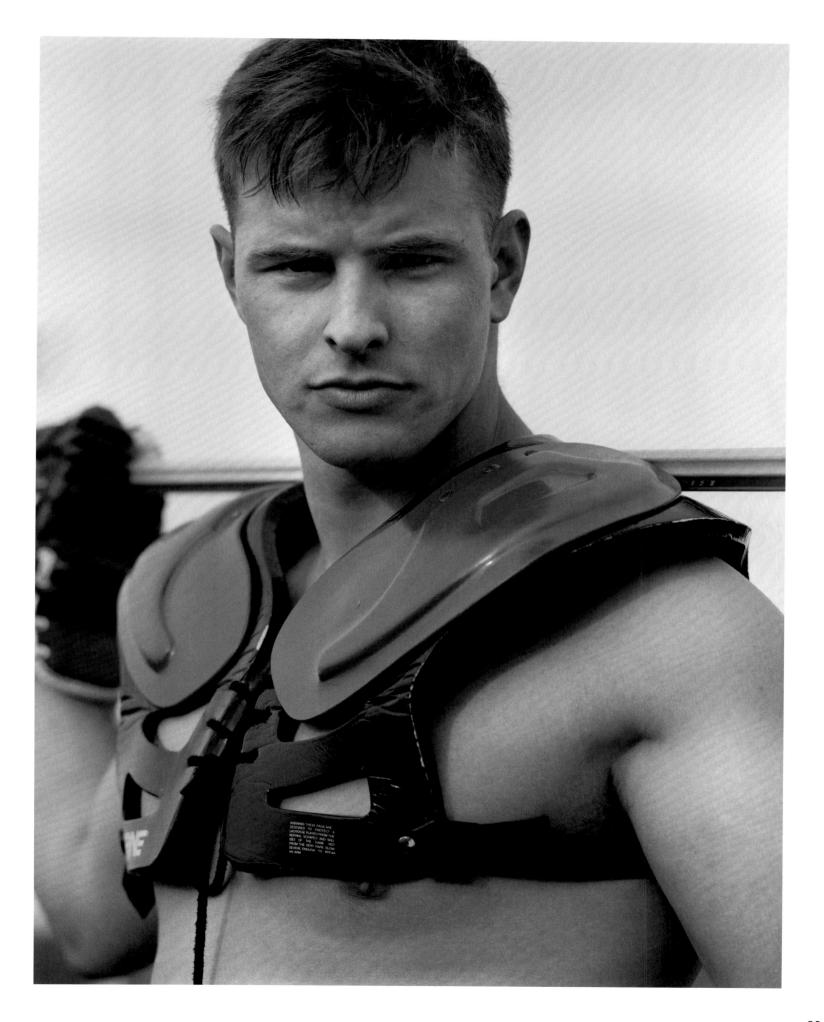

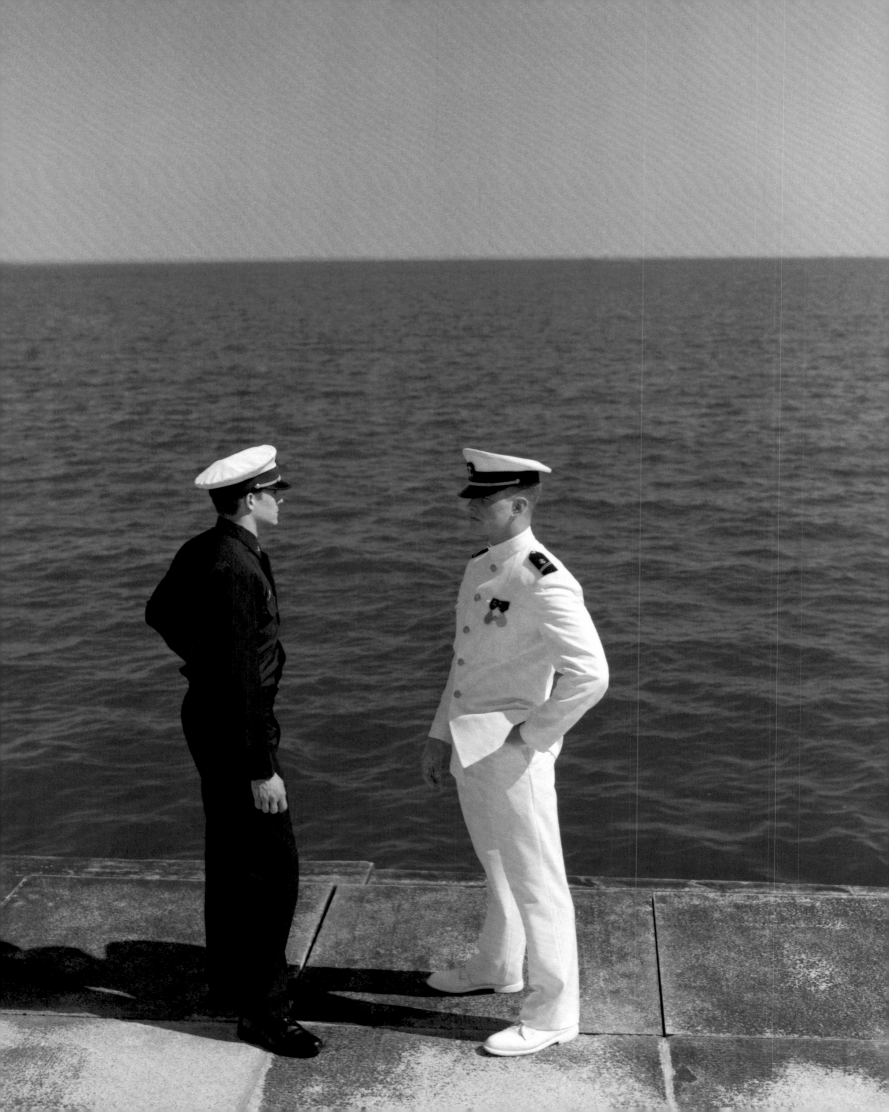

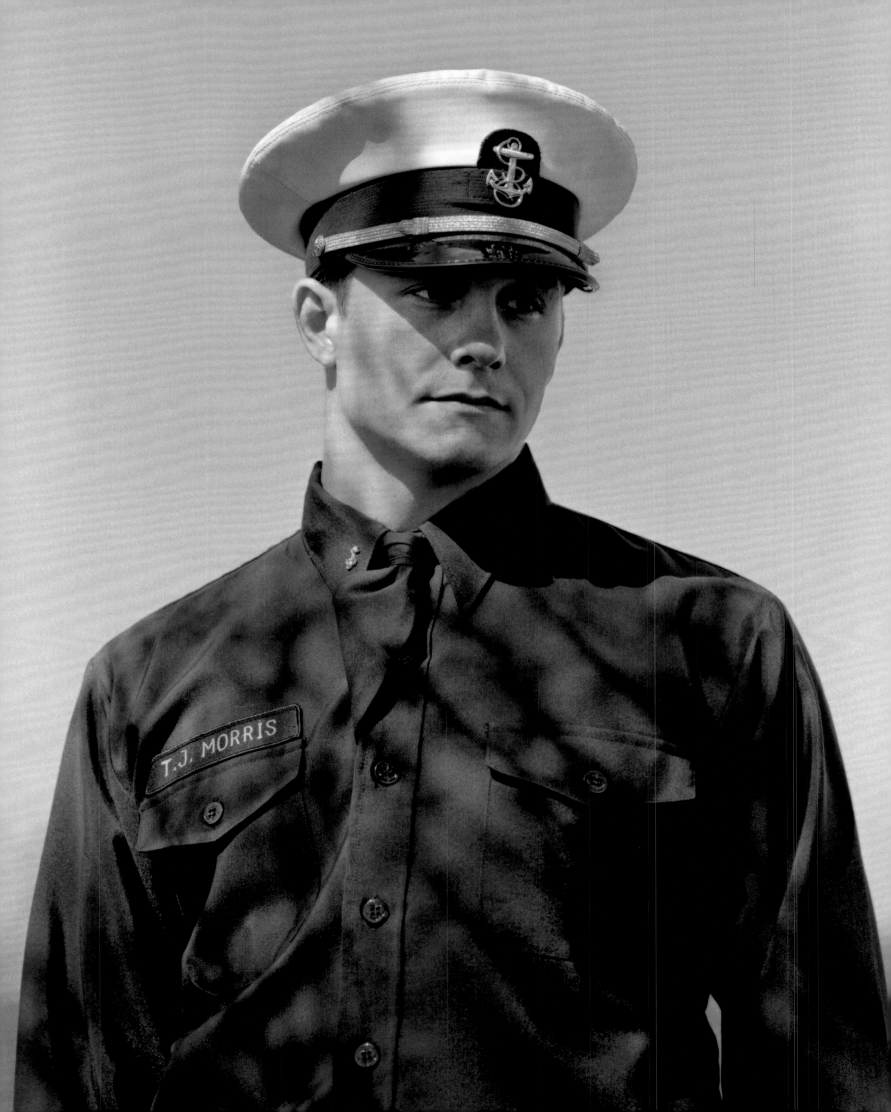

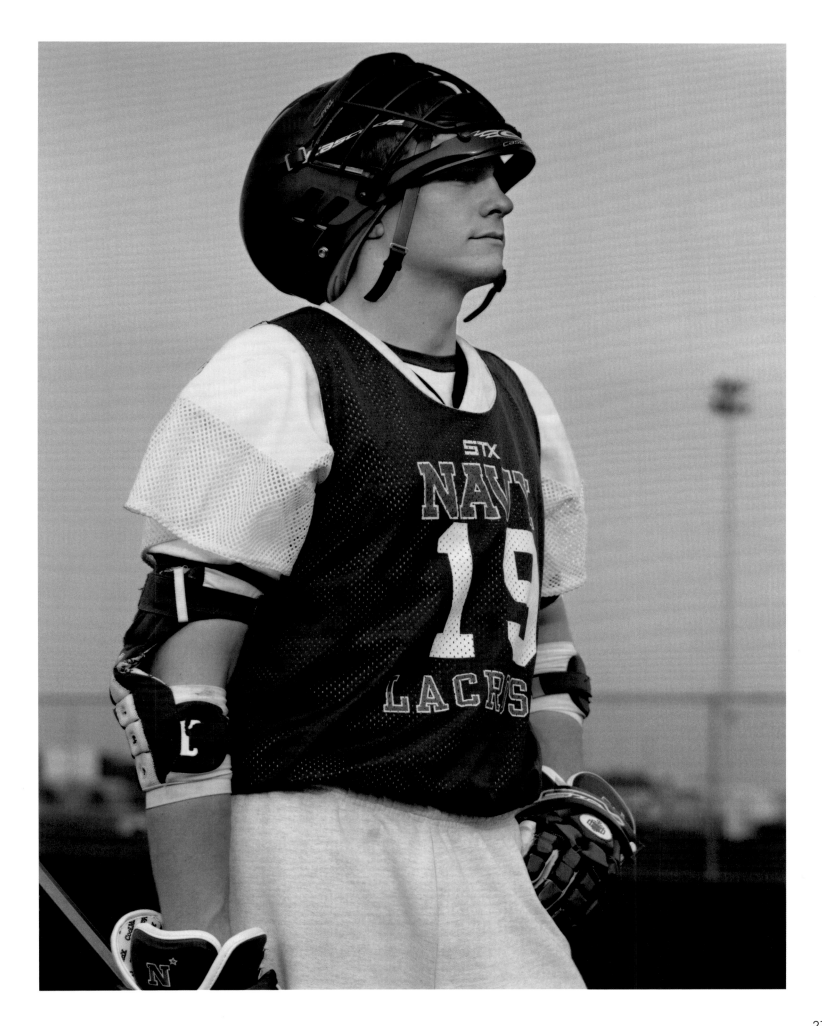

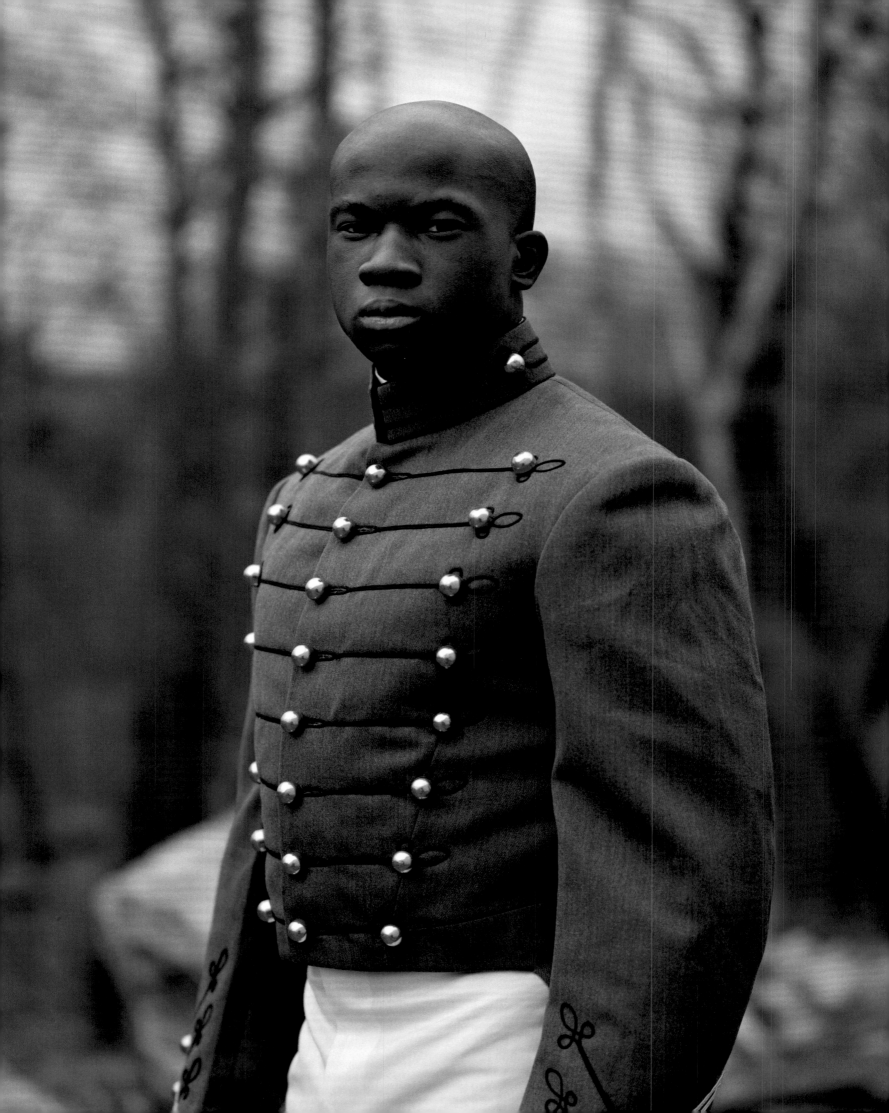

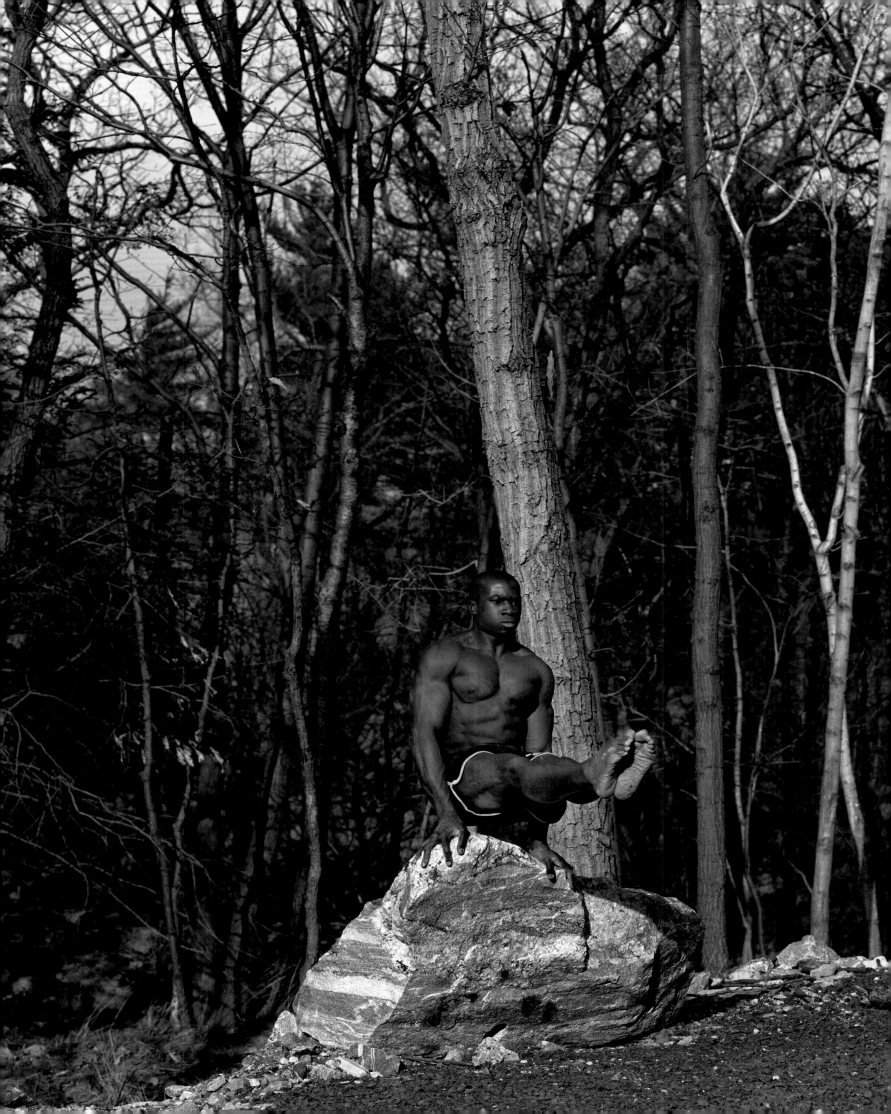

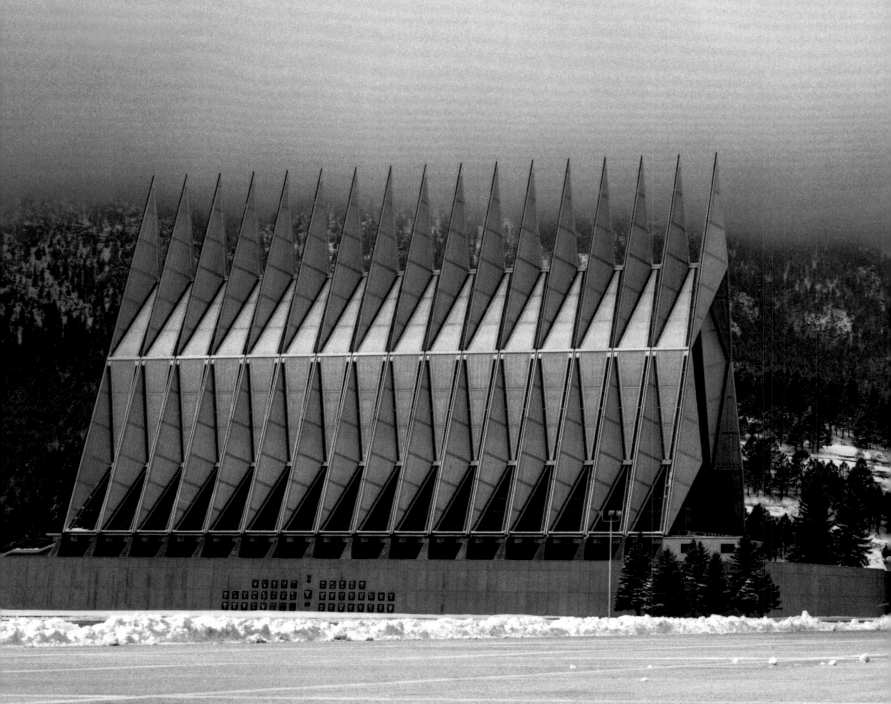

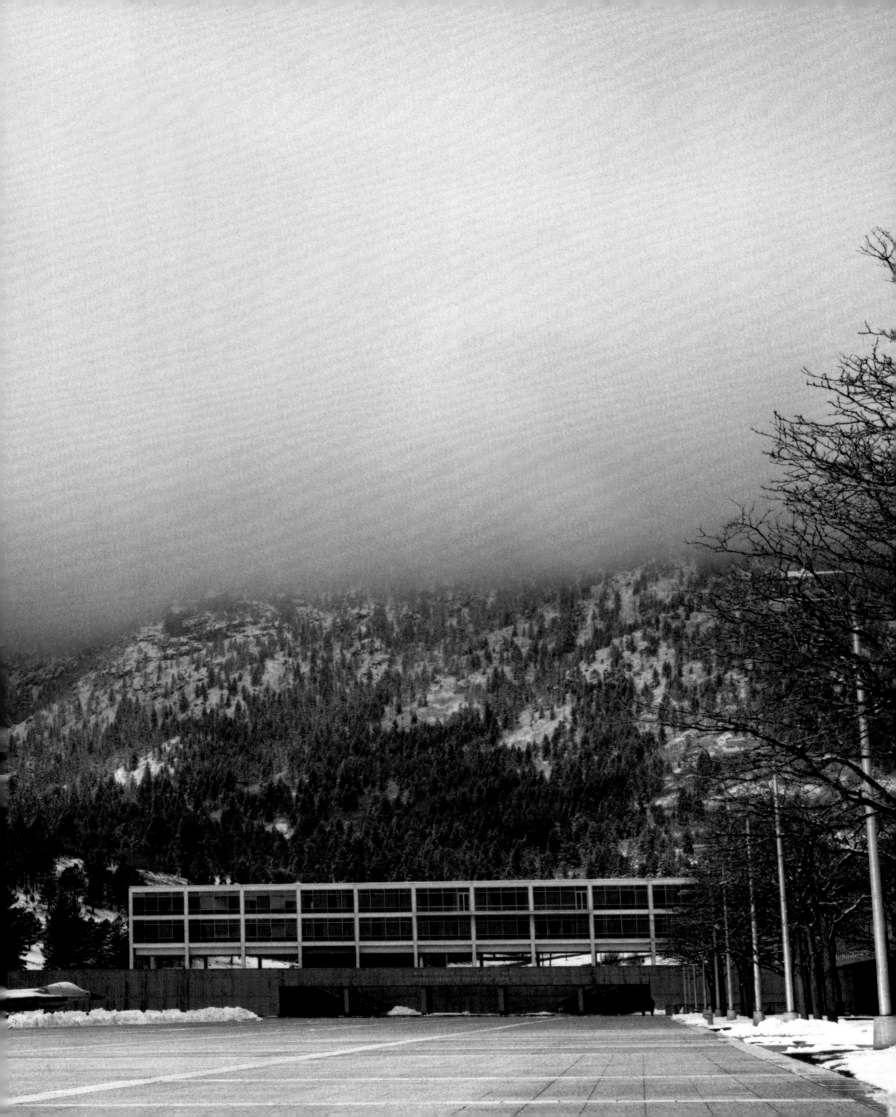

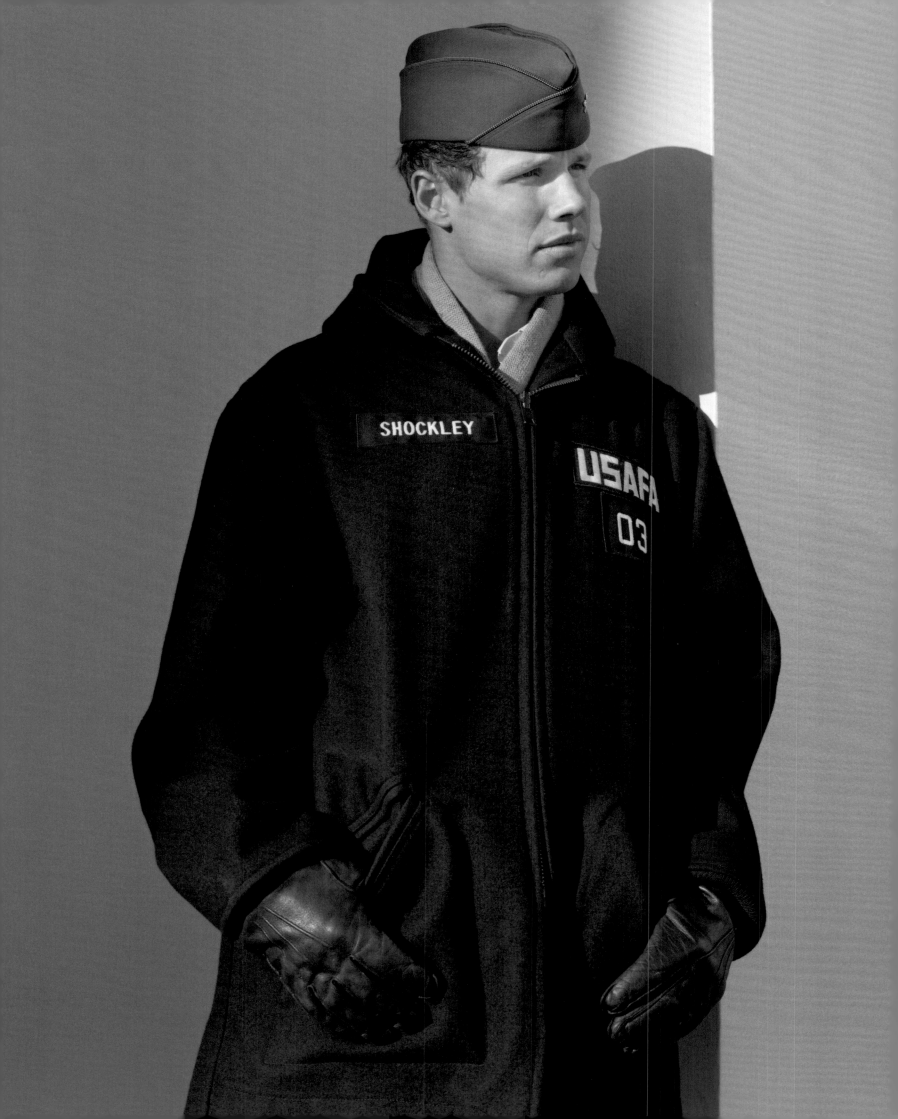

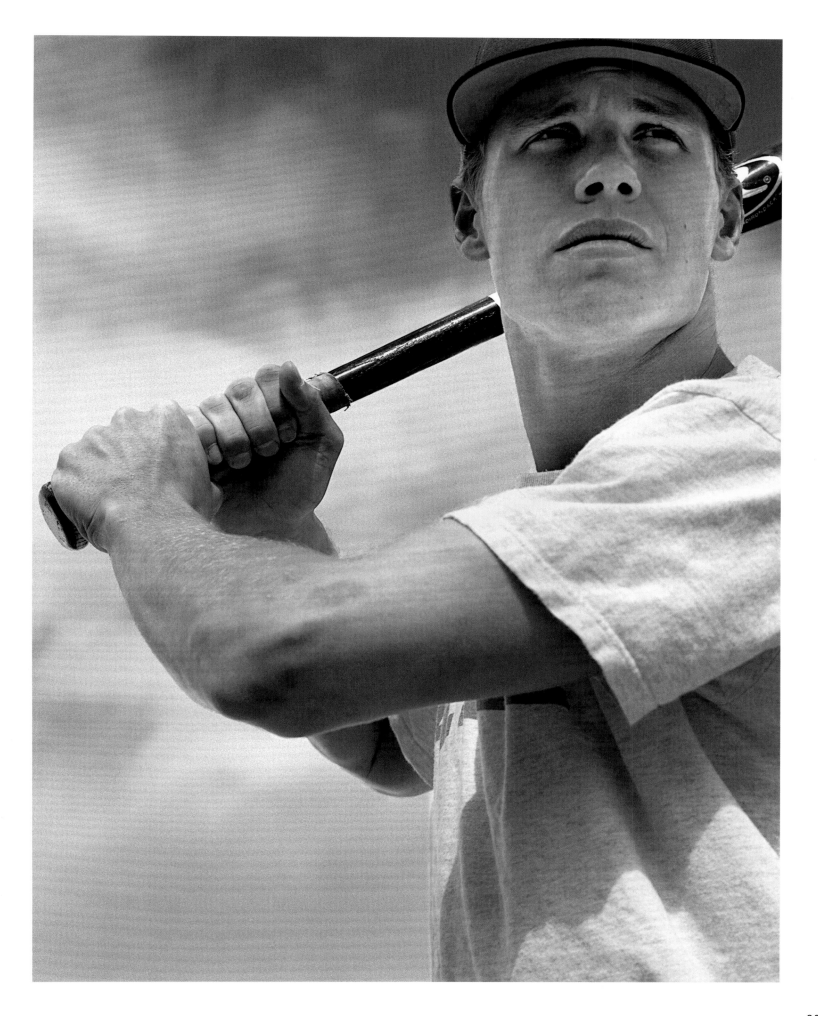

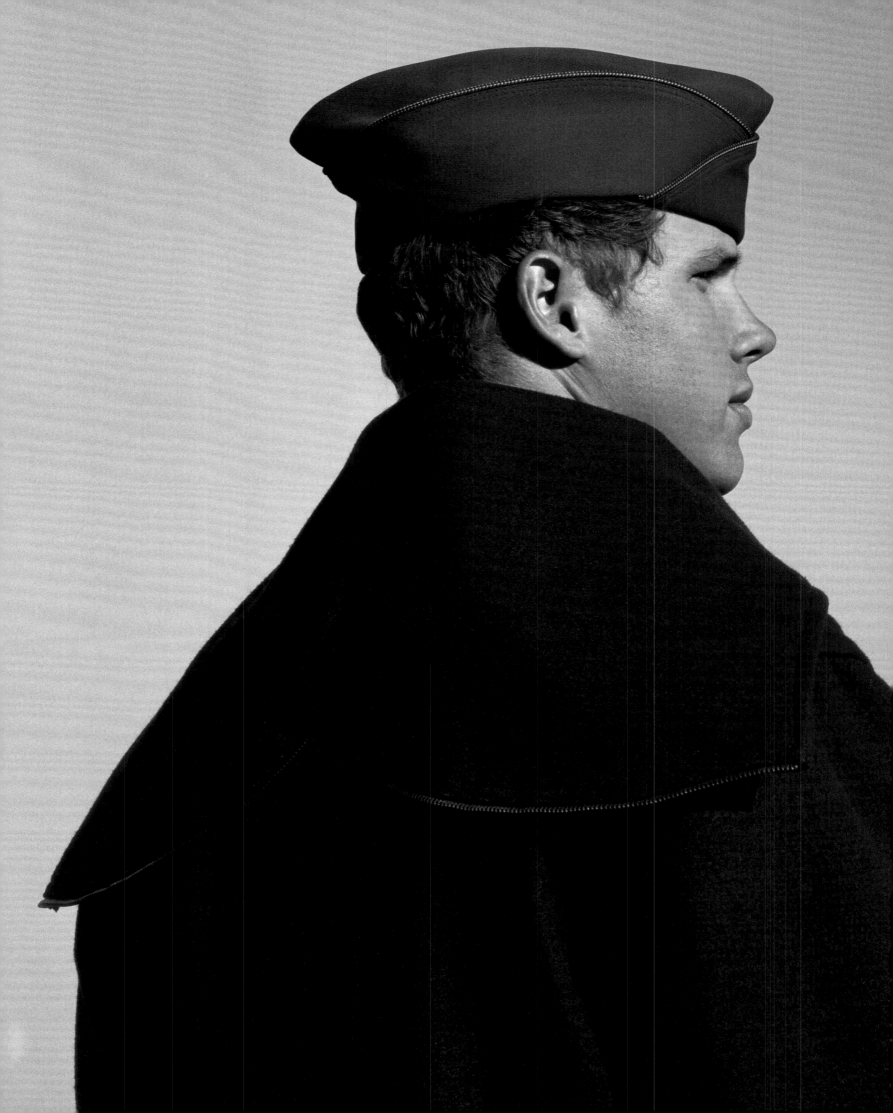

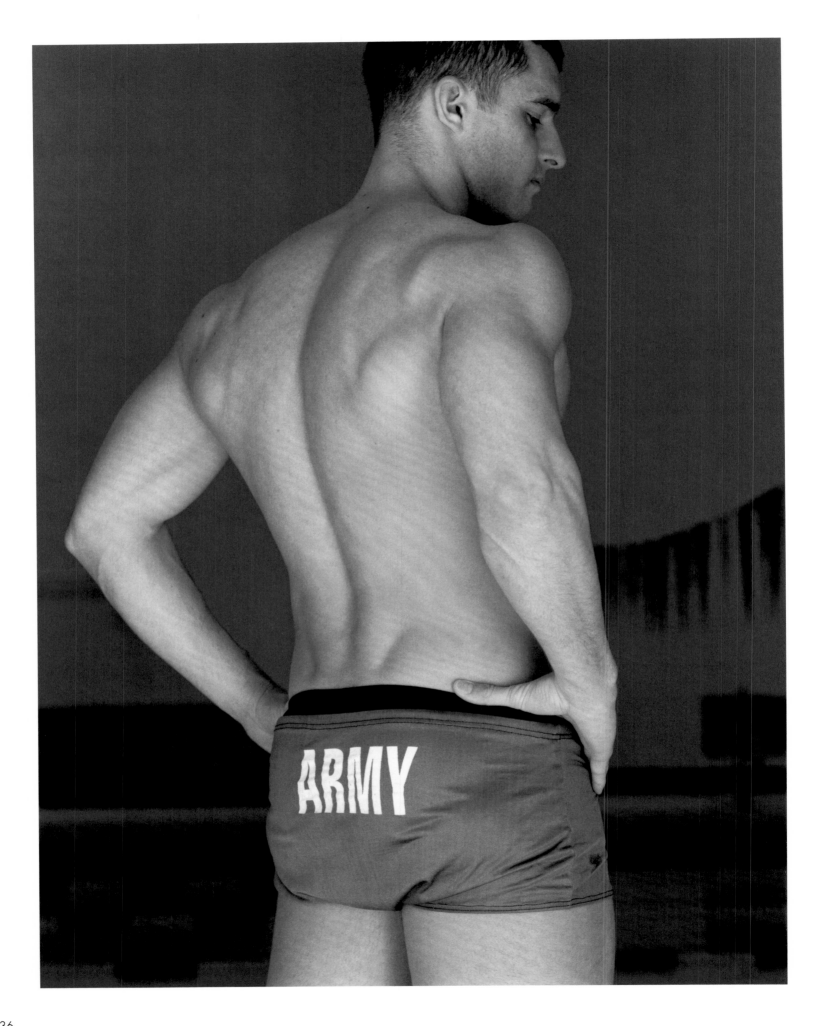

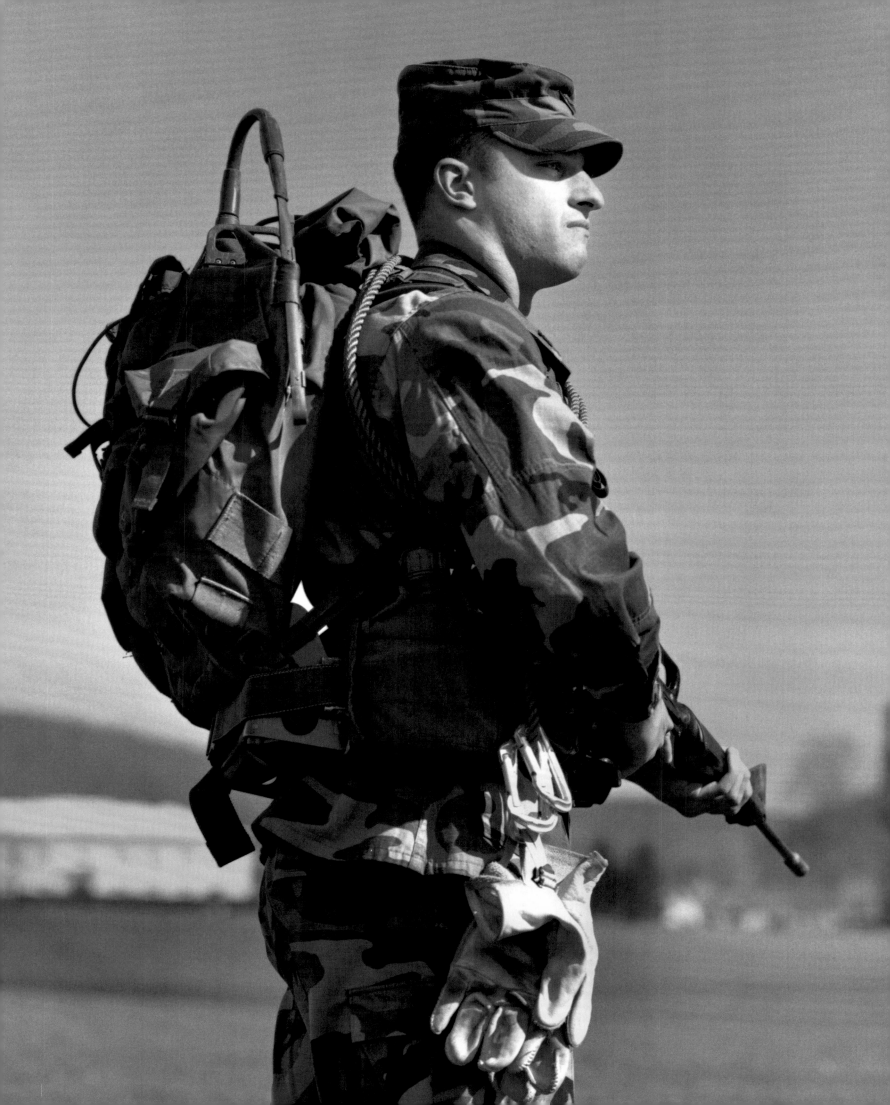

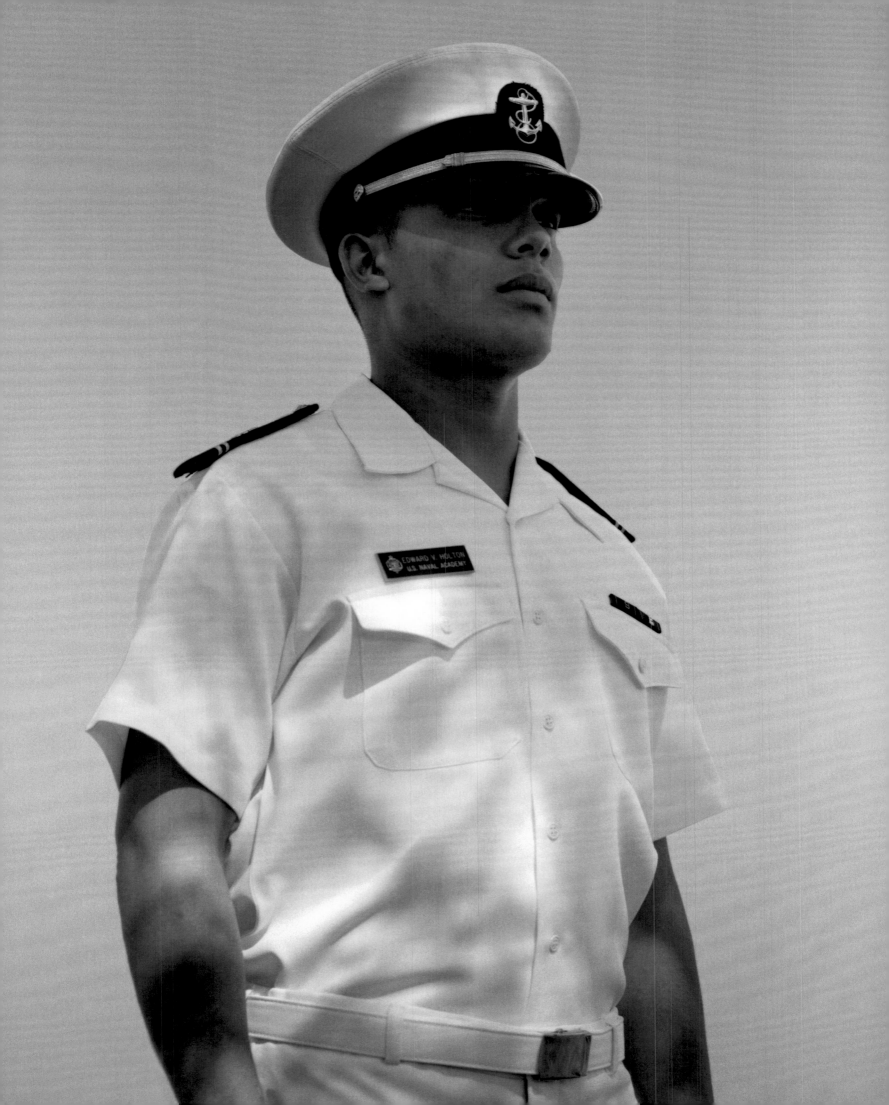

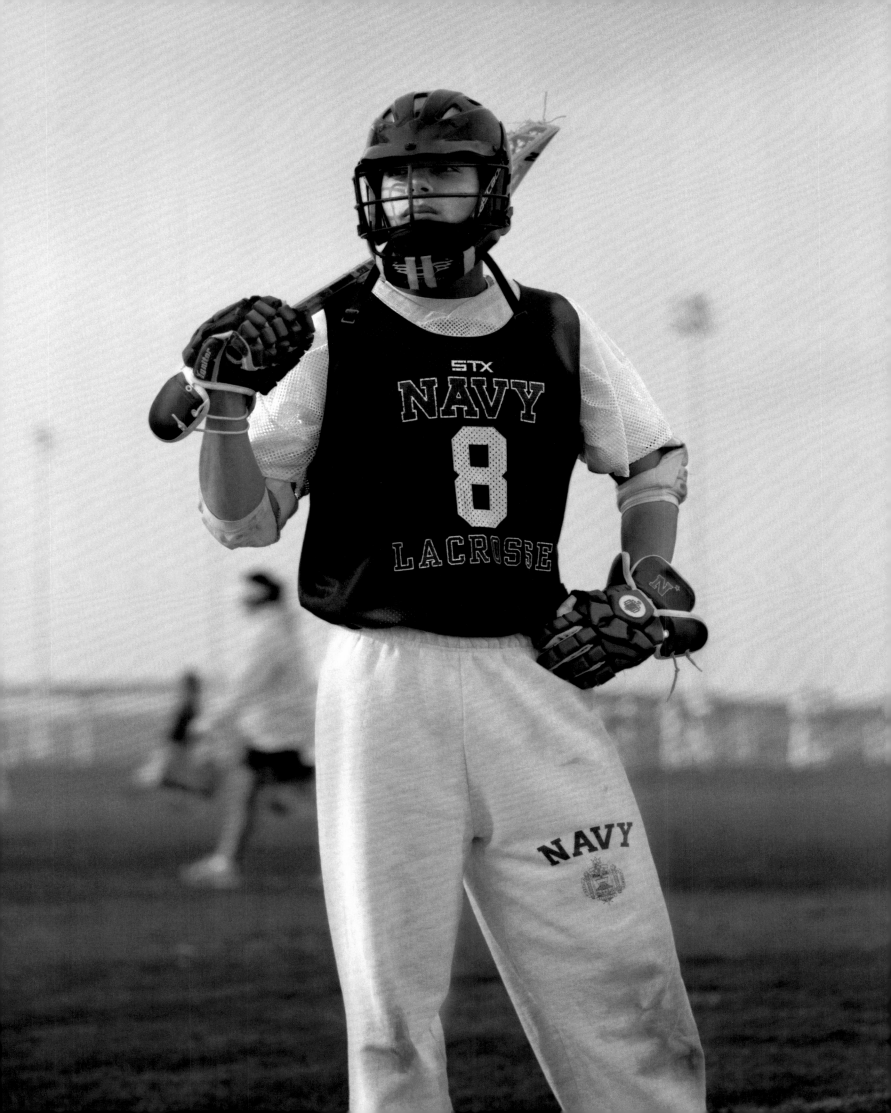

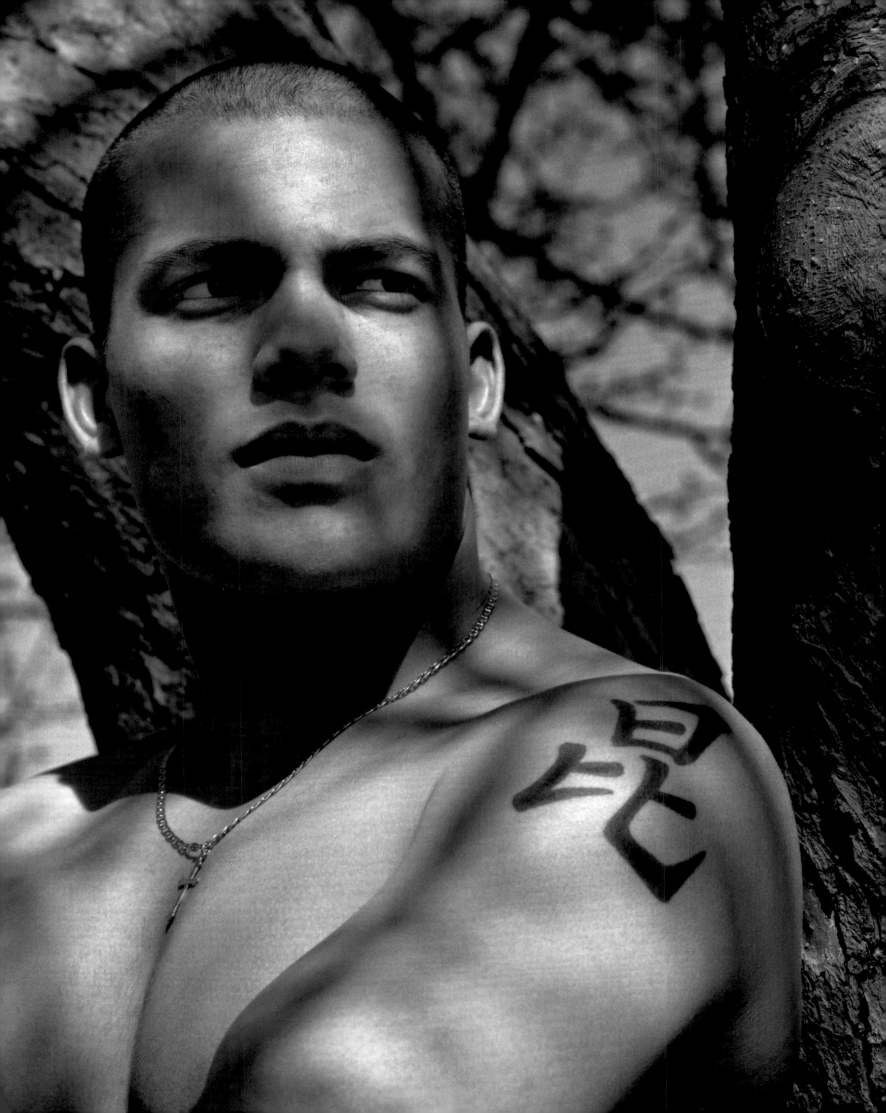

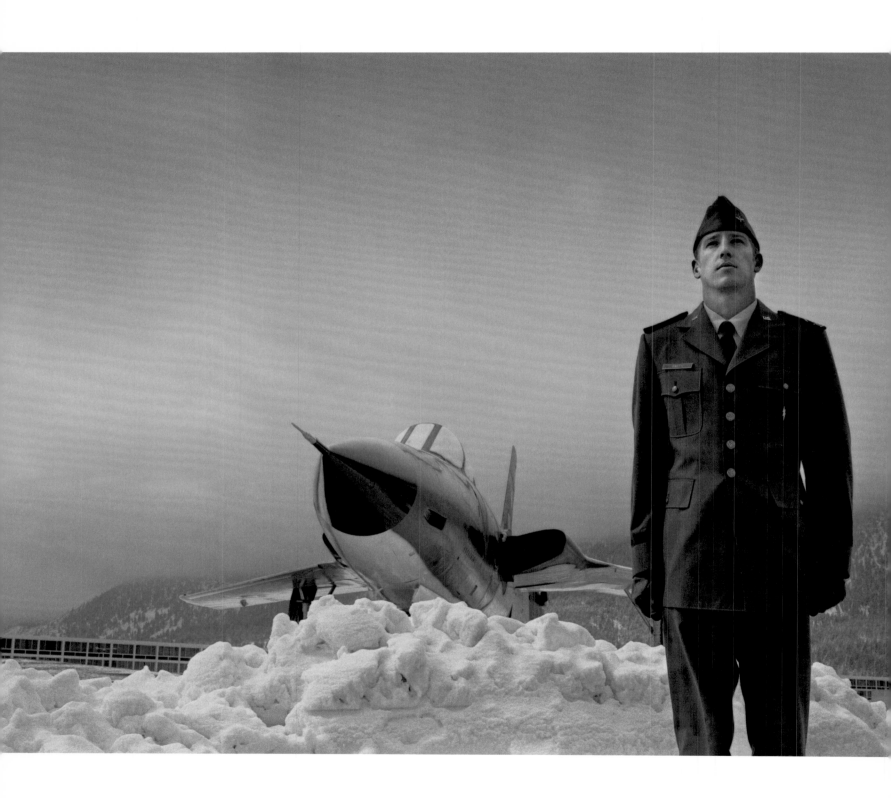

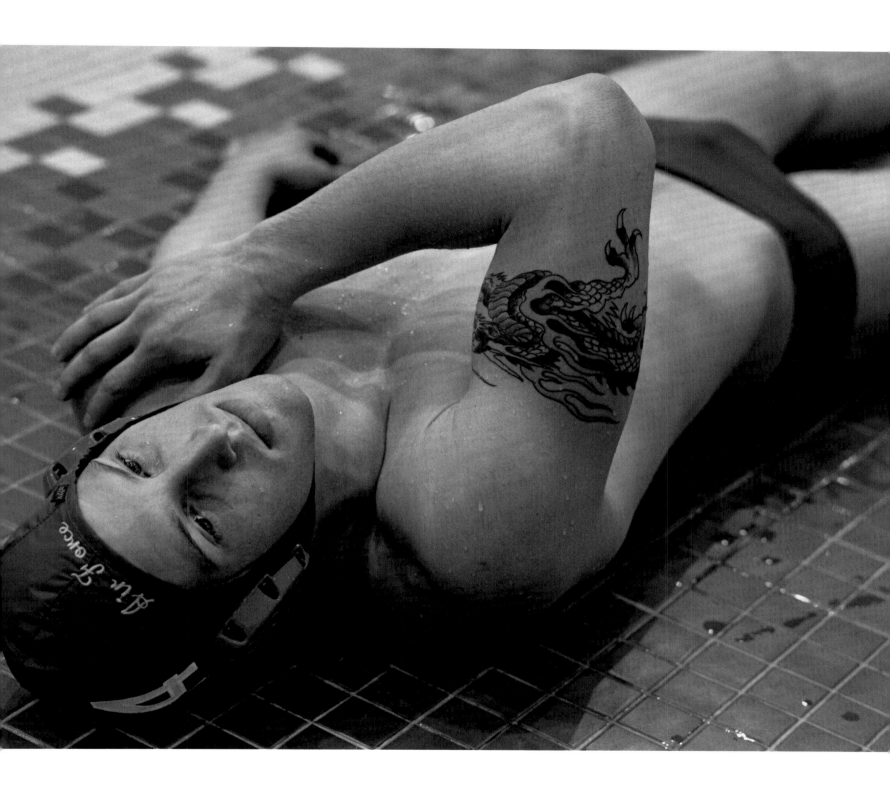

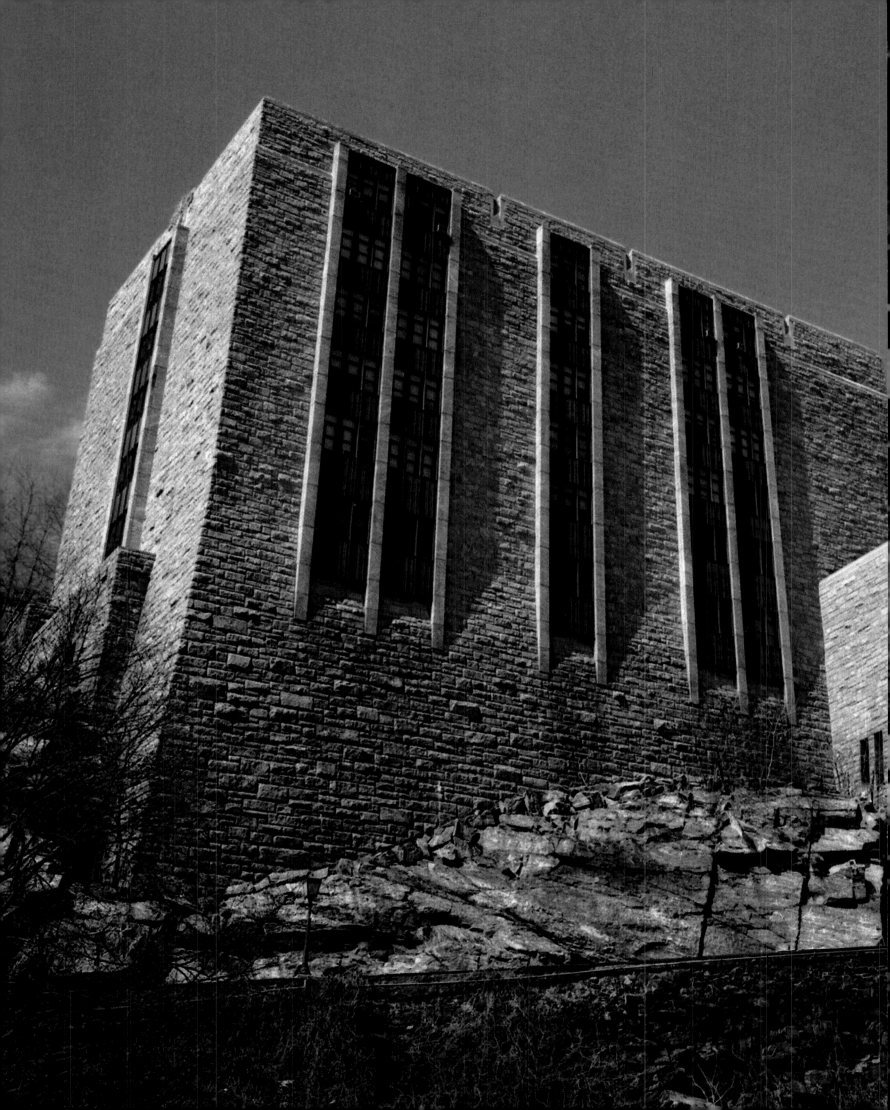

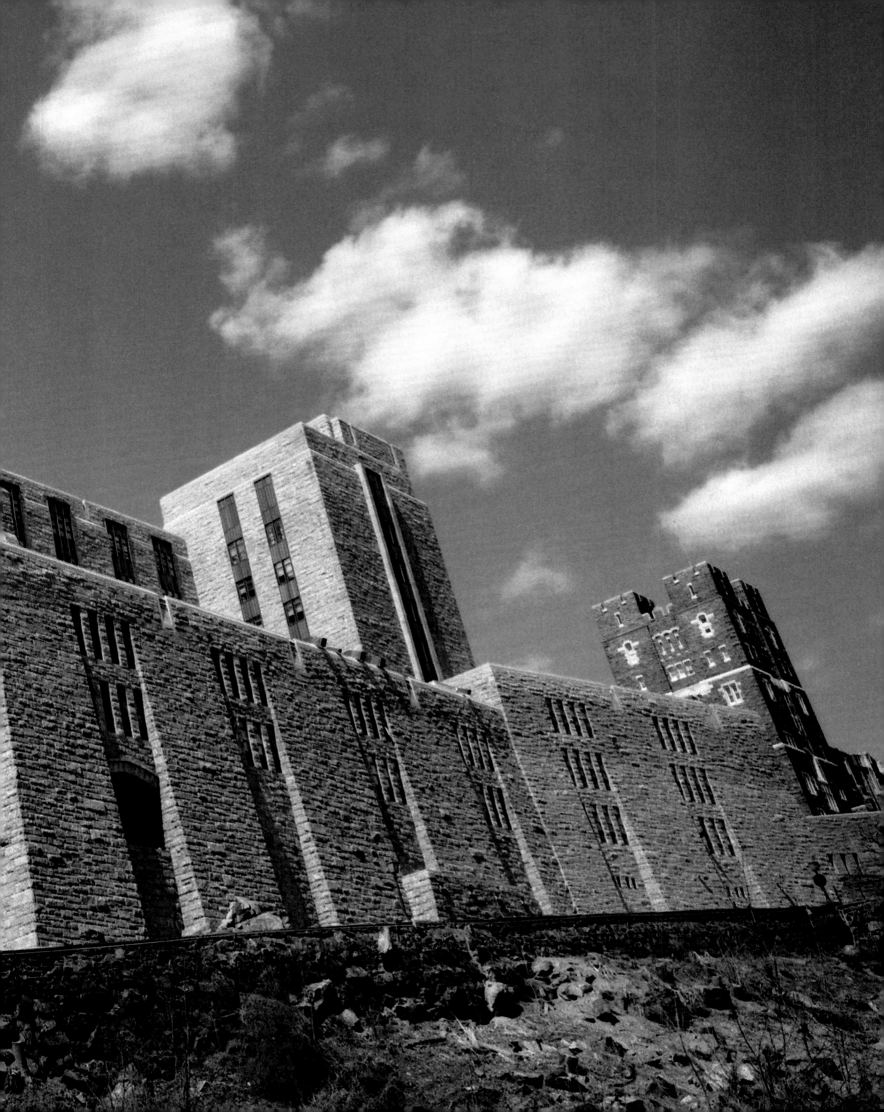

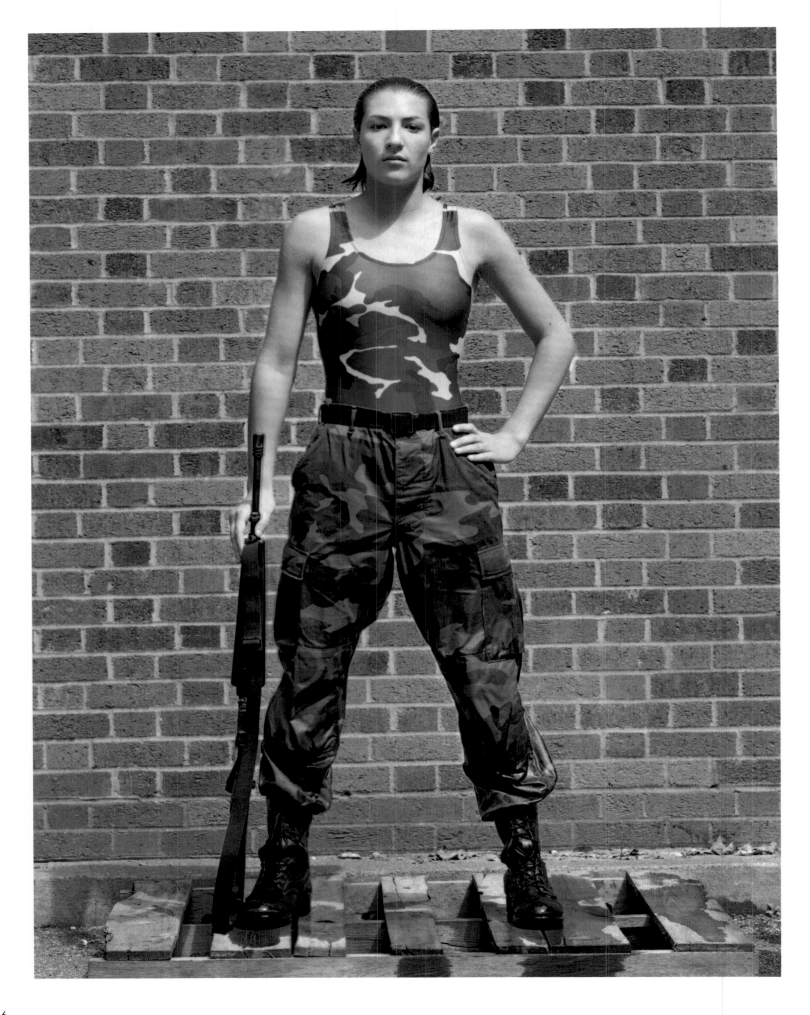

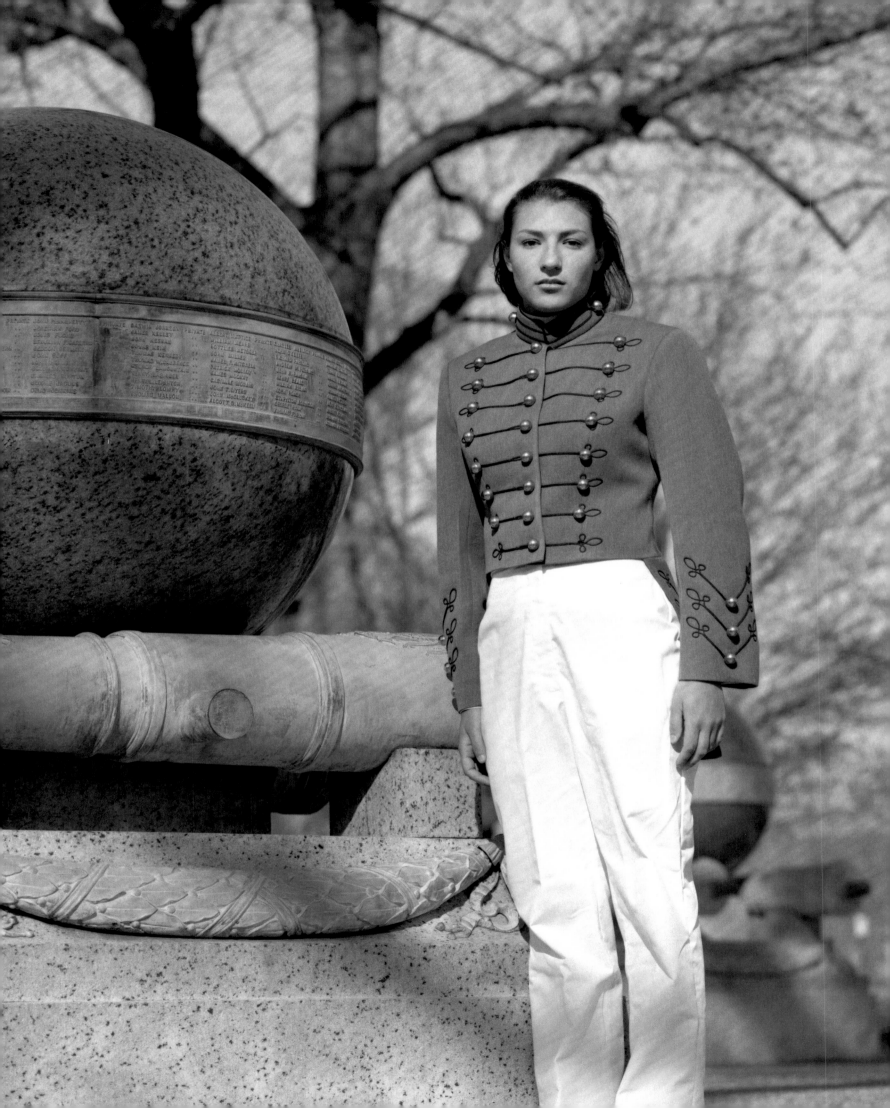

The partially visible inscriptions on the bronze band of the monument read:

PRIVATE JOHN PENNEBERRY PRIVATE EDWIN JOHNSON PRIVATE JAMES ...
ABRAHAM FORD JAMES KELLEY WILLIAM MEAD
SILAS FLOOD JOHN KEENAN COTTLIEB MENSEL
BENJAMIN BRADFORD JOHN KEIM JOHN MILLER
JOHN BOFF THOMAS MENSER JAMES F. MITBALL
 HELROE EMOUNTAIN BATLCA MOLLY
CHARLES KITTON WM. LEIGHTON JAMES McCRAY
GEORGE JACOBS TIMOTHY LOWRY C.BSMILE MORAN
GOLD KILLEBERG THOMAS MALSON JOHN T. MYERS
 JOHN McCLUSKEY
 ALCOTT D. MIKREL

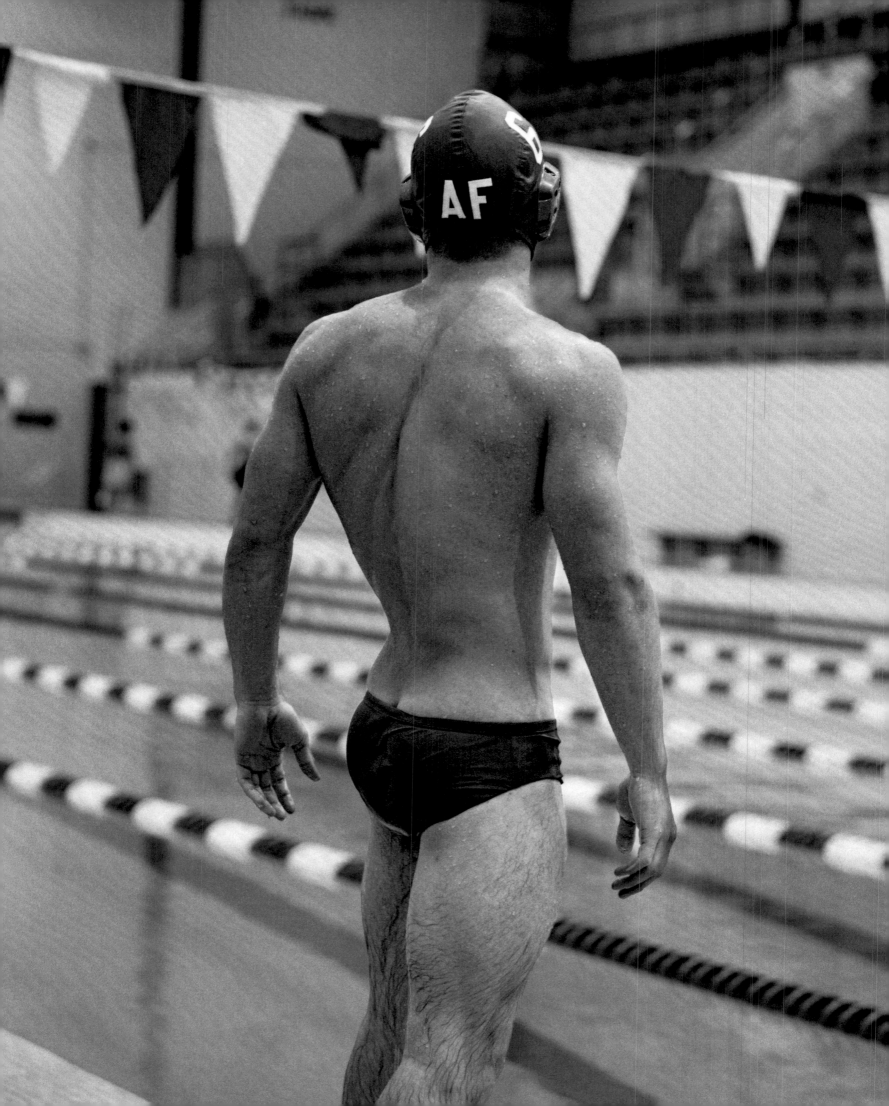

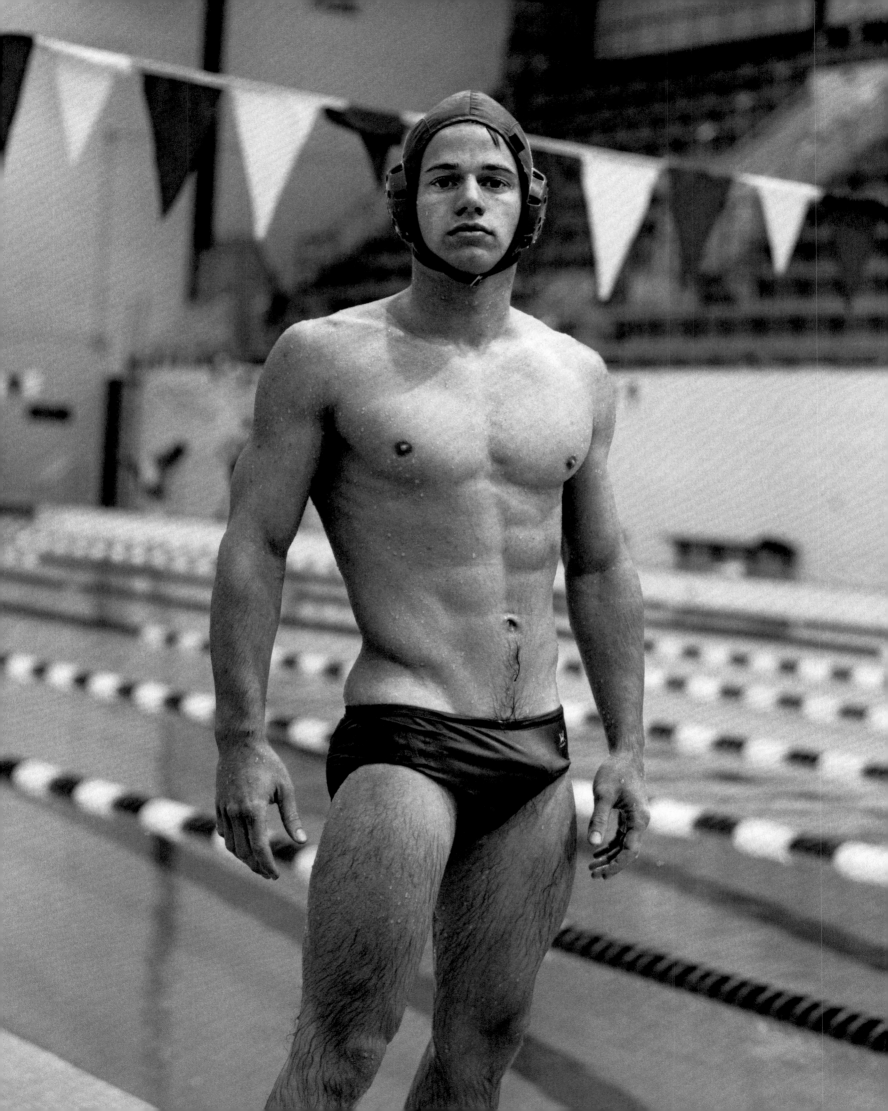

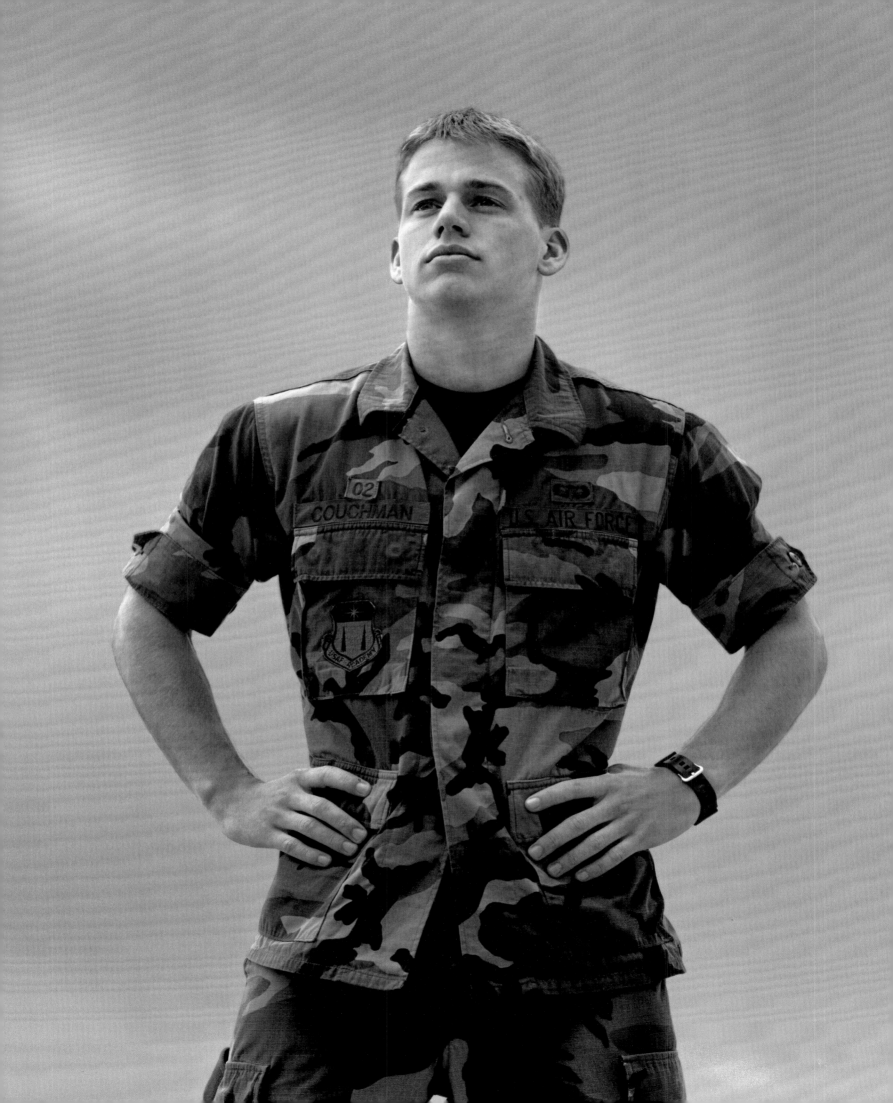

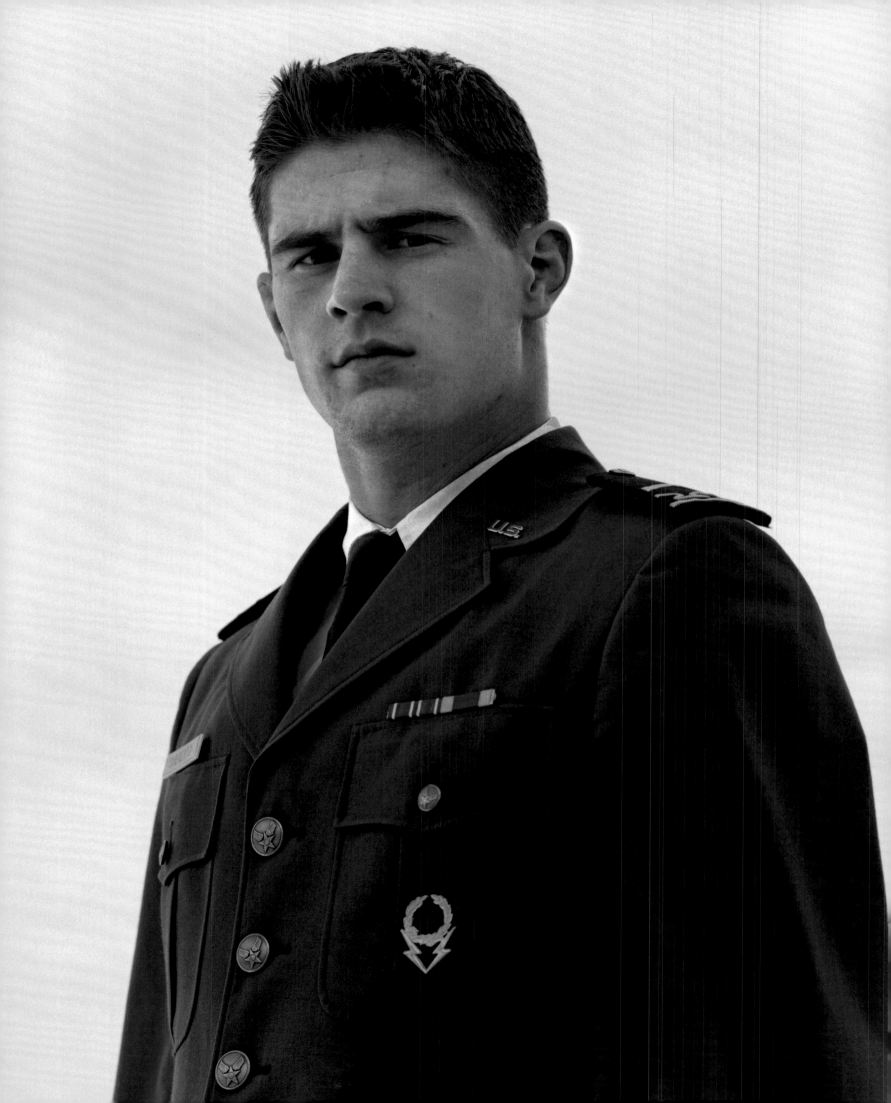

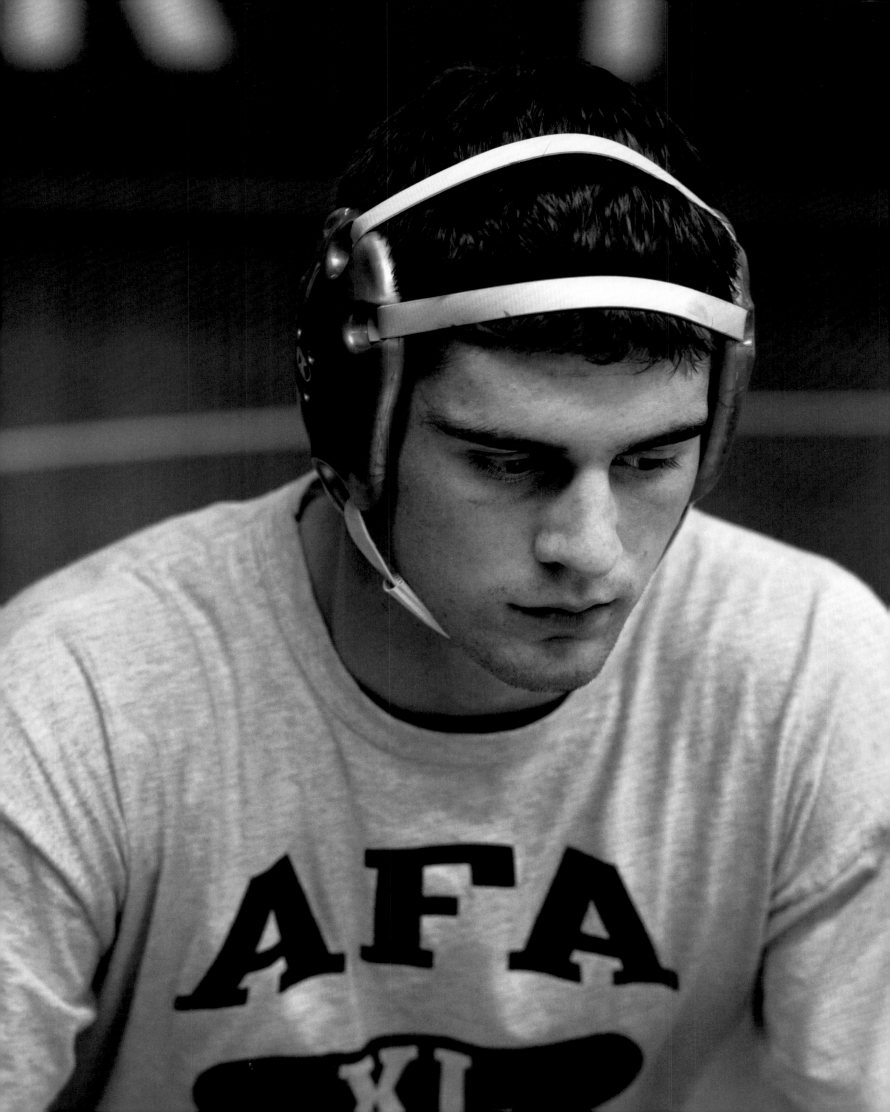

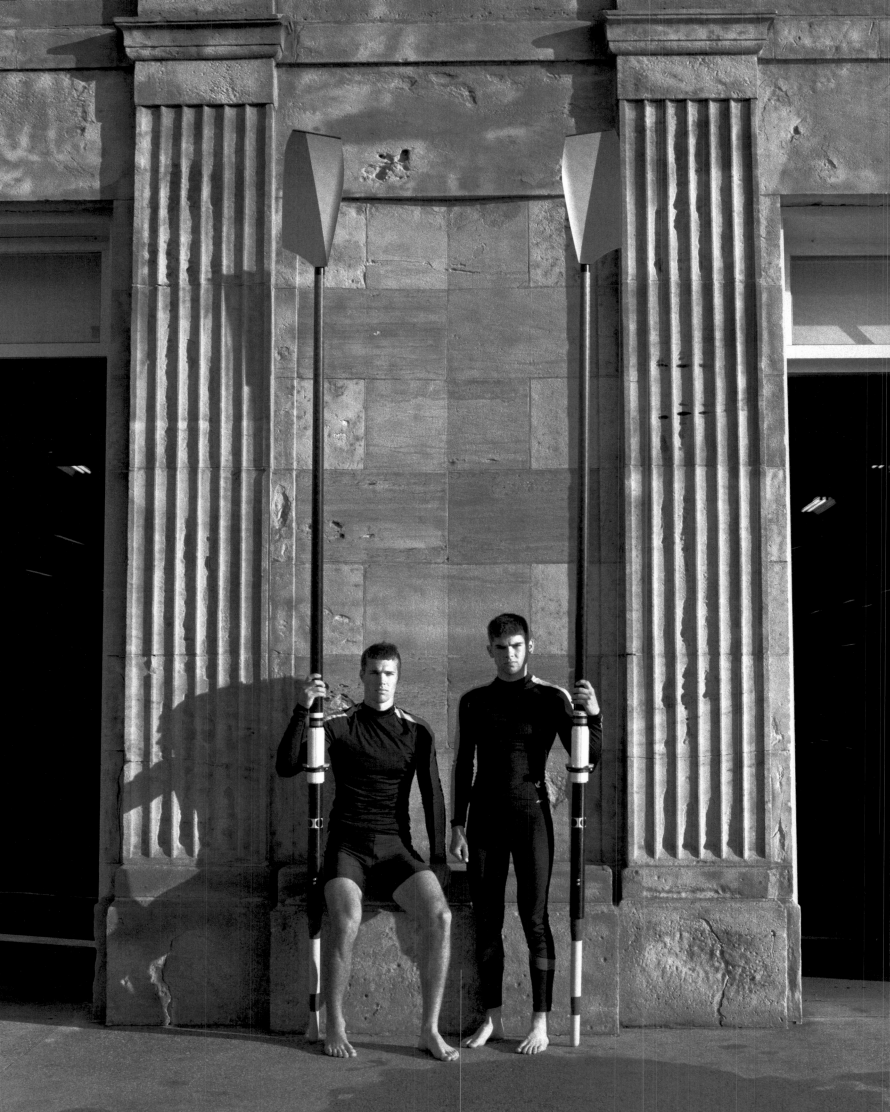

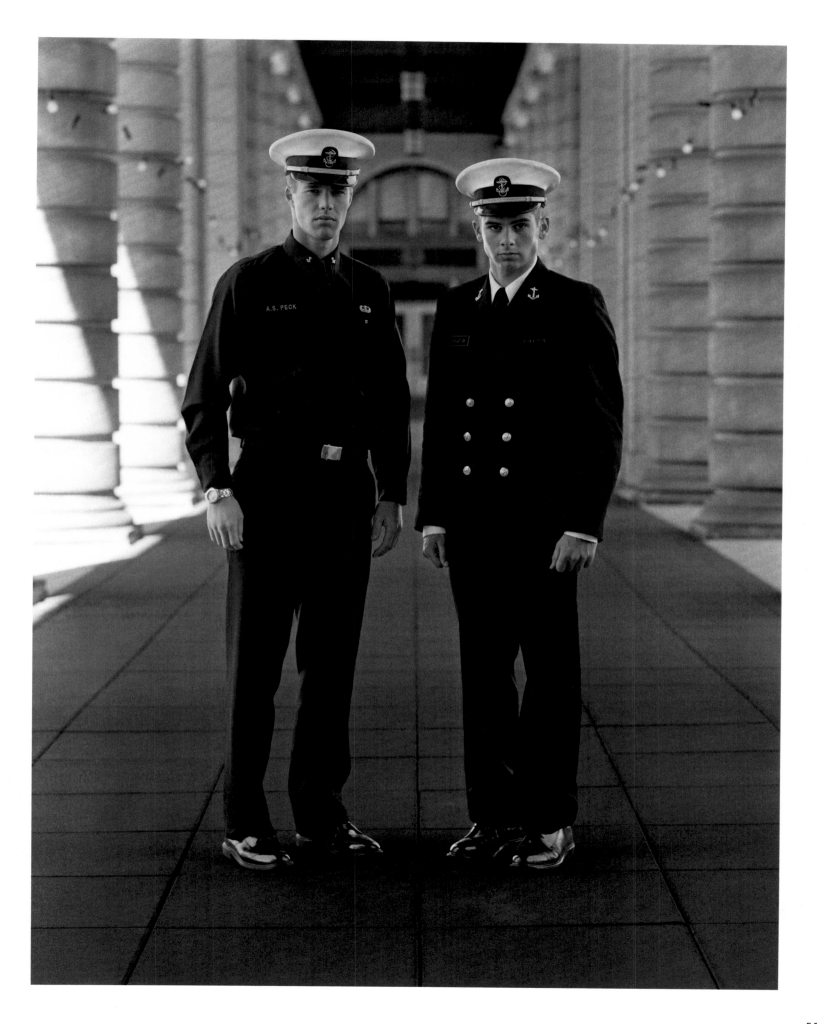

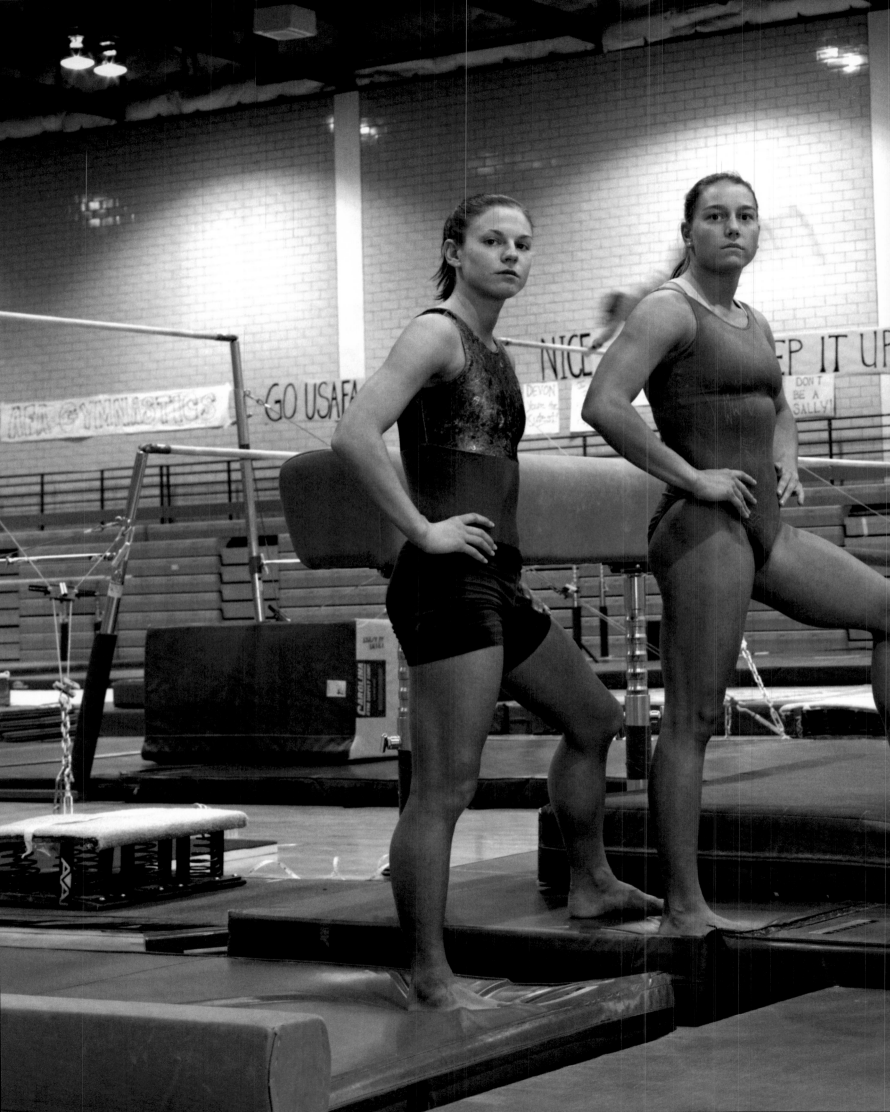

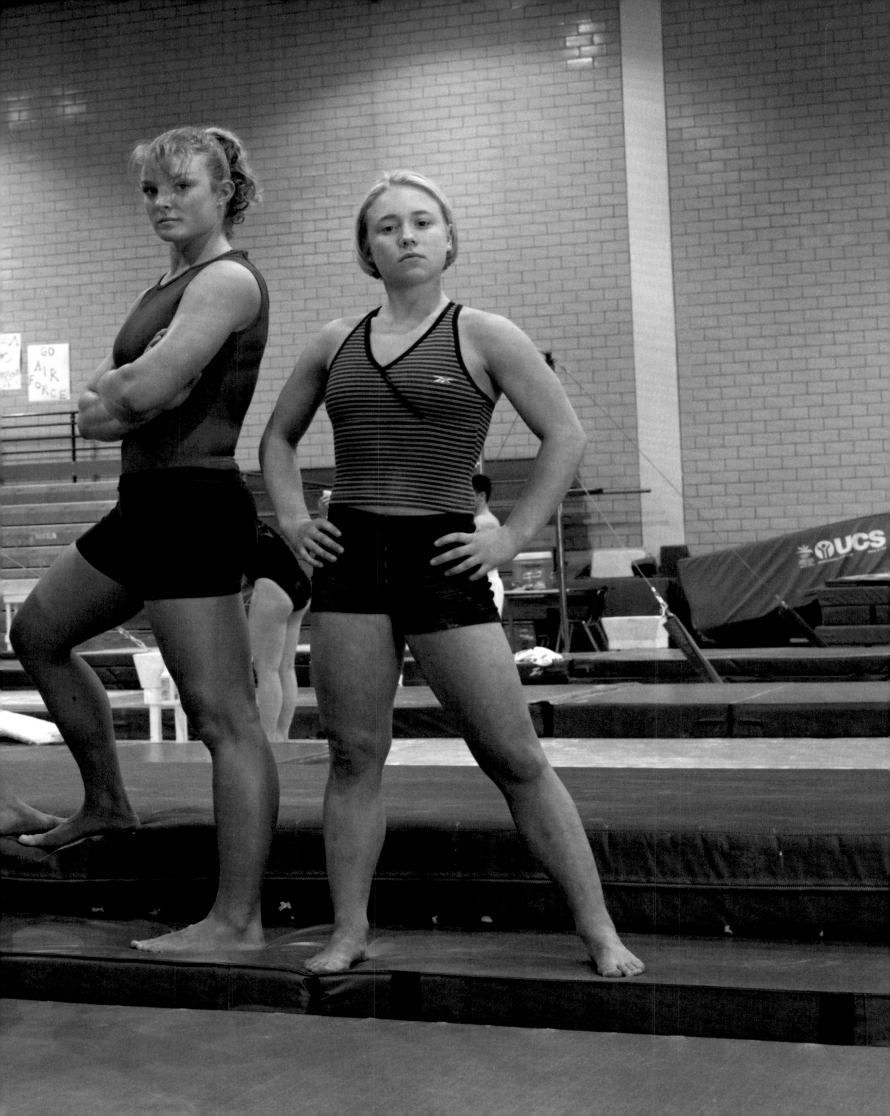

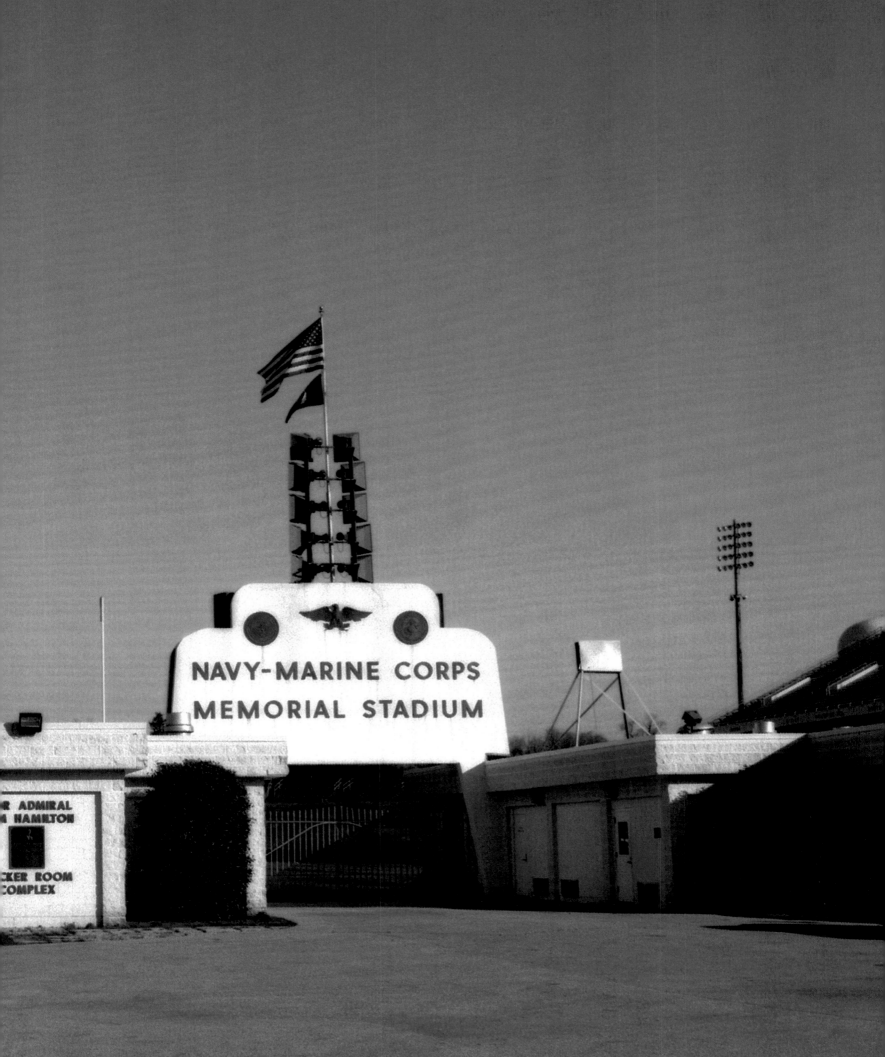

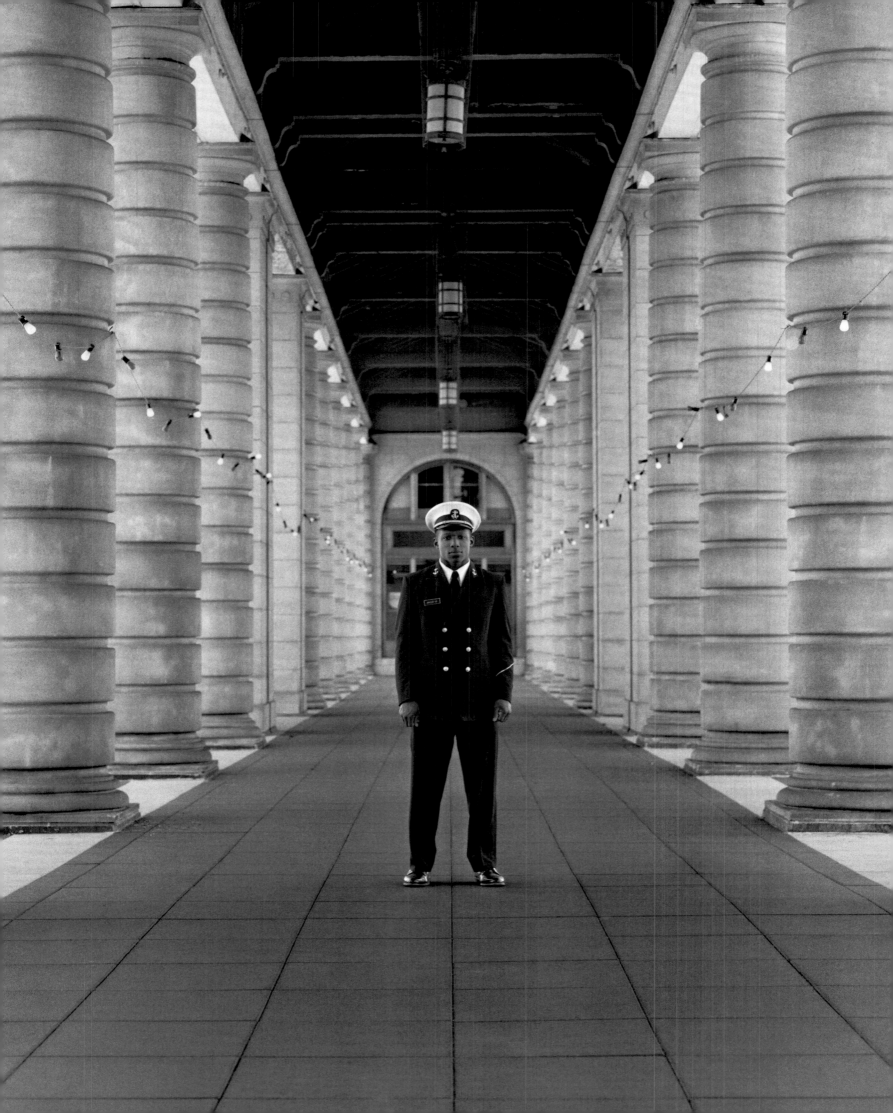

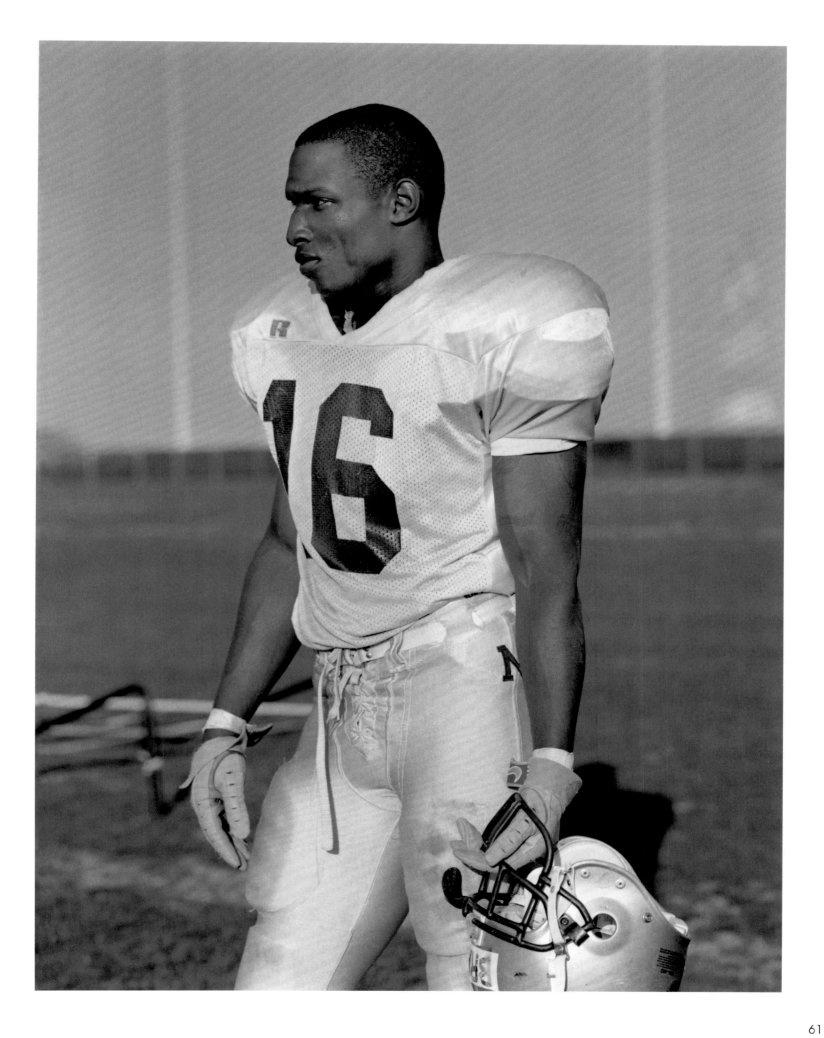

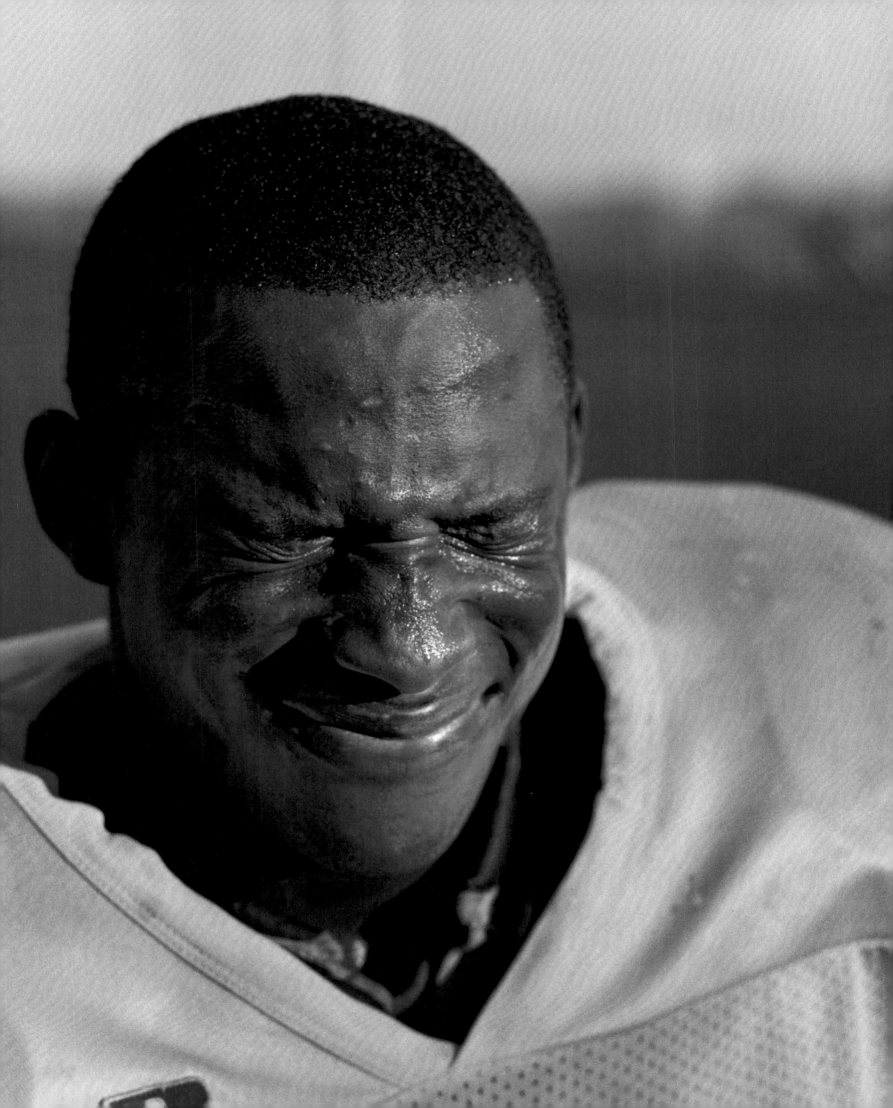

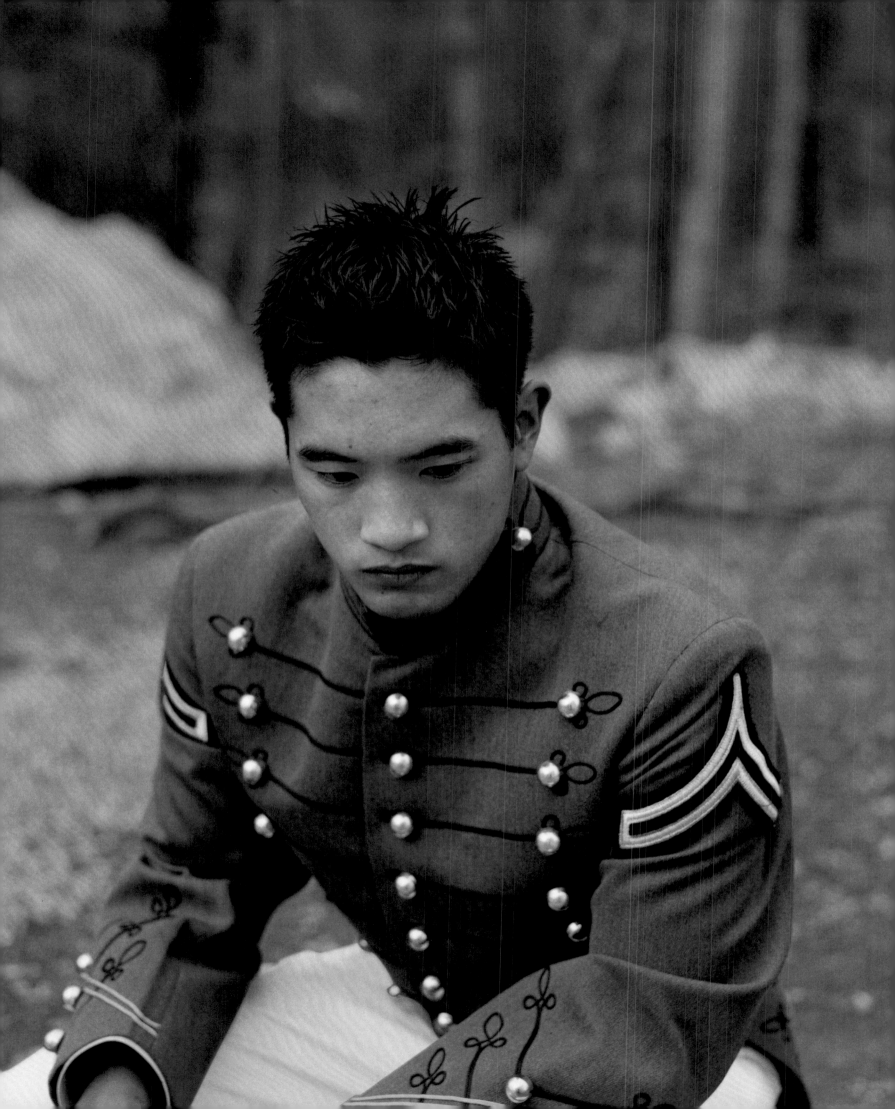

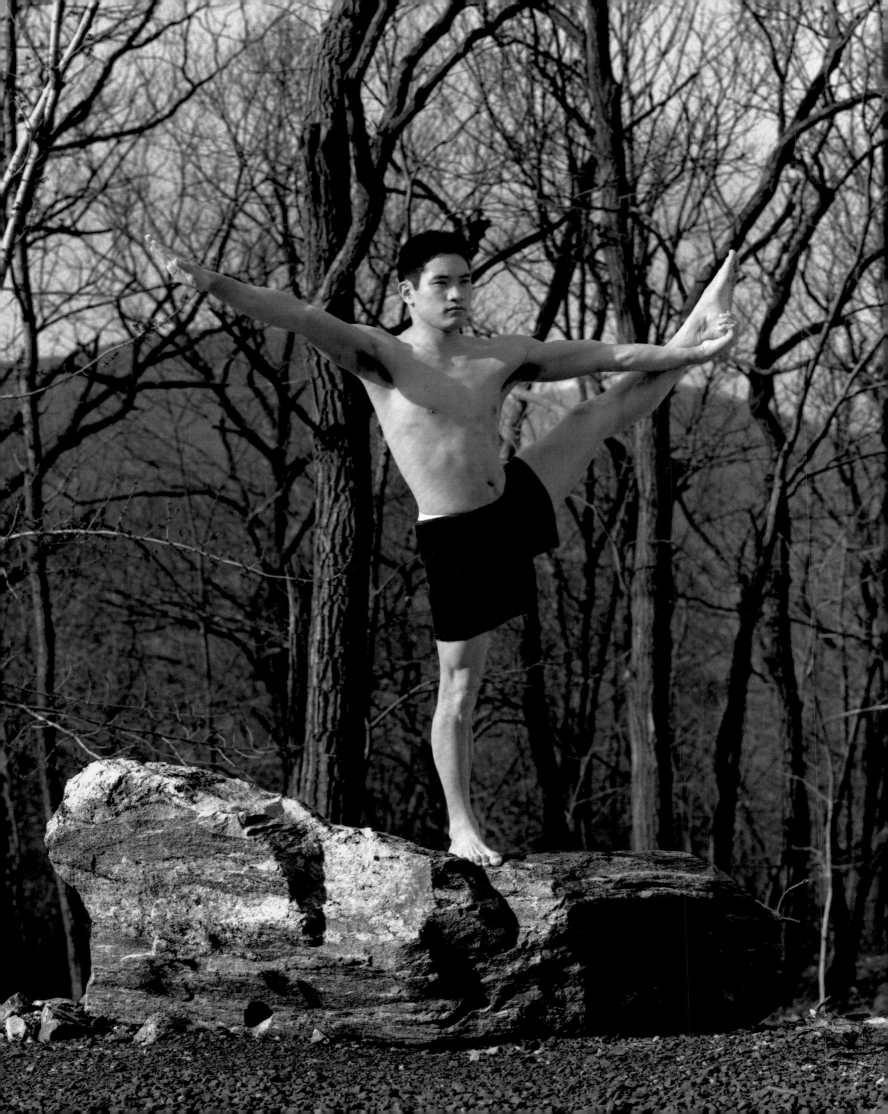

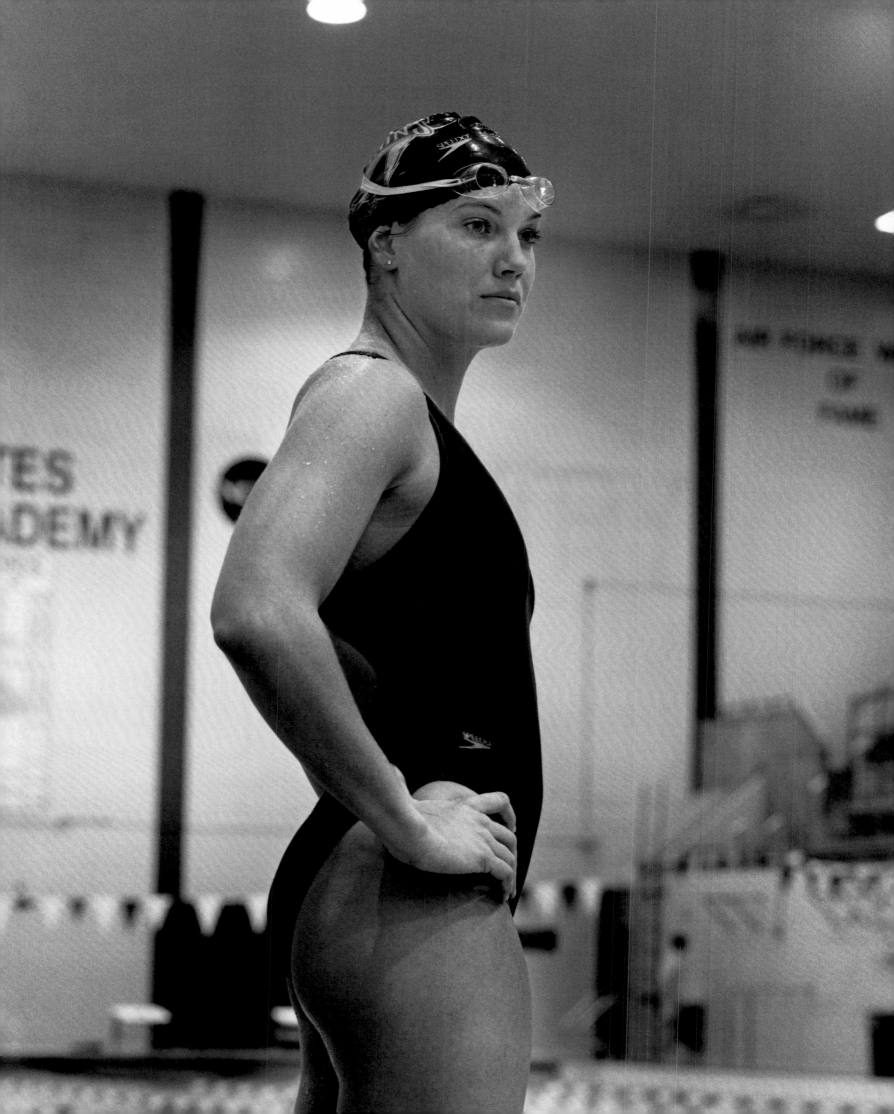

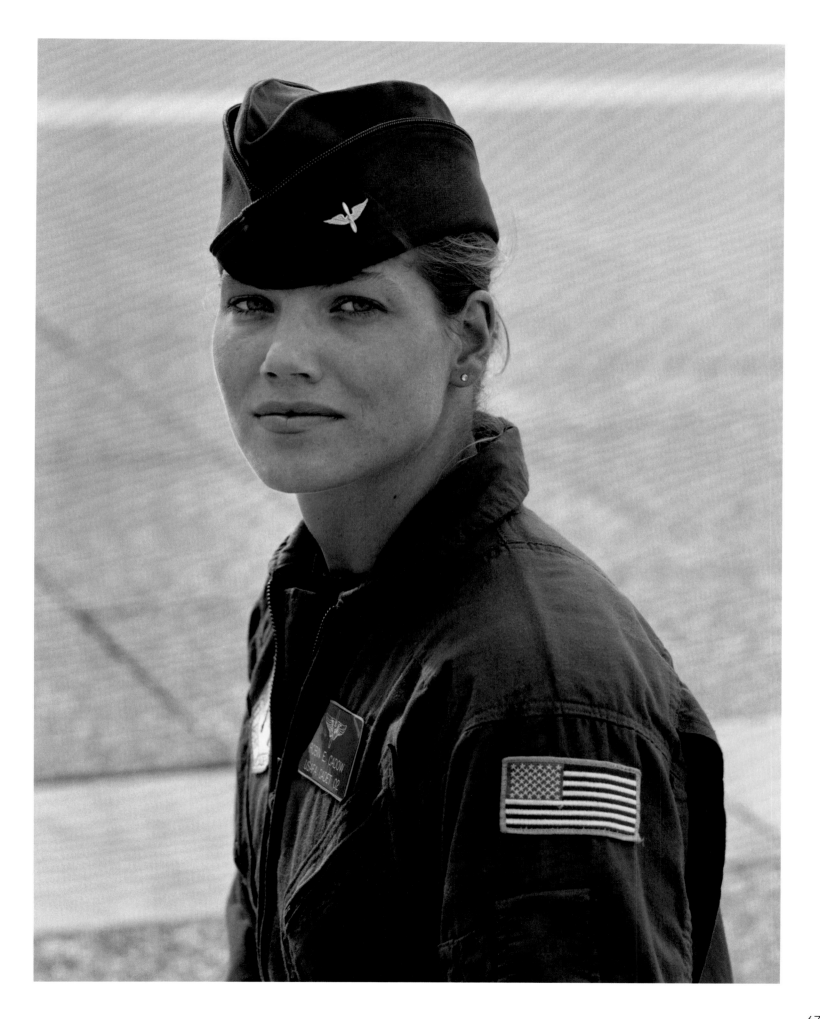

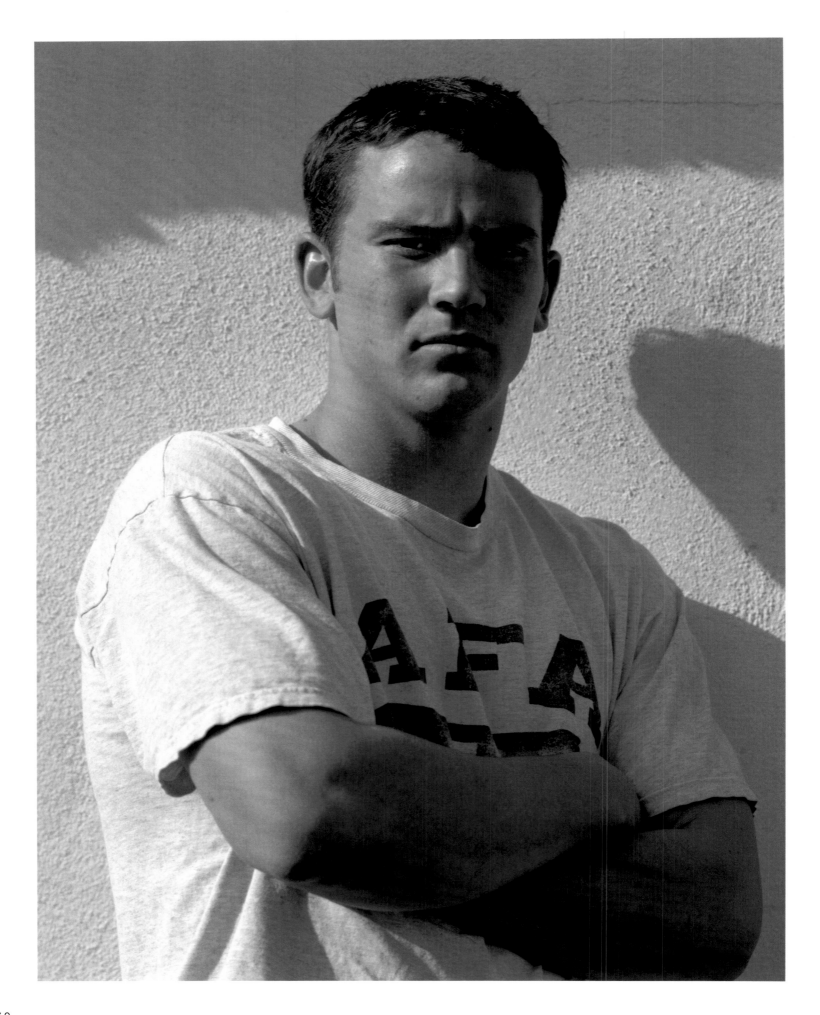

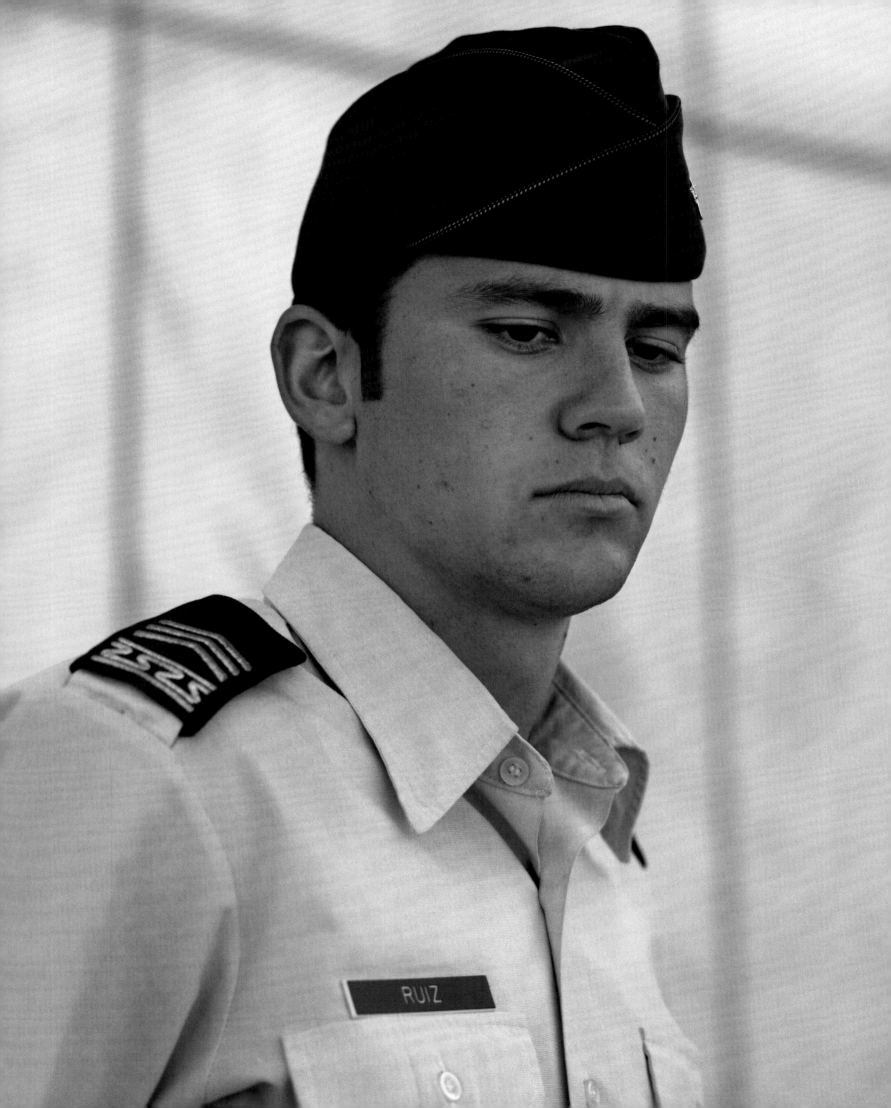

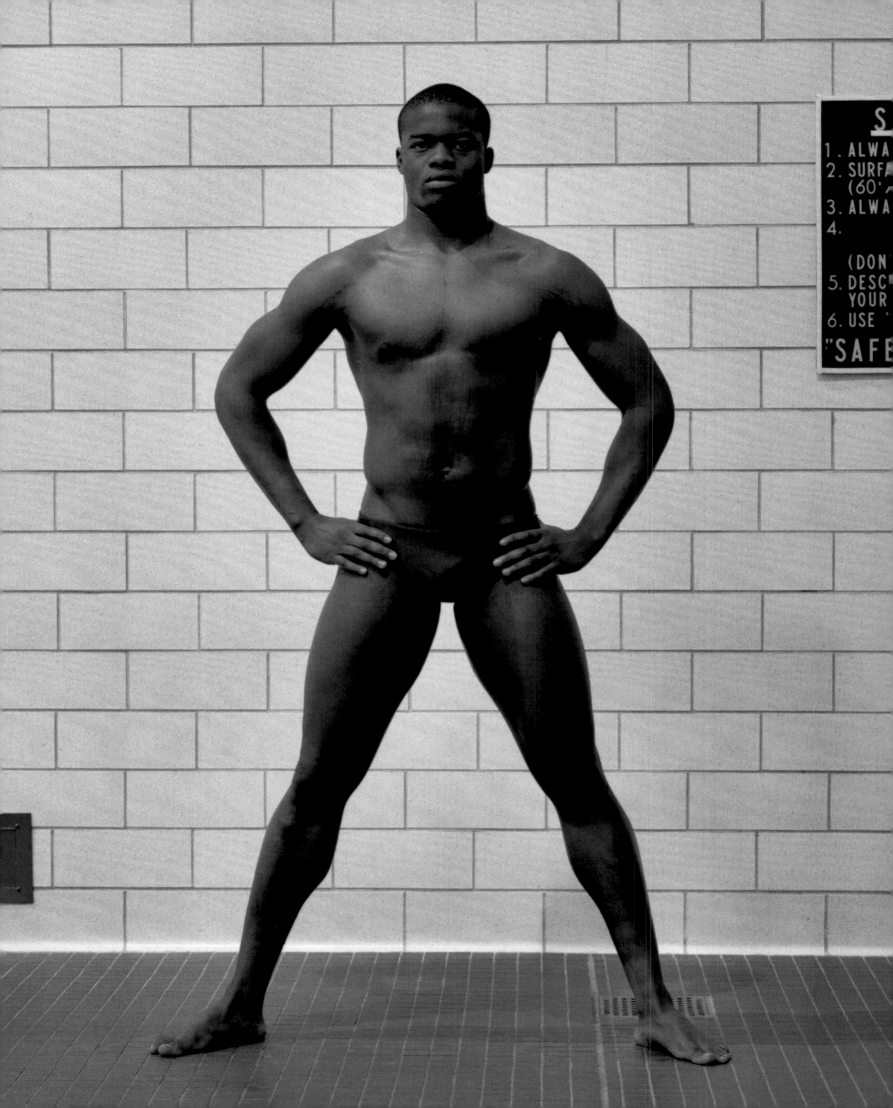

S

1. ALWA
2. SURFA
 (60' ~
3. ALWA
4.

 (DON'

5. DESC
 YOUR
6. USE '

"SAFI

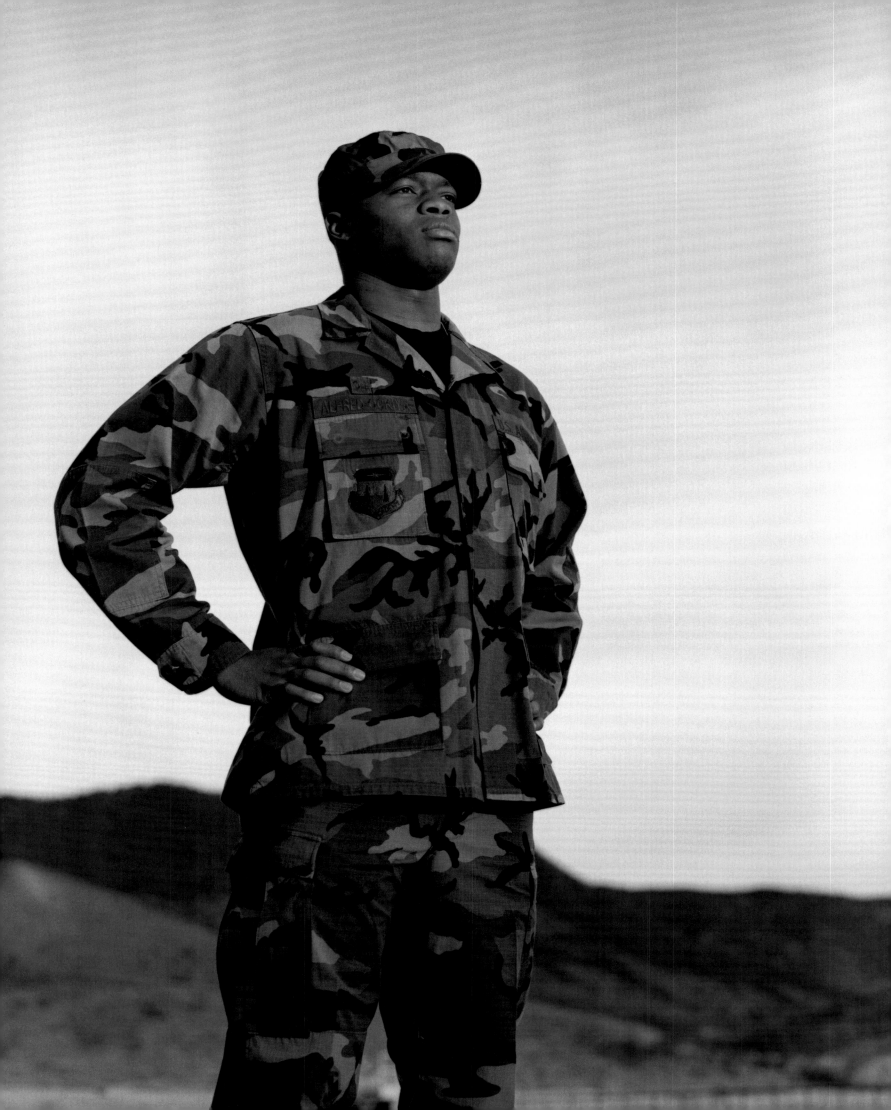

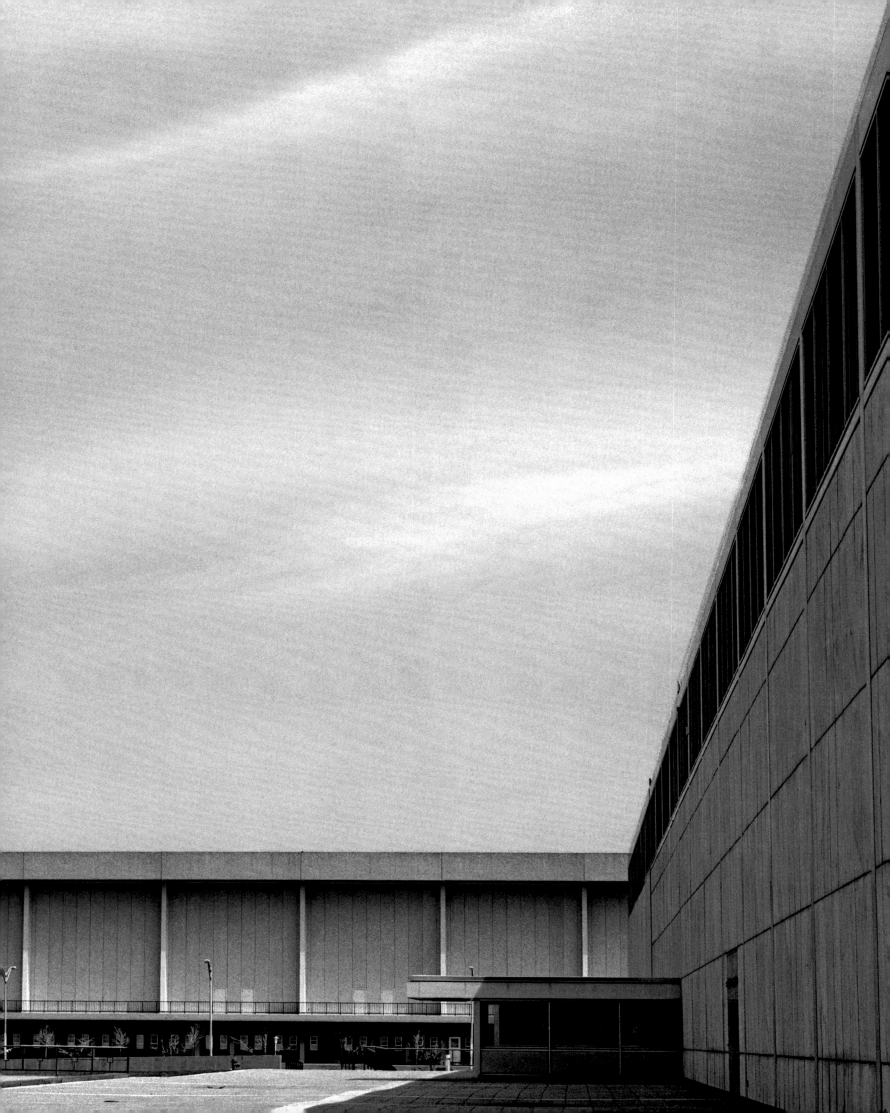

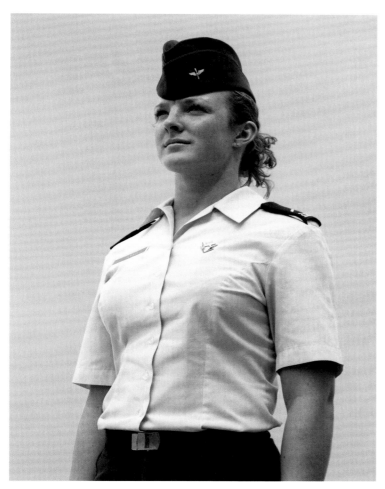
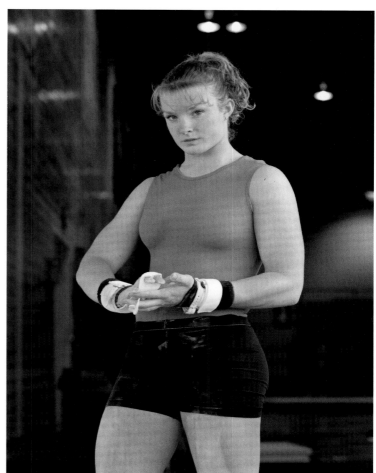
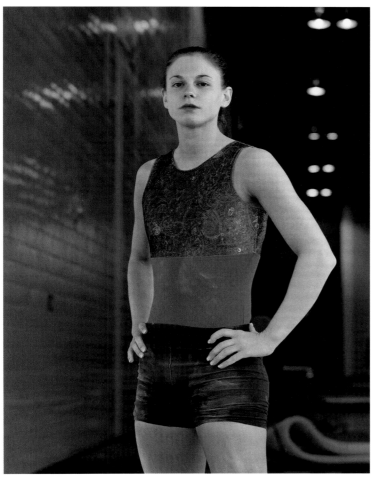
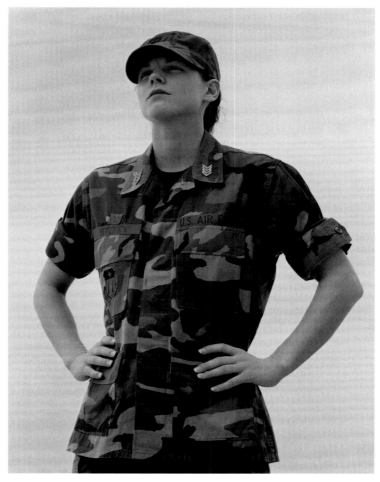

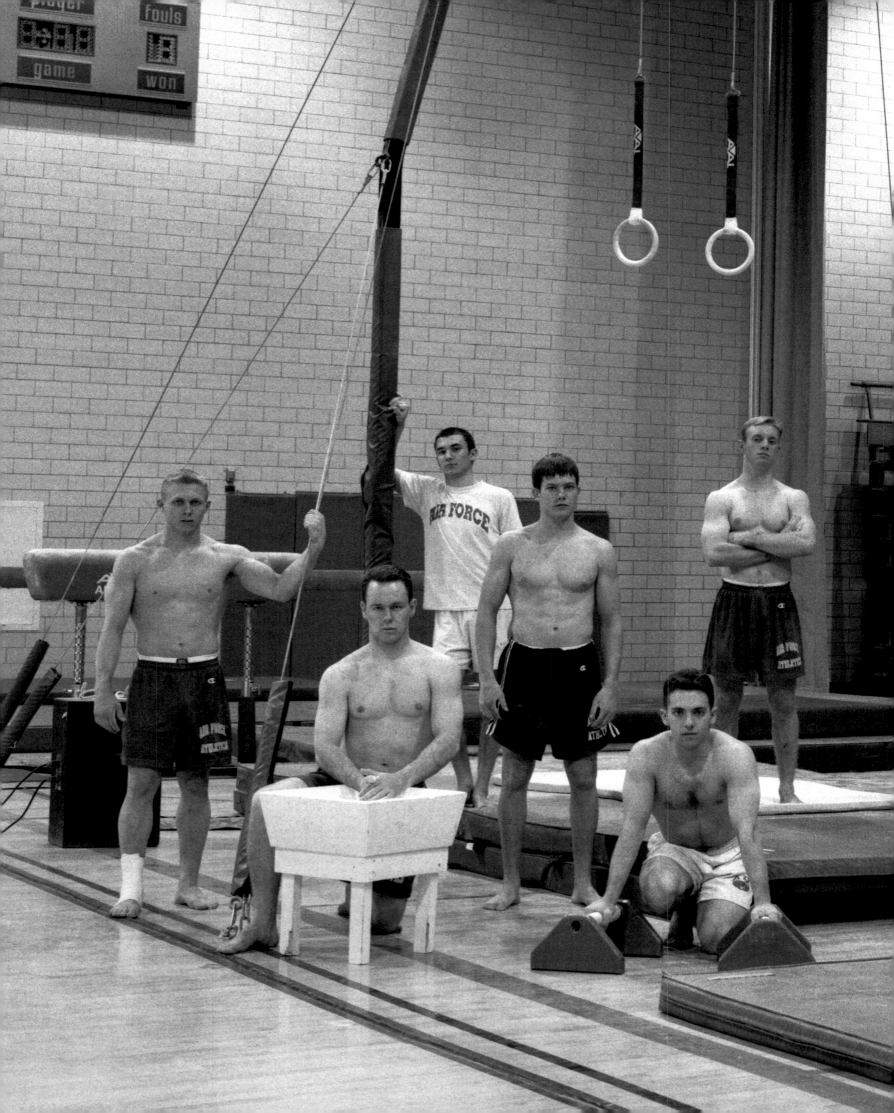

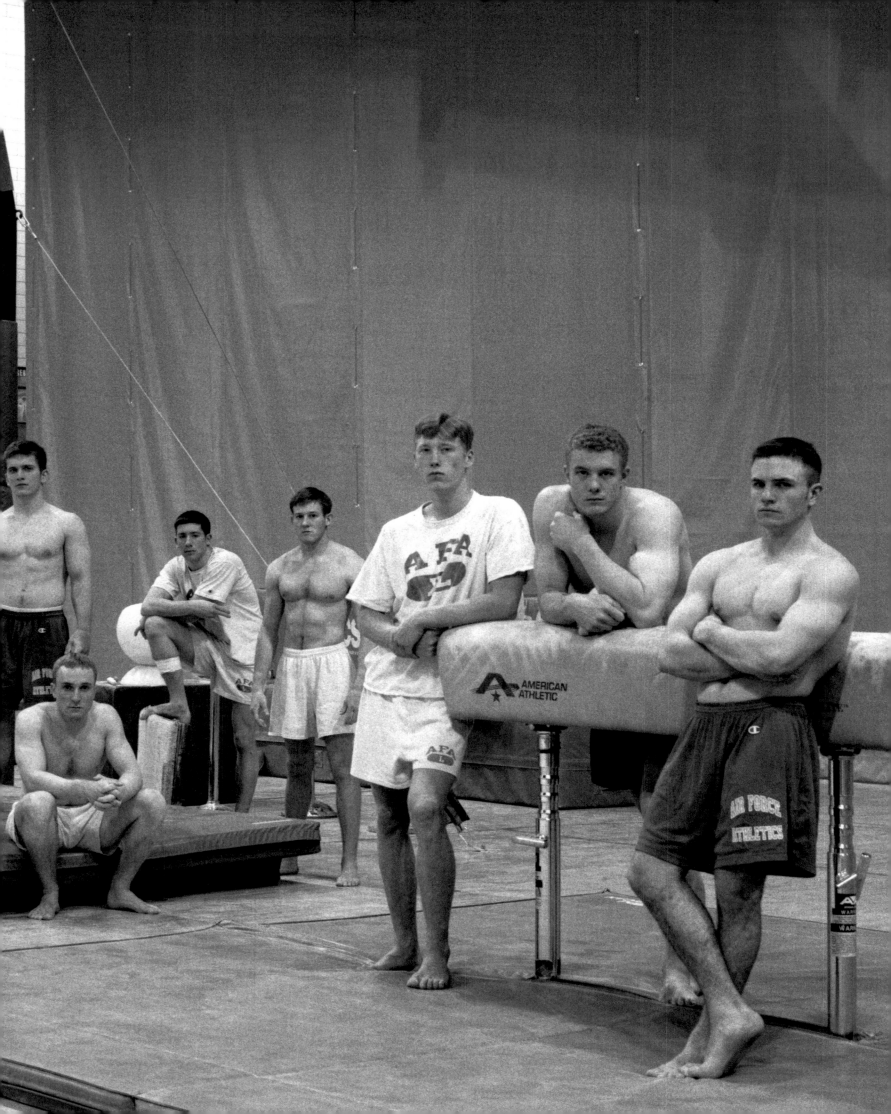

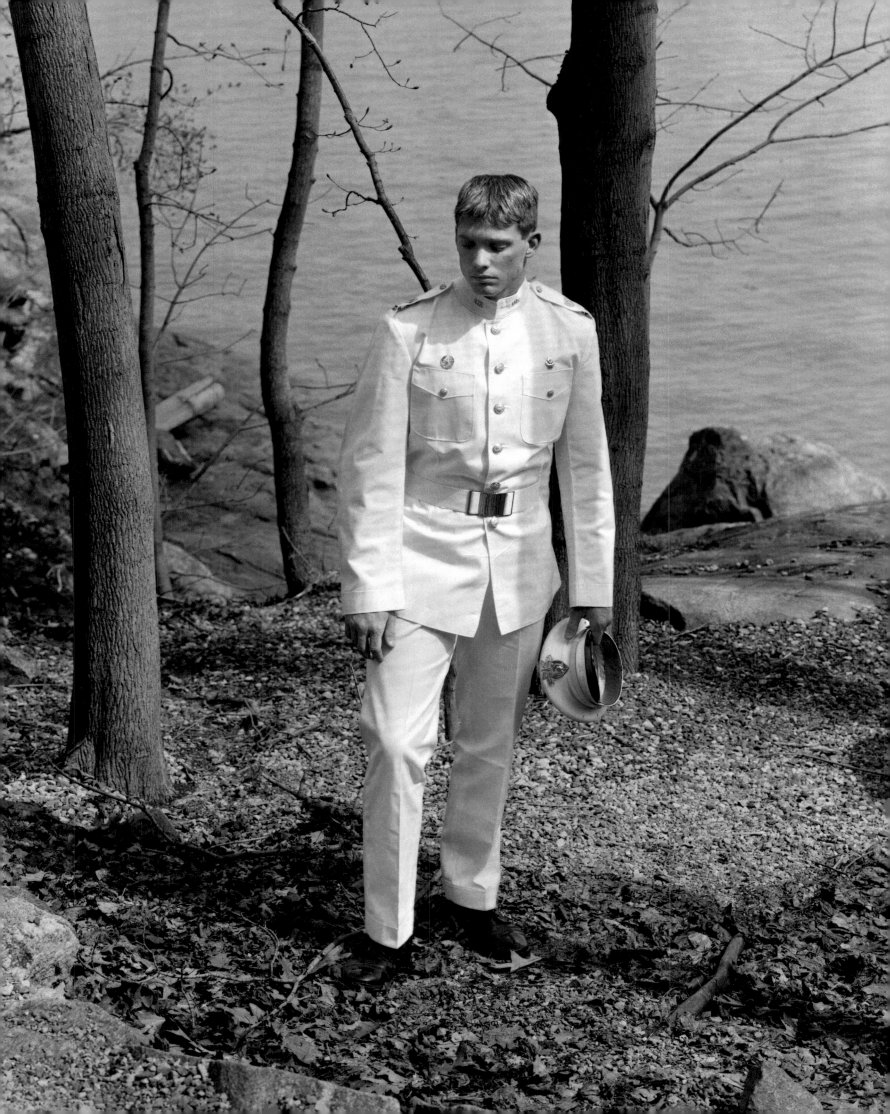

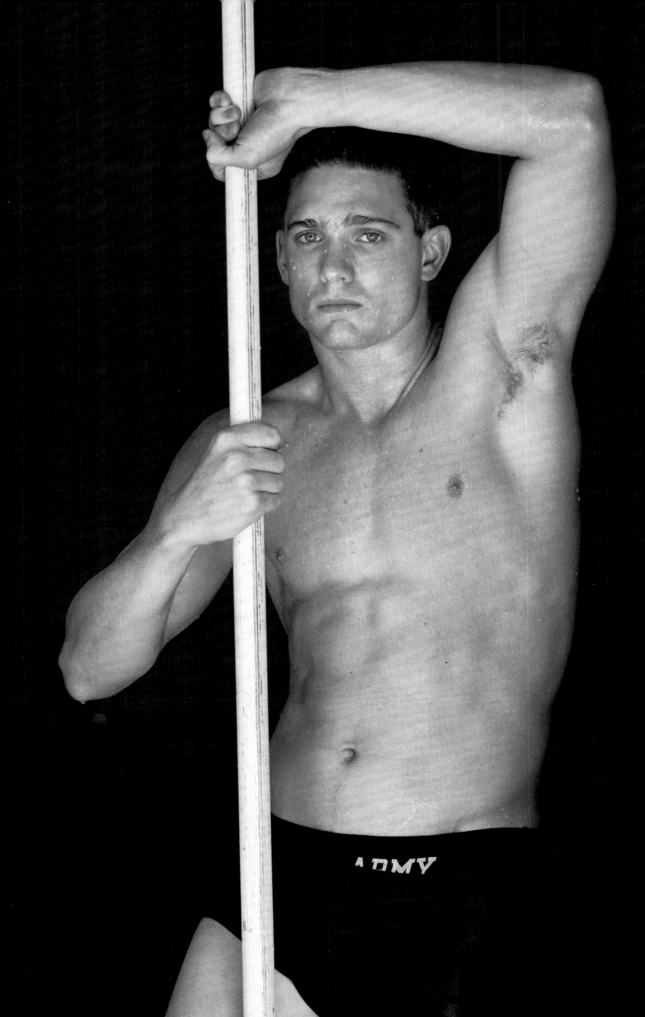

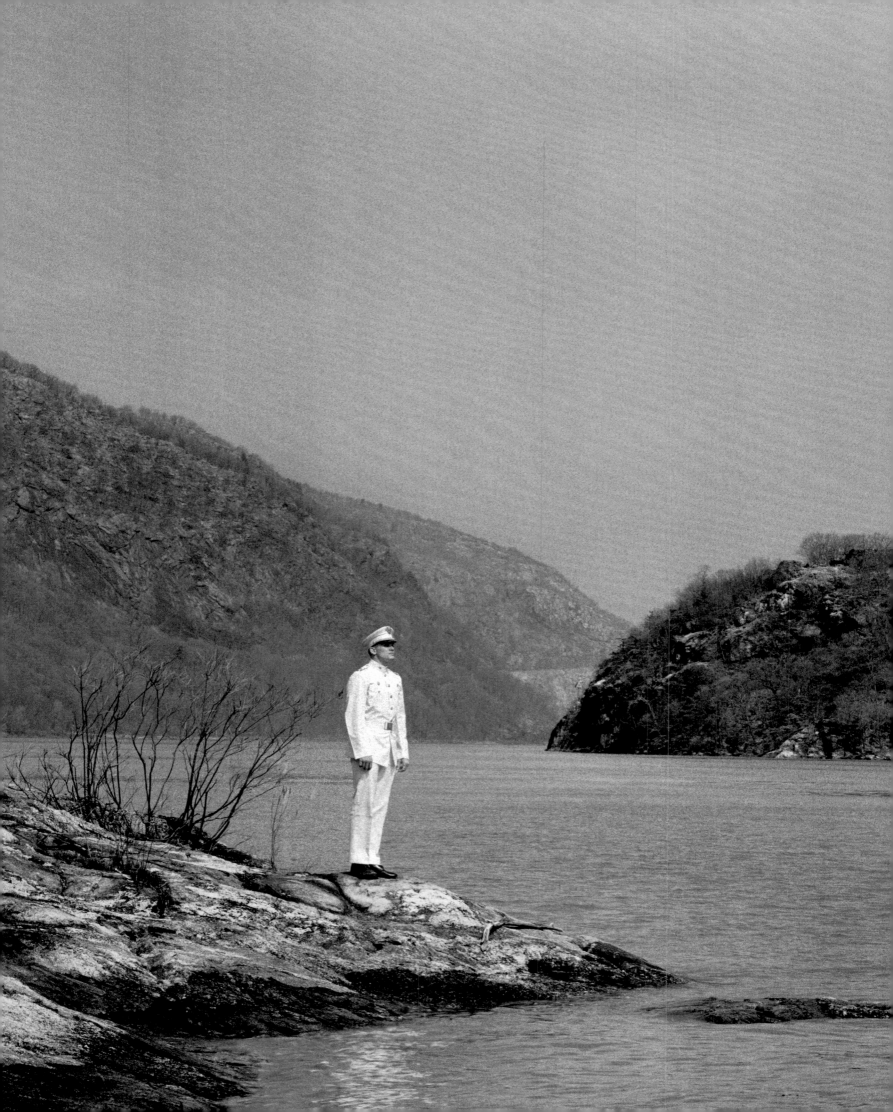

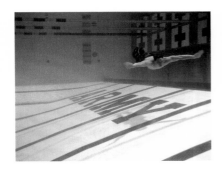 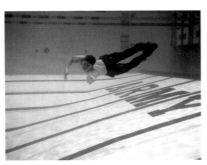 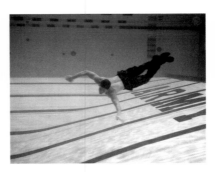 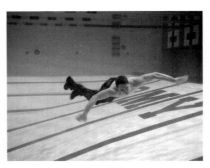

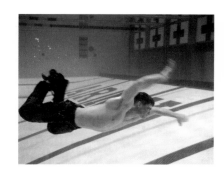 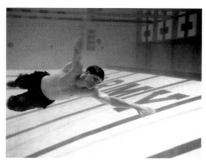 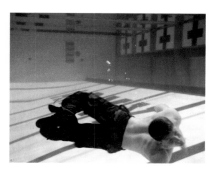

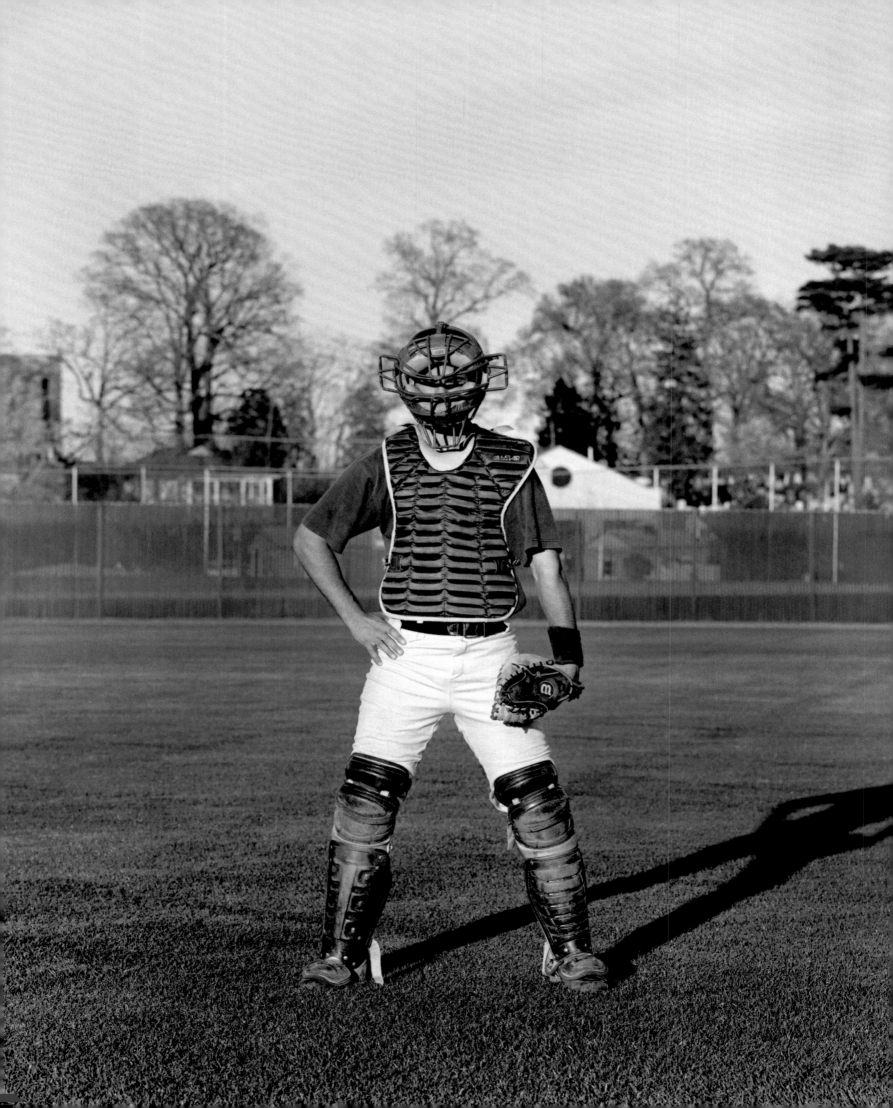

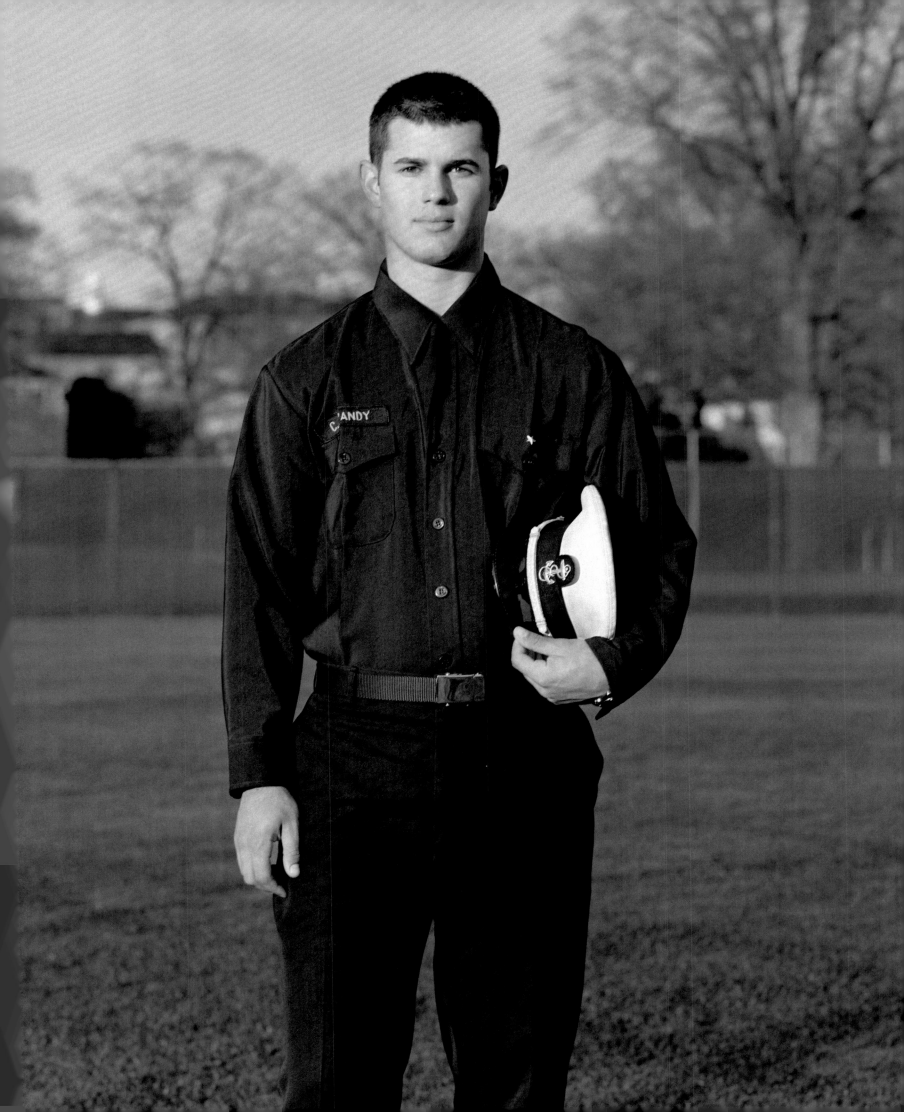

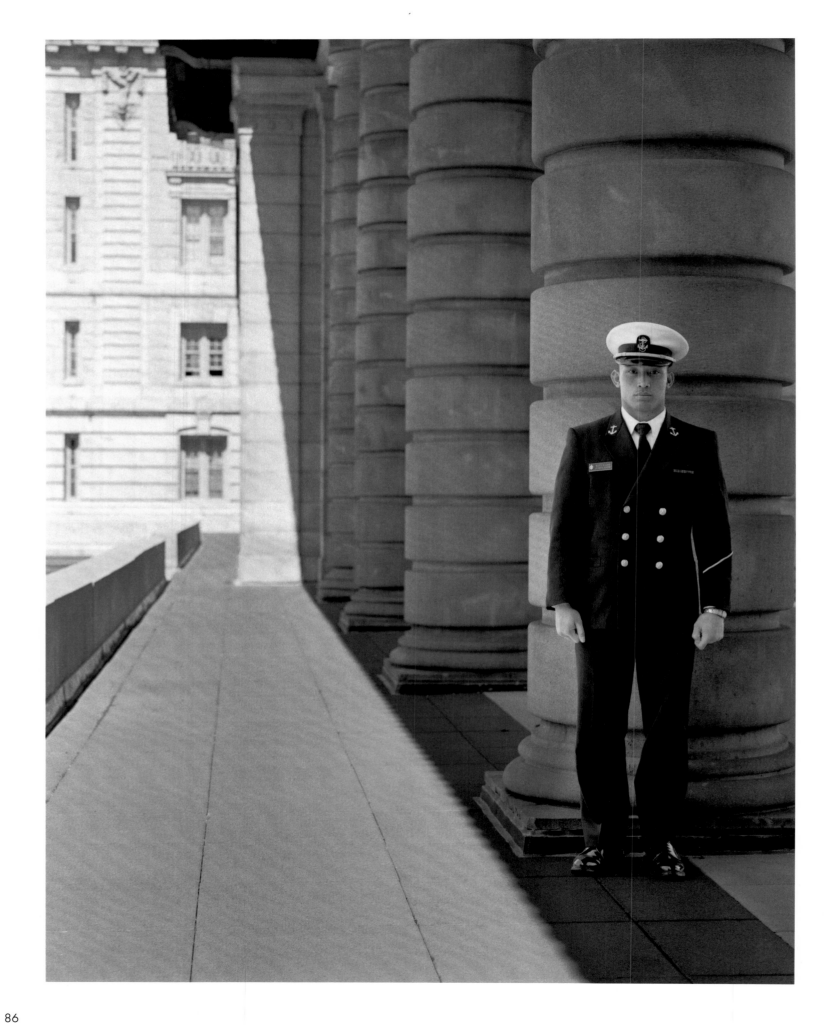

86

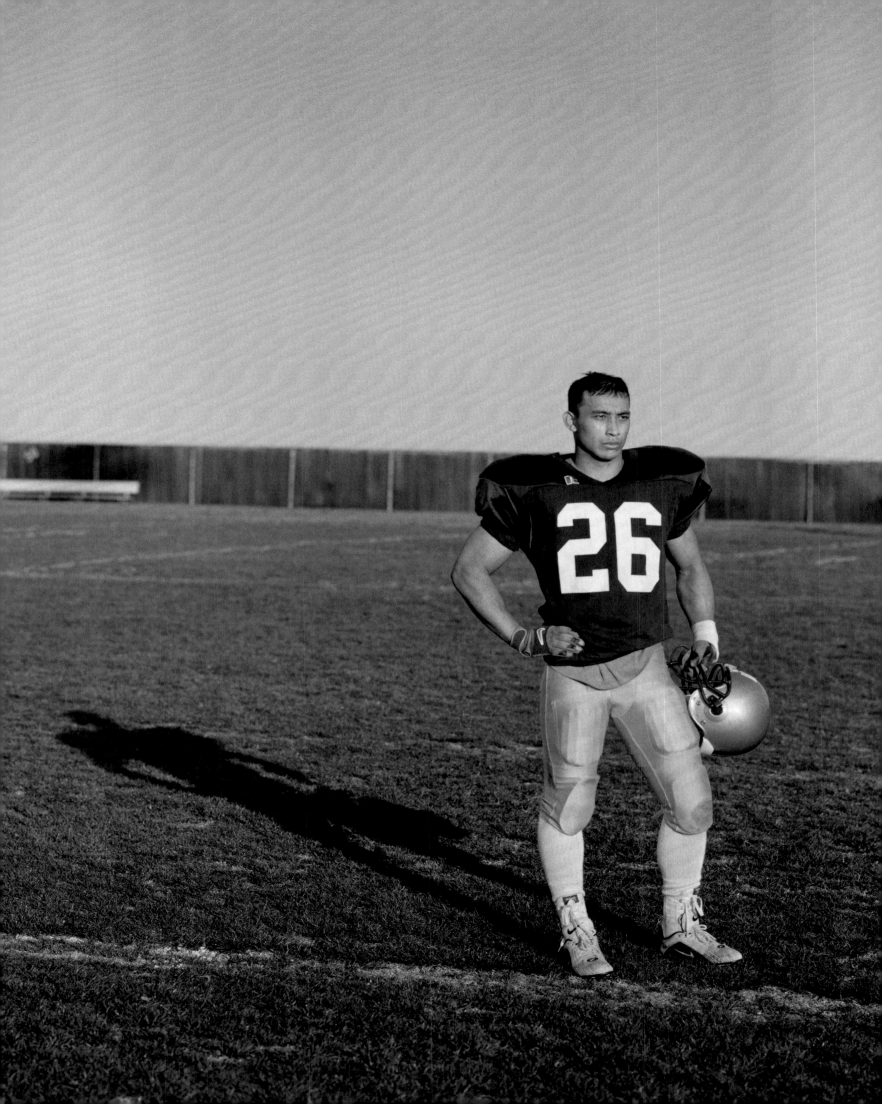

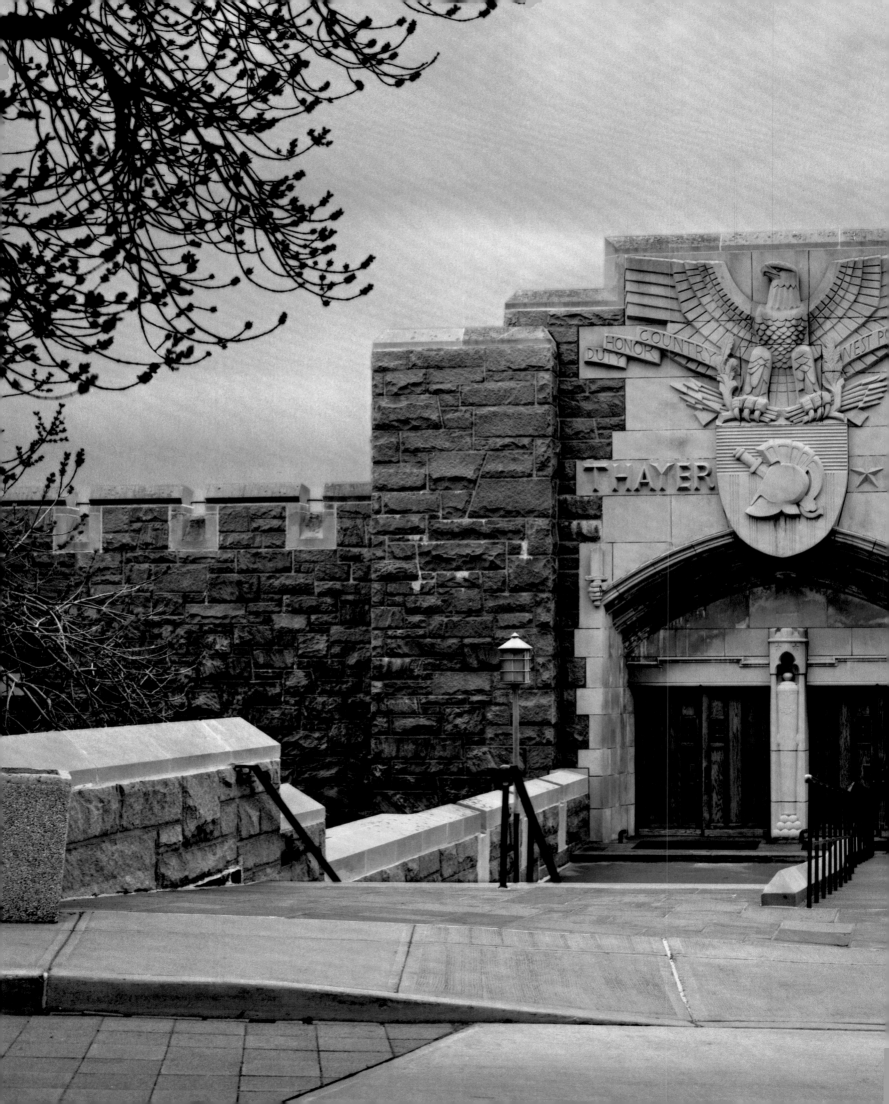

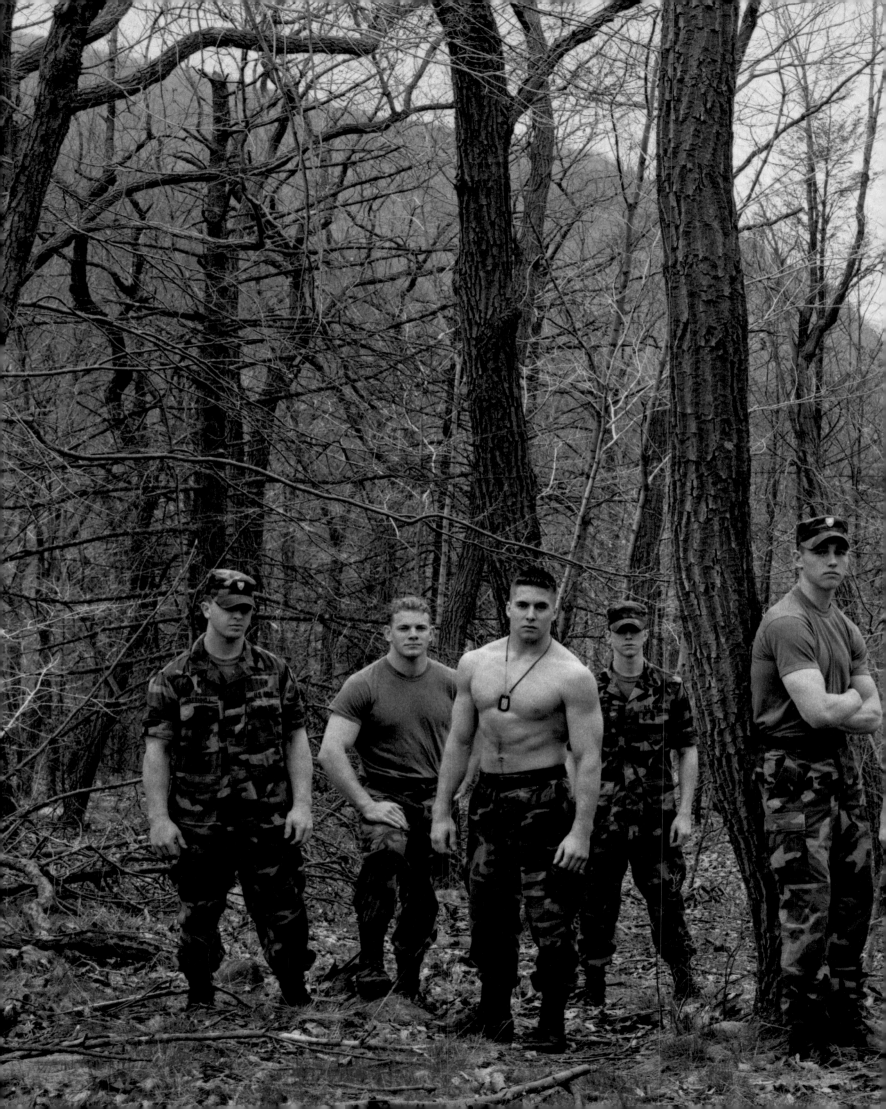

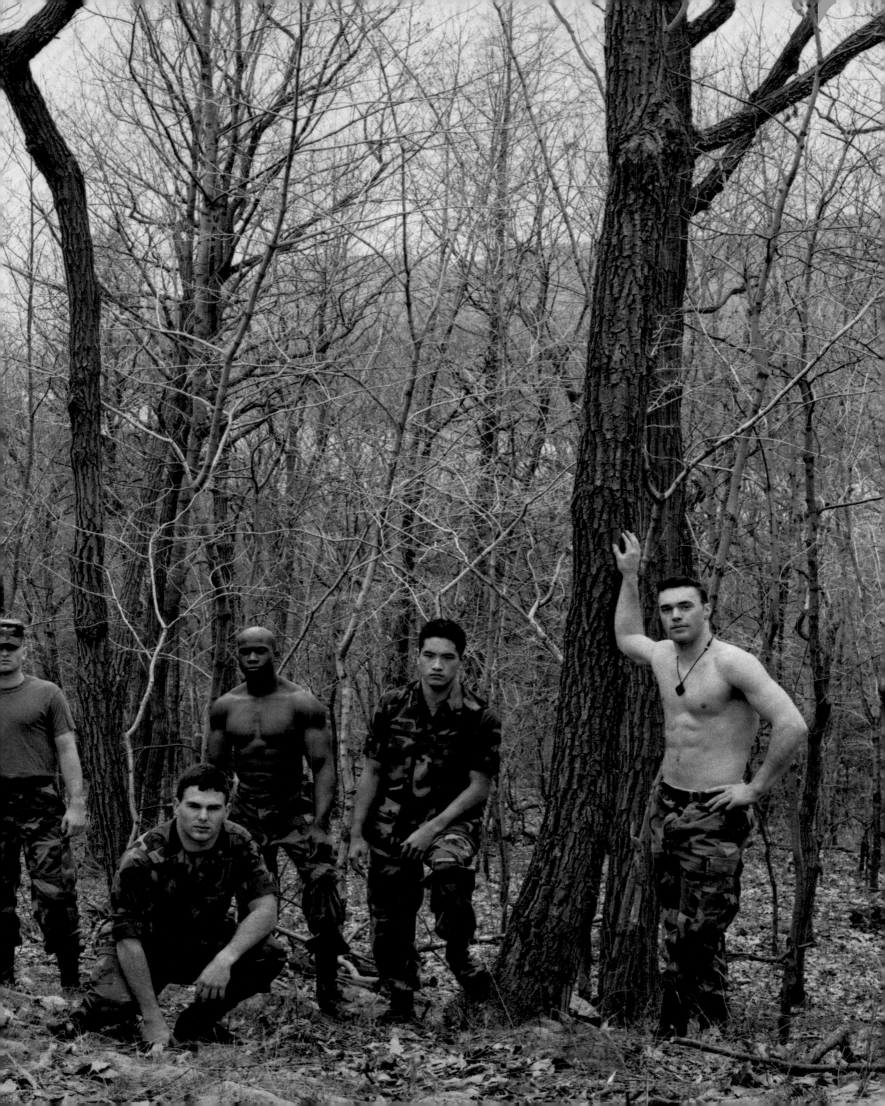

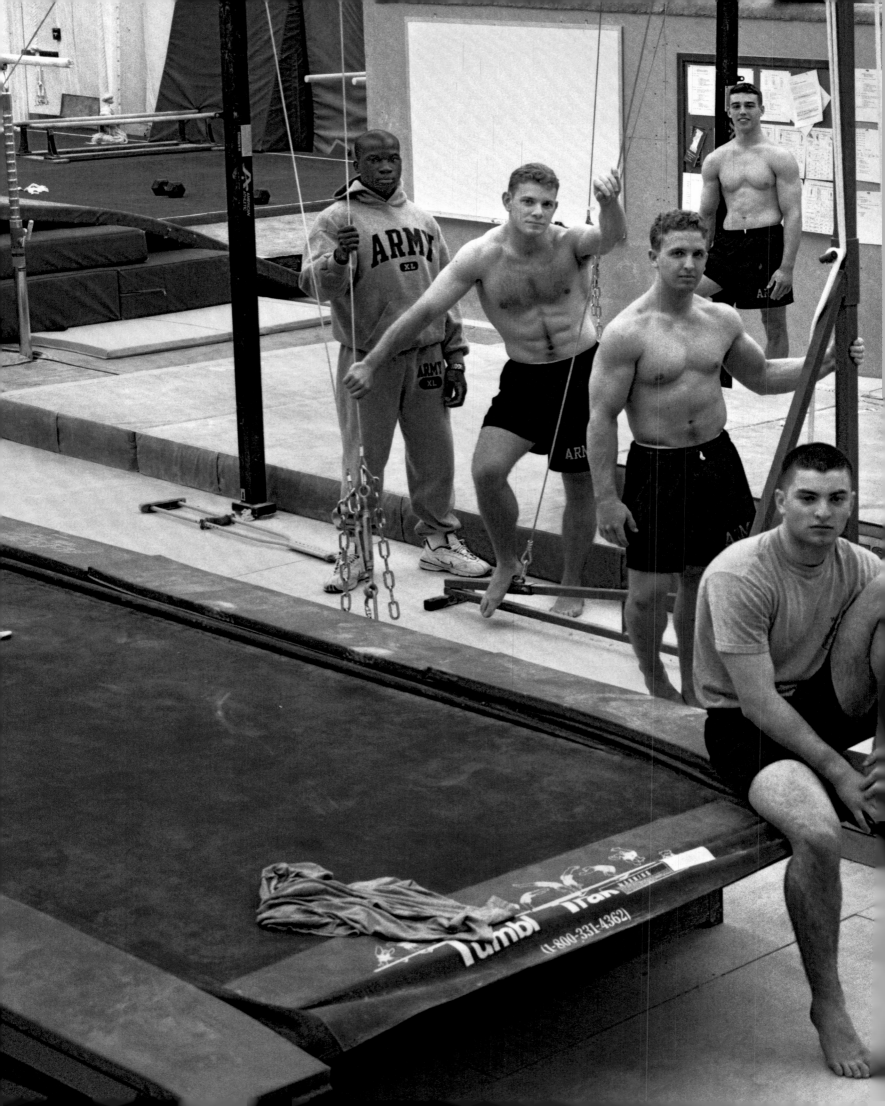

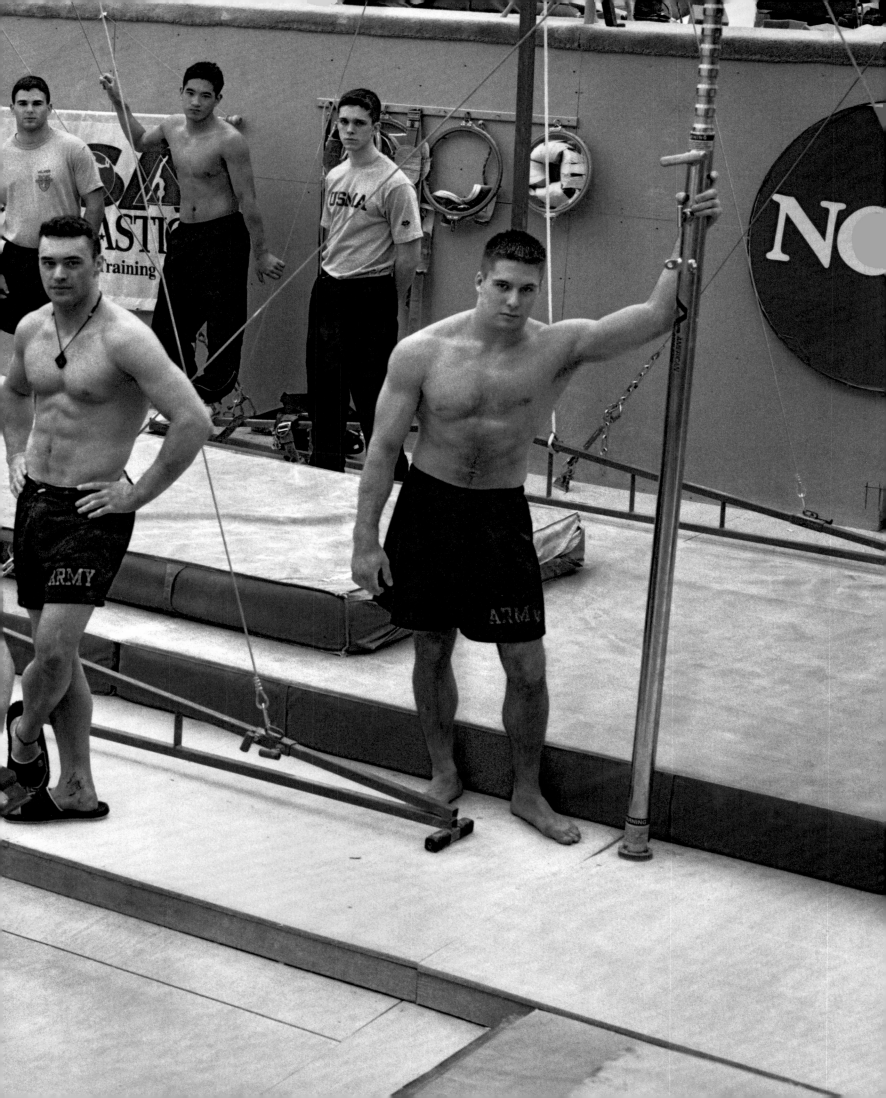

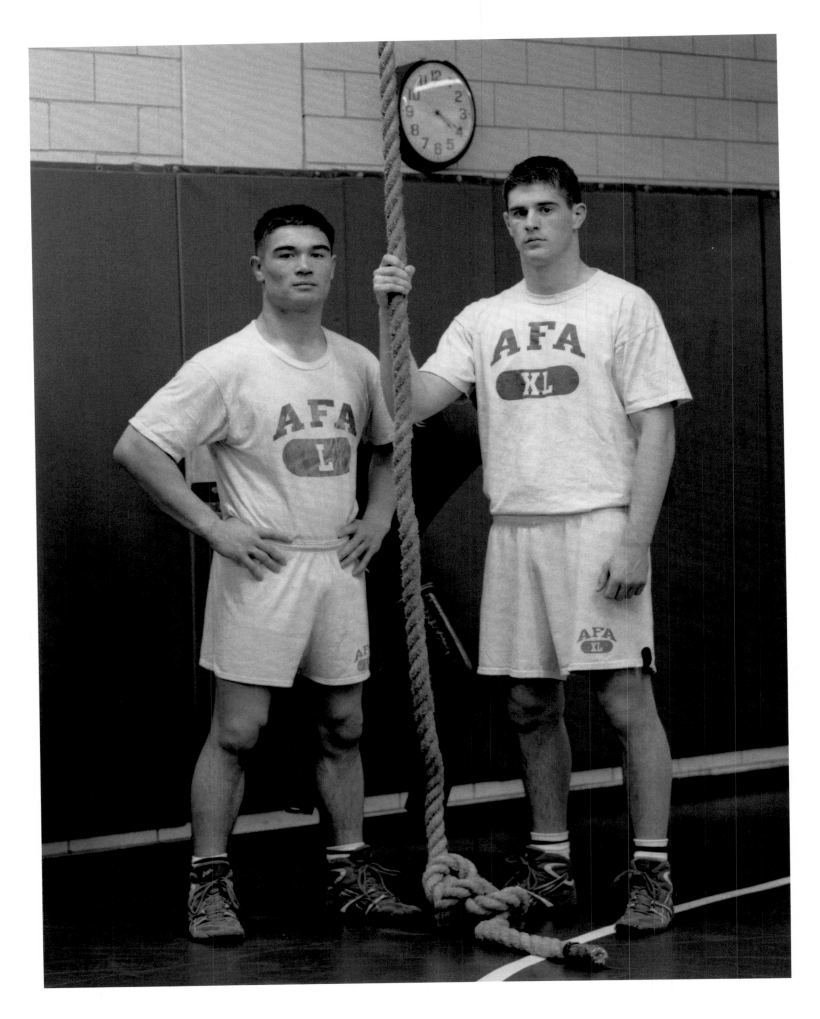

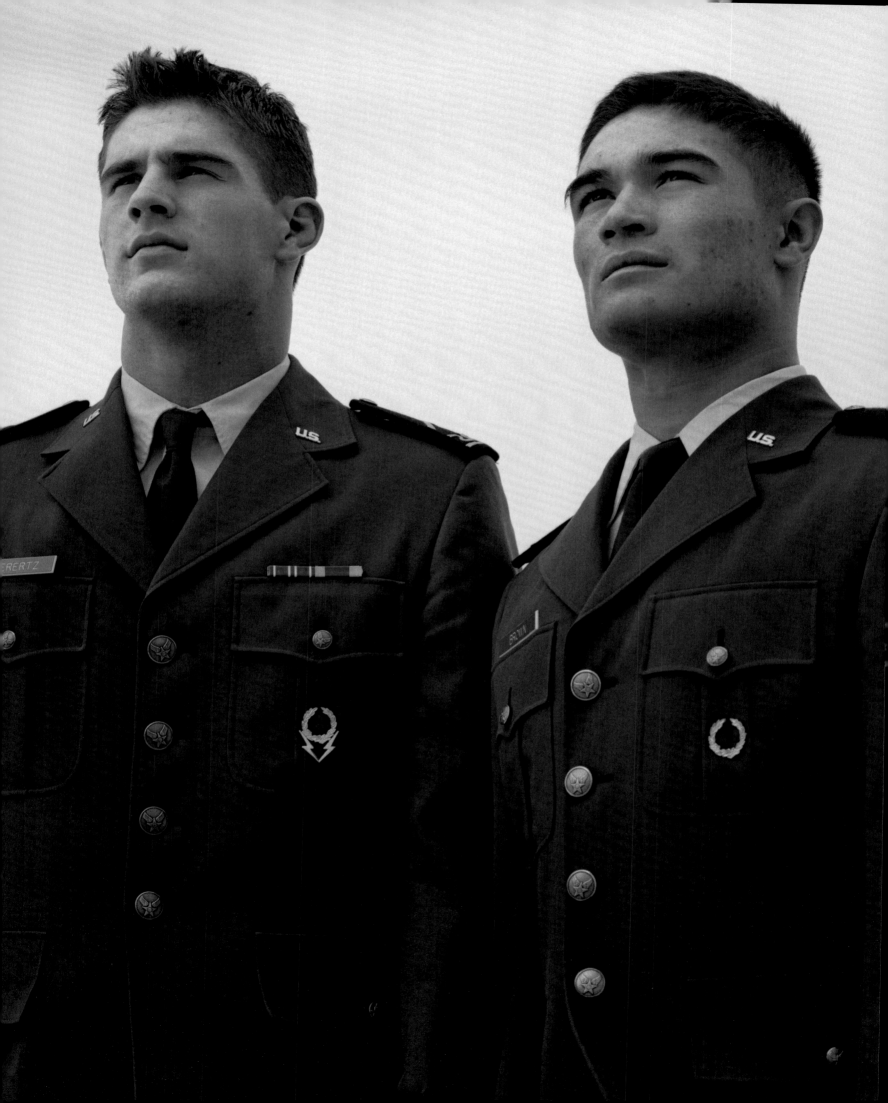

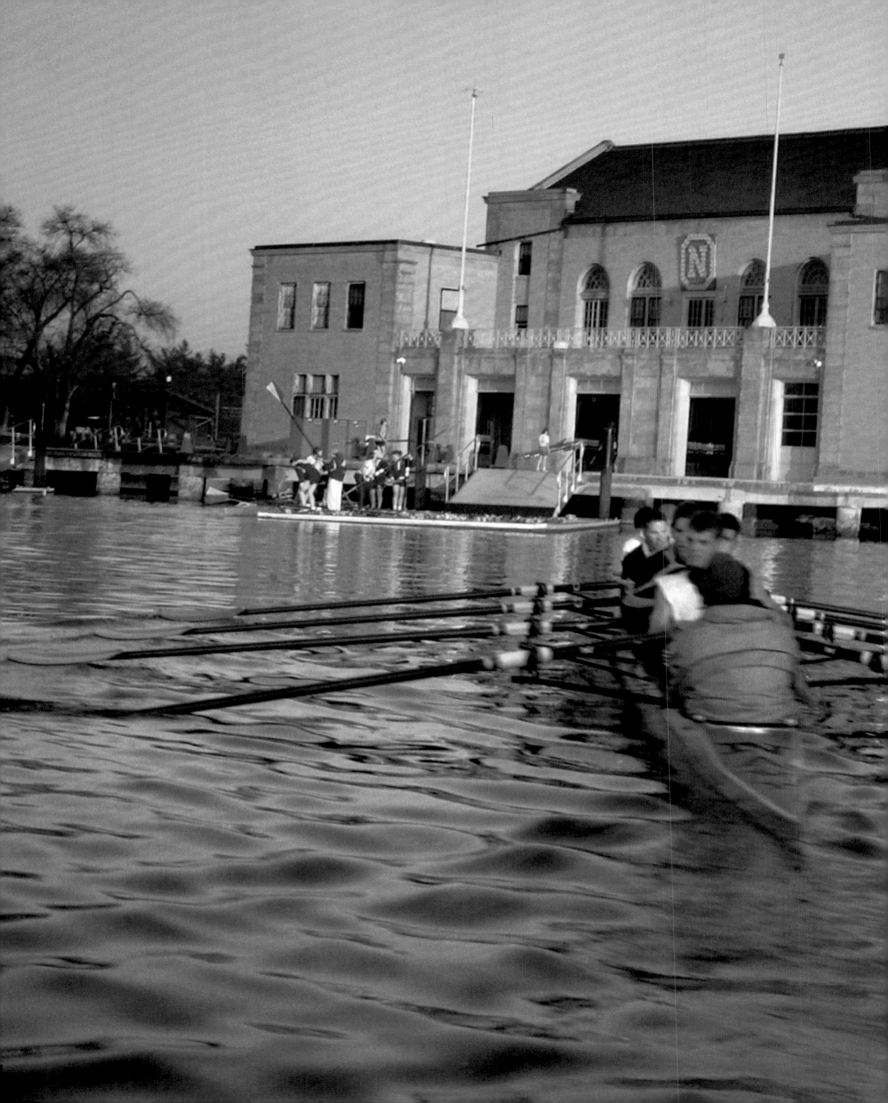

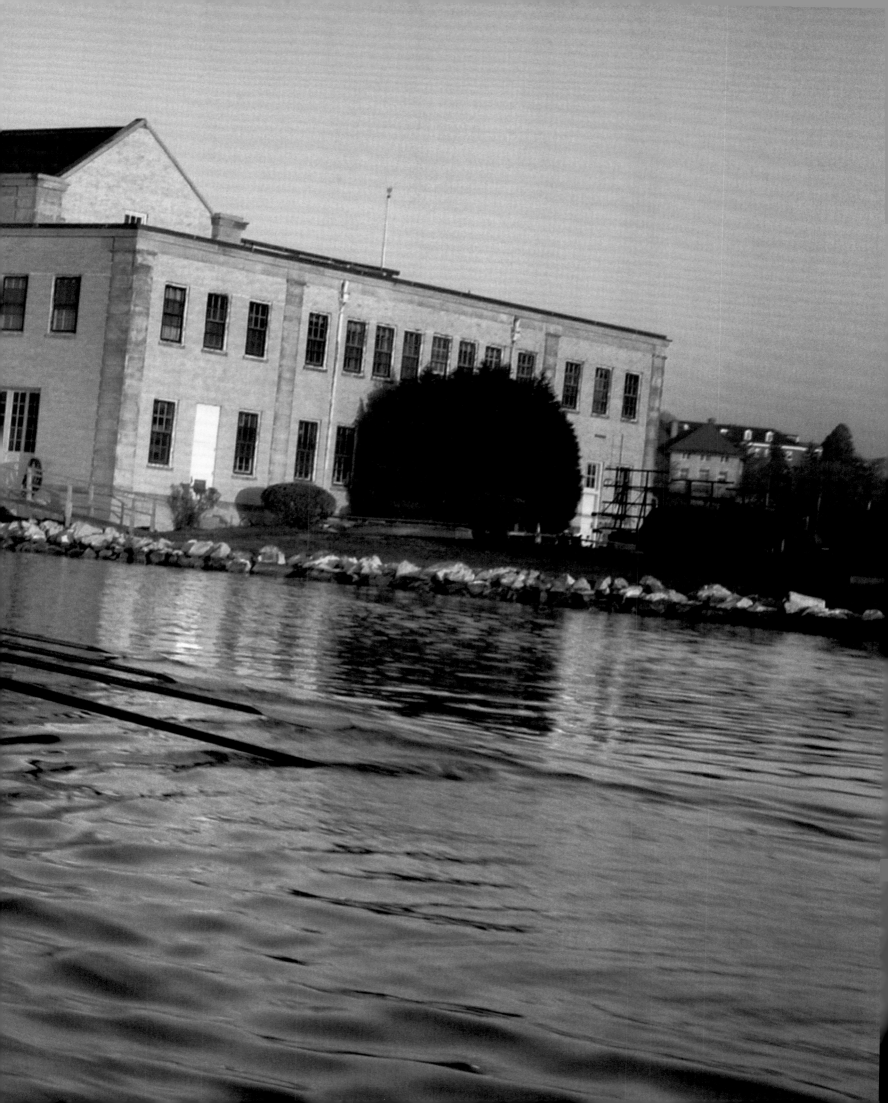

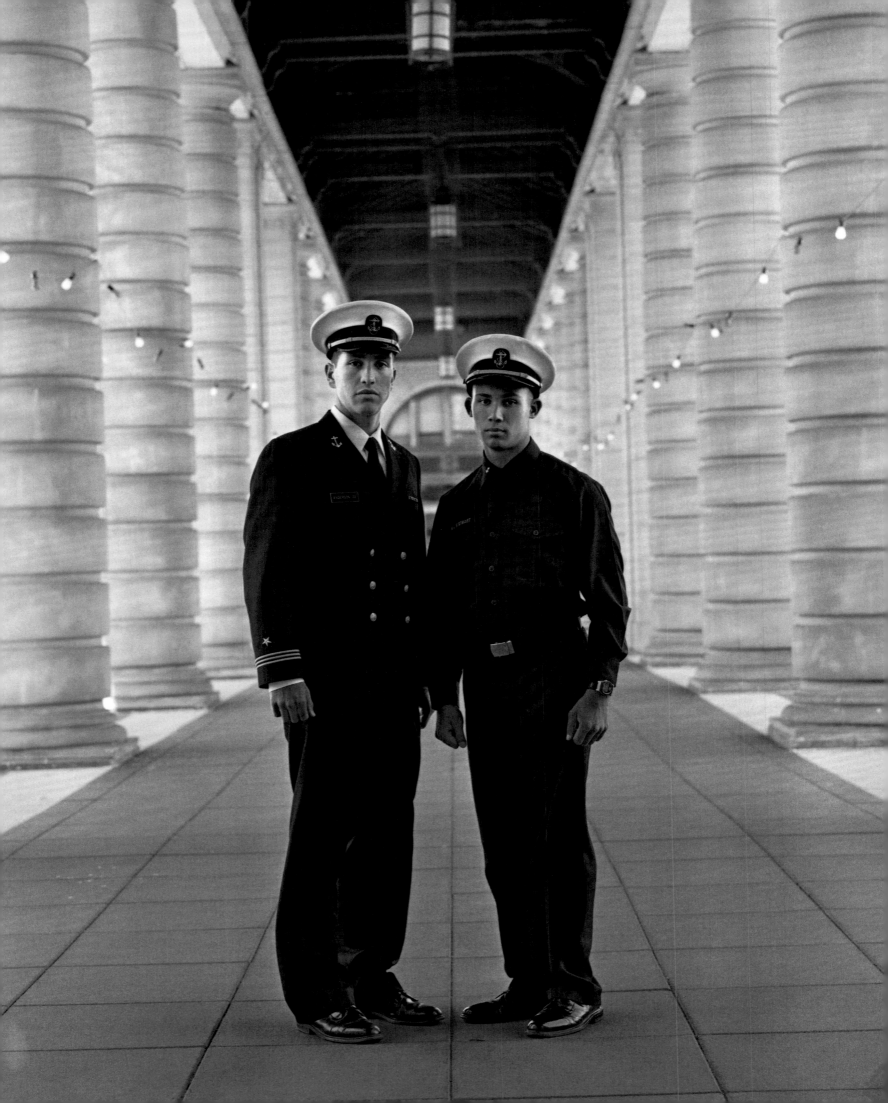

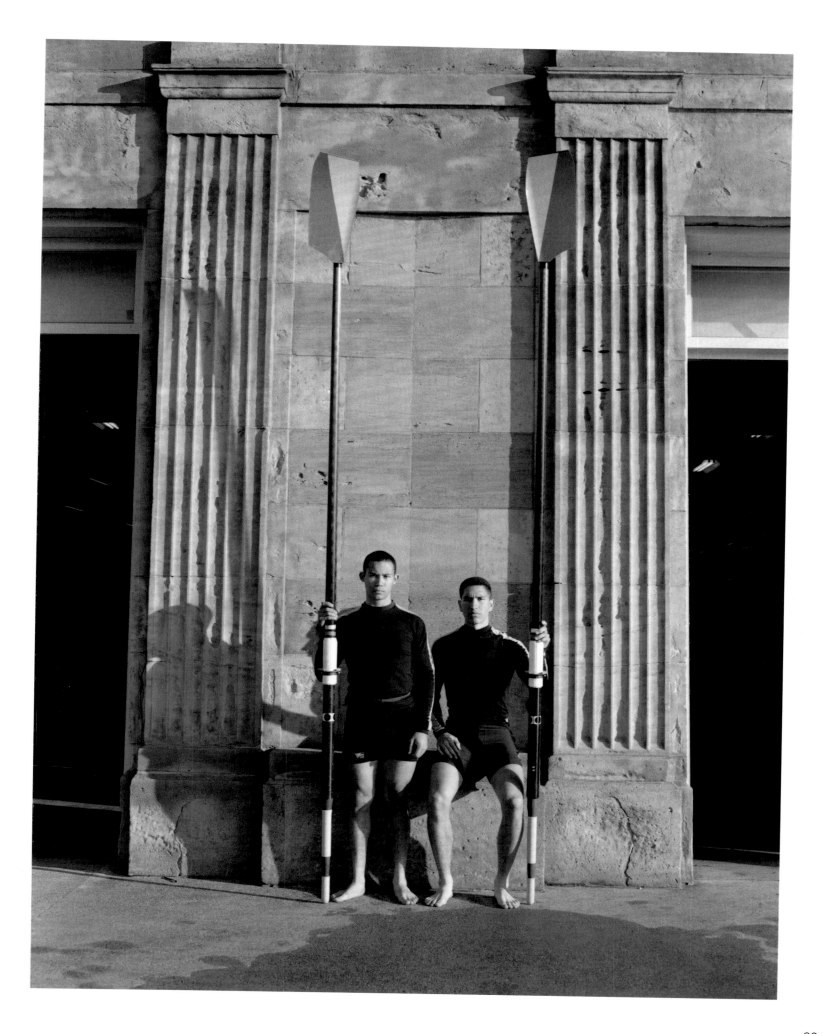

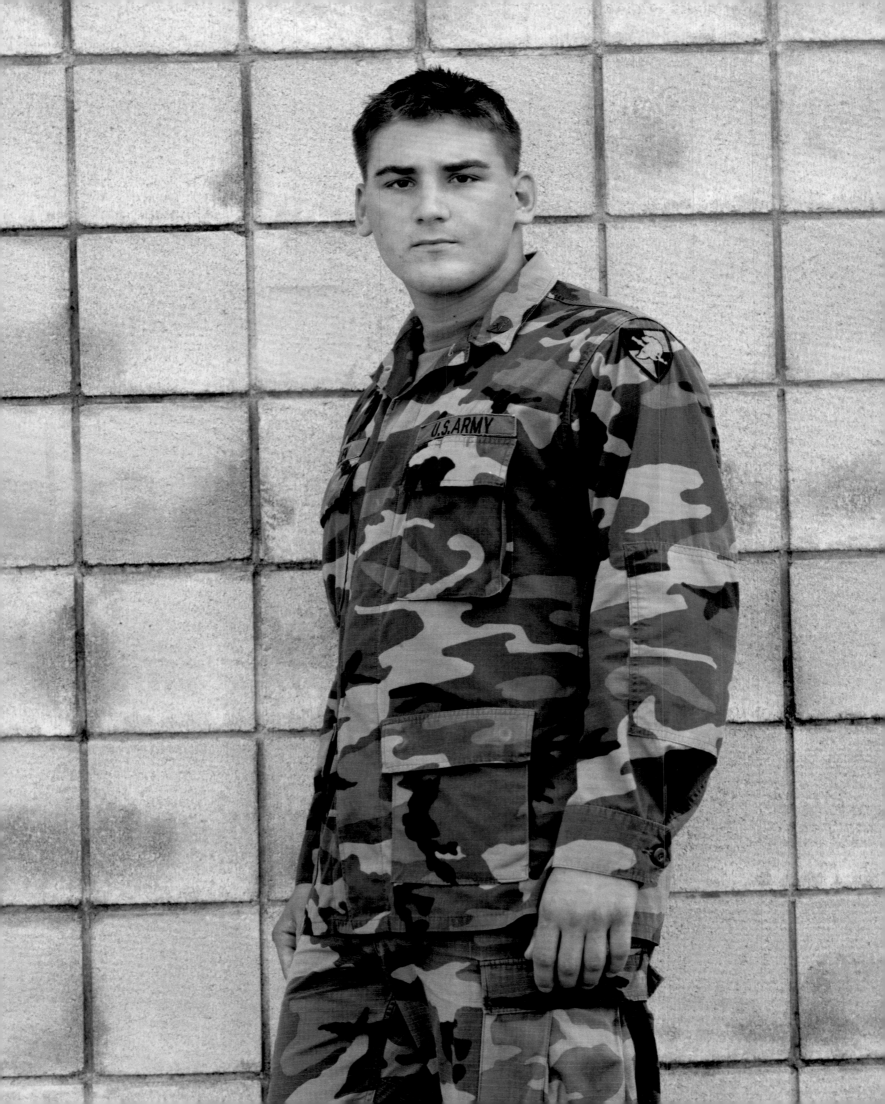

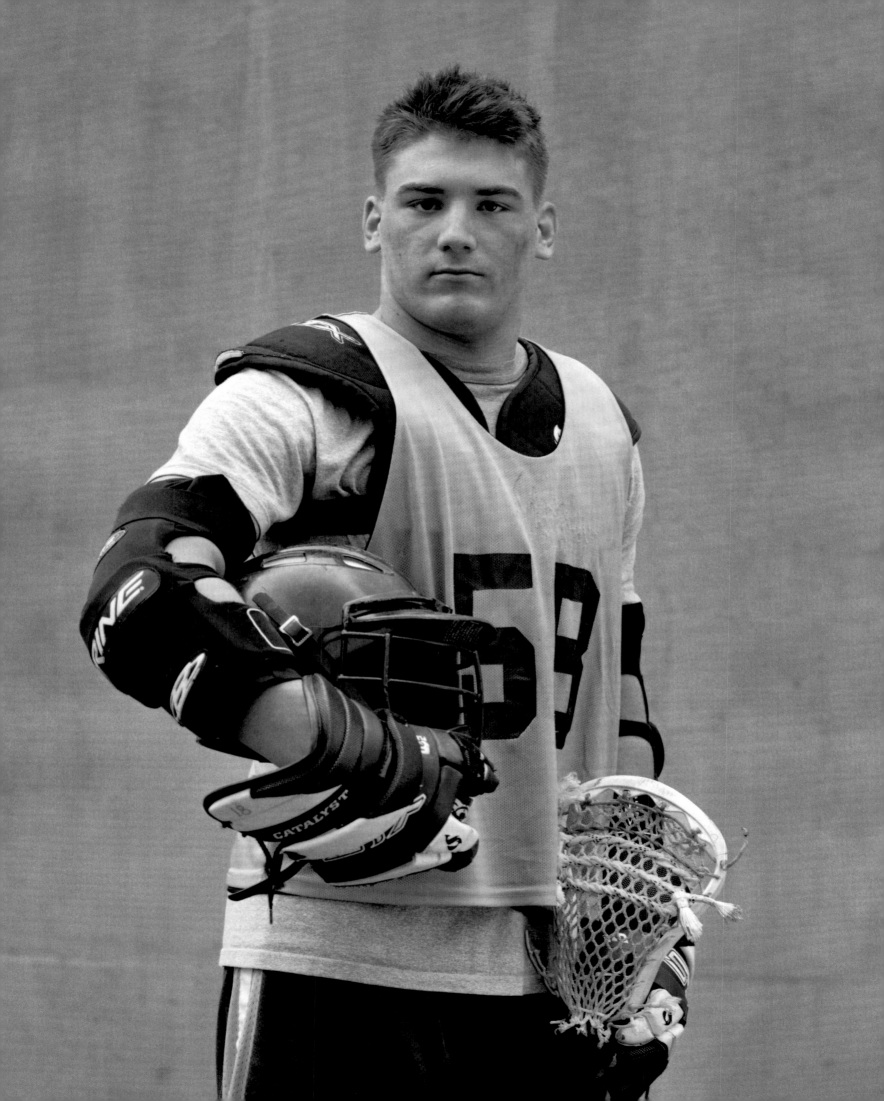

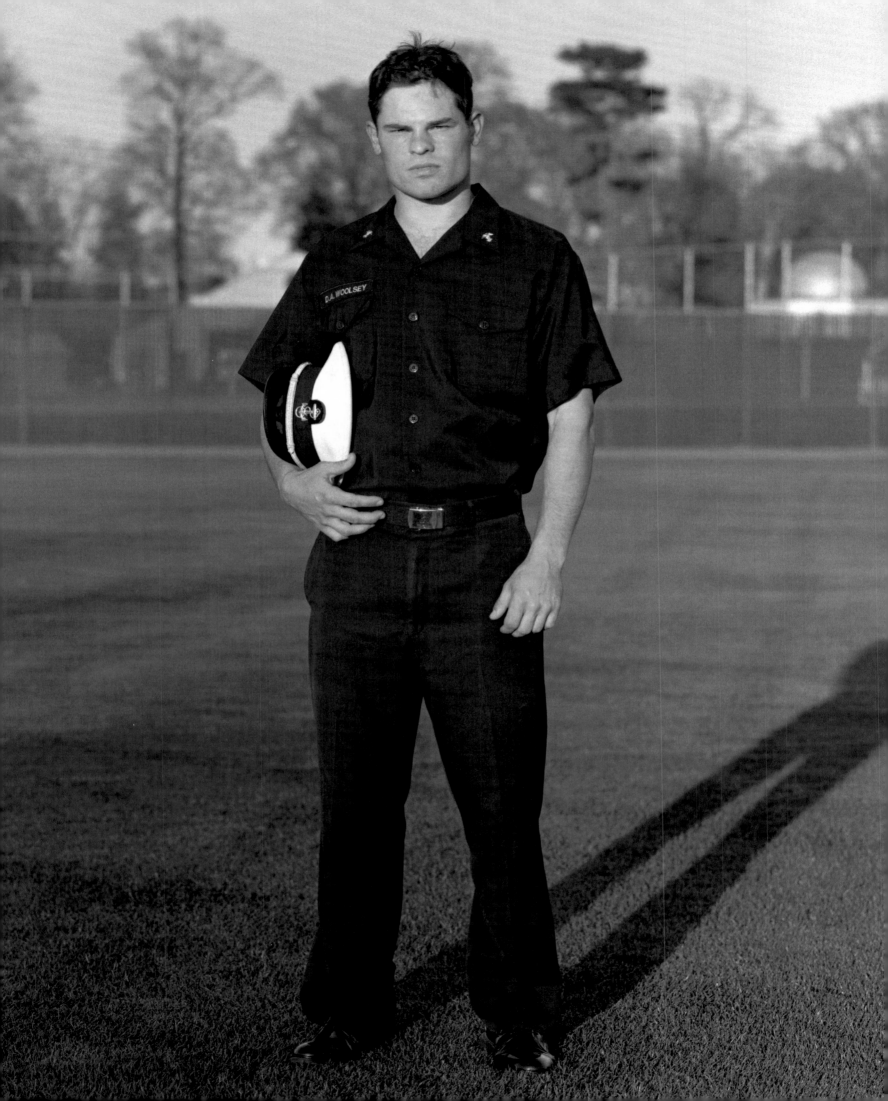

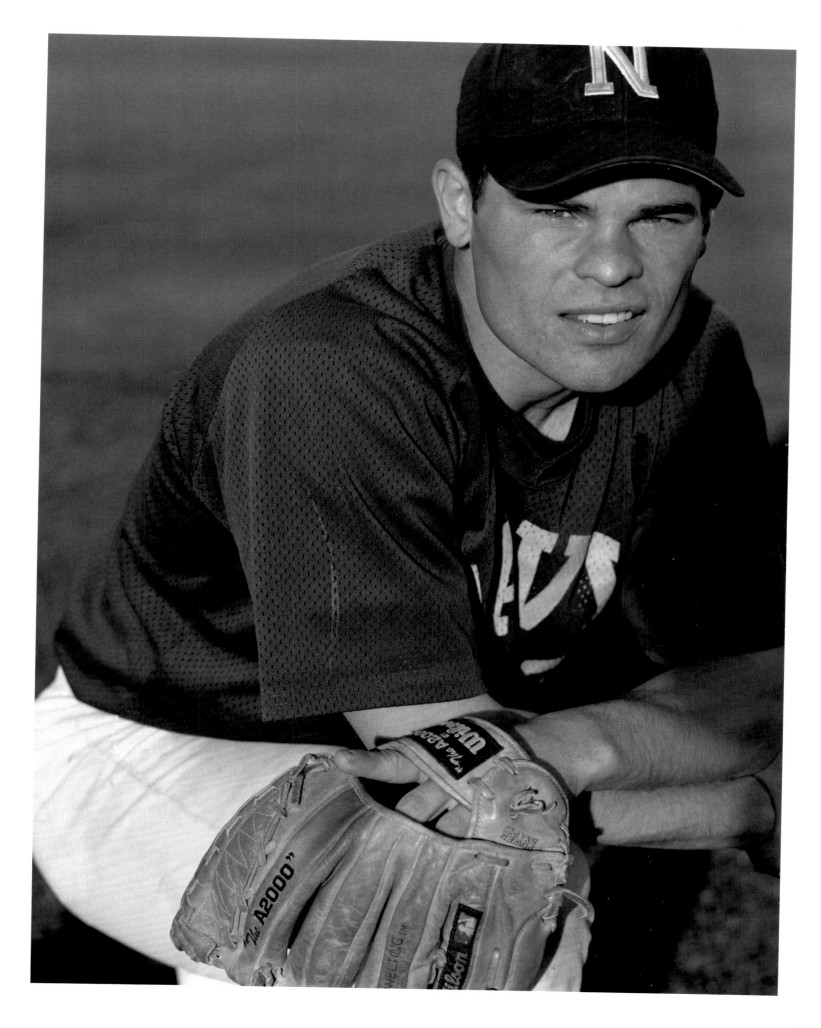

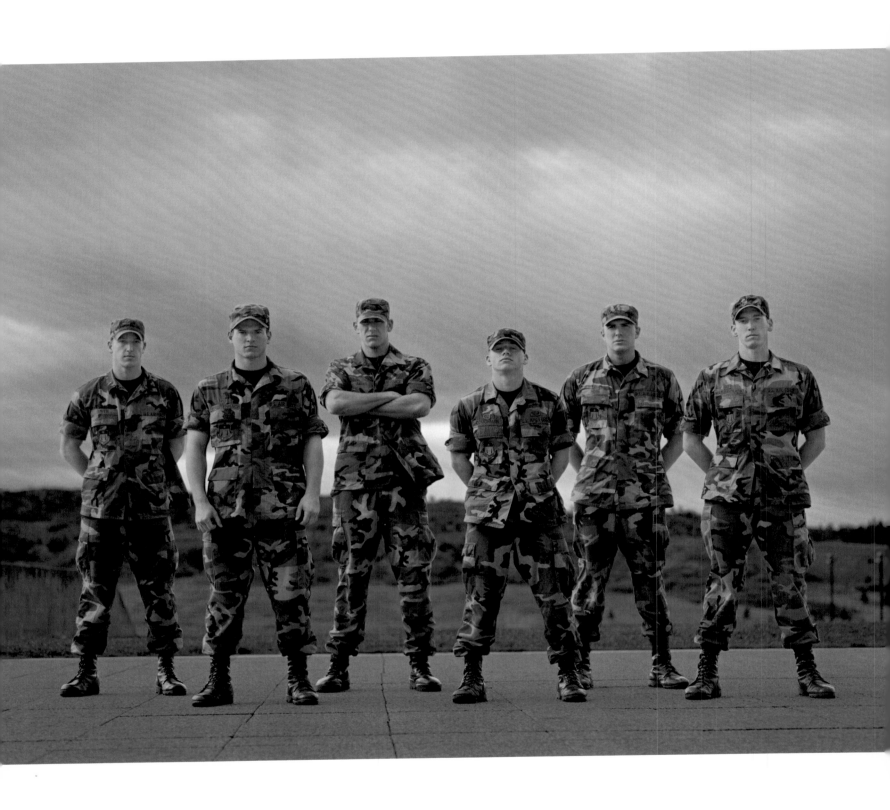

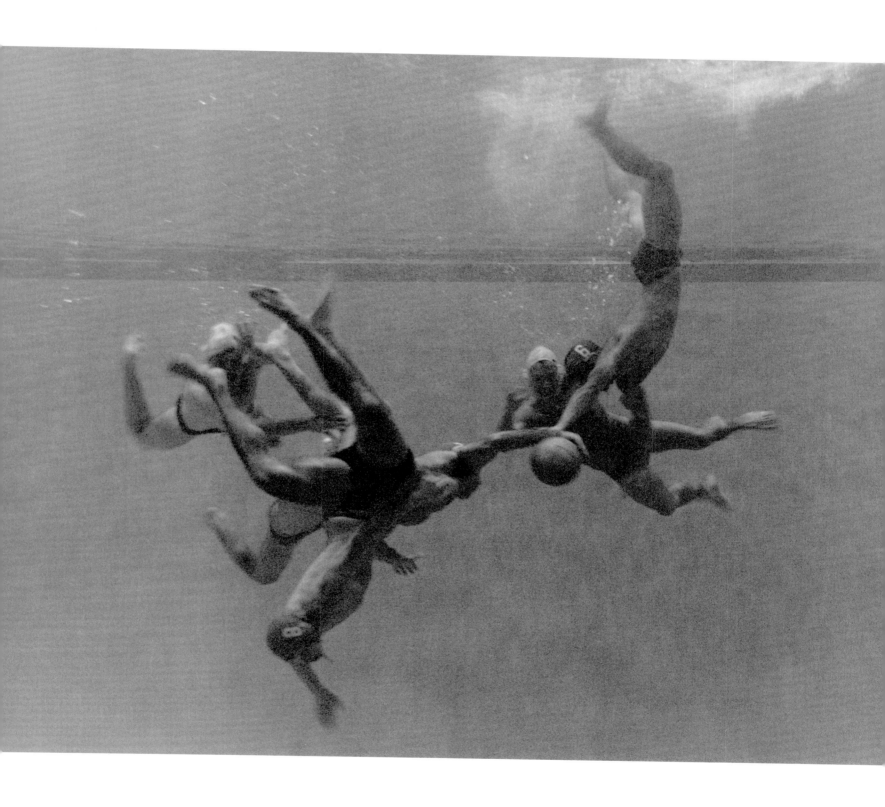

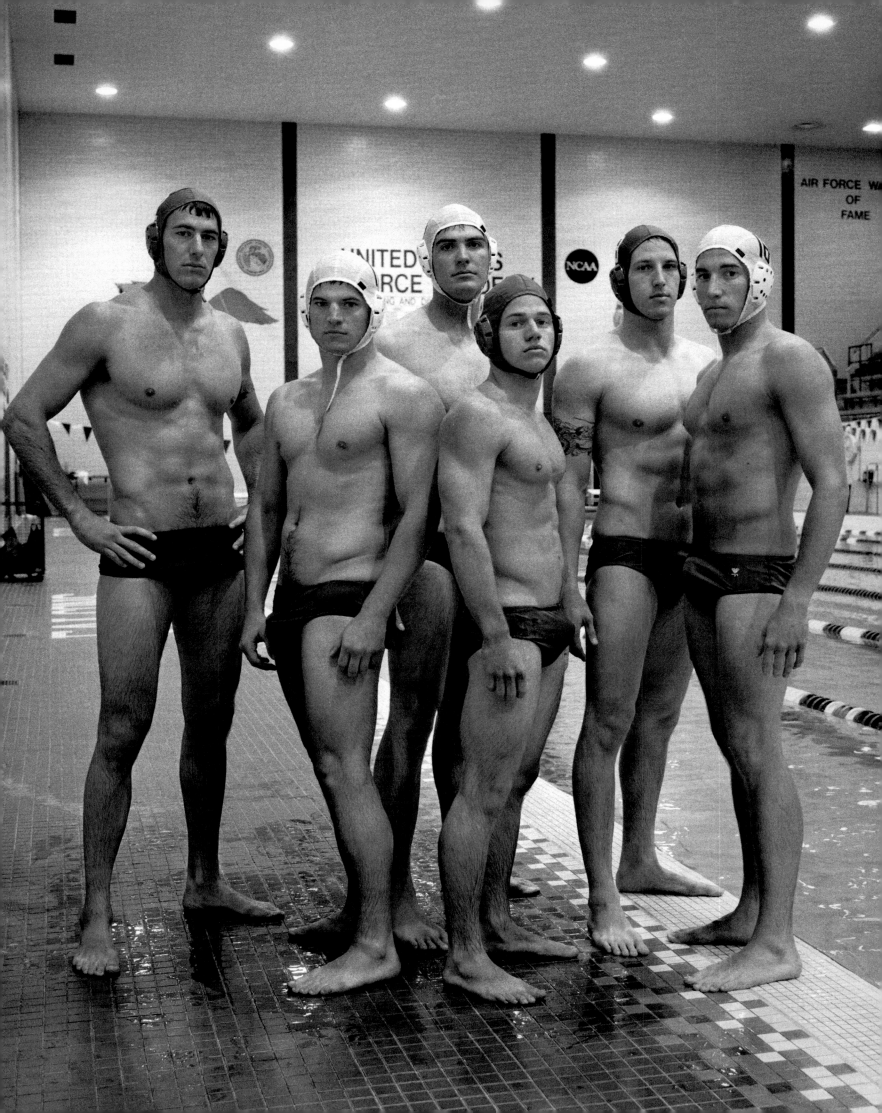

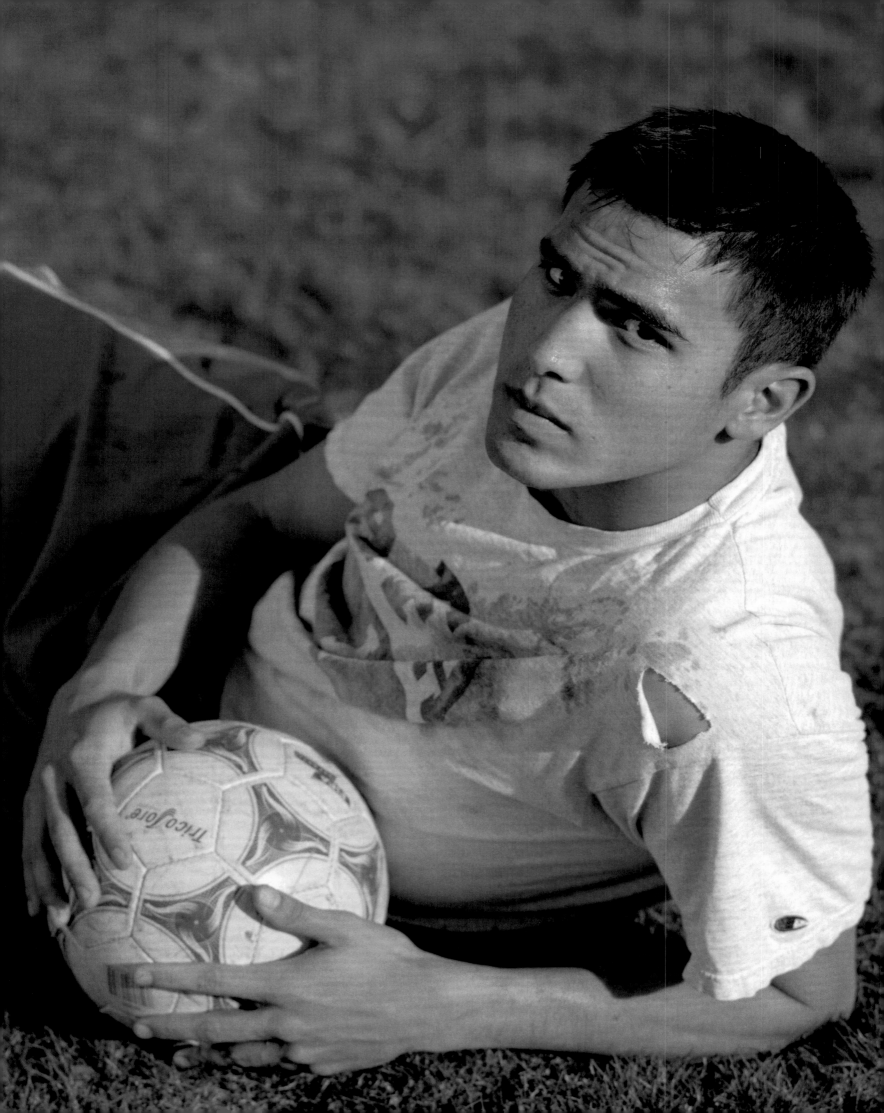

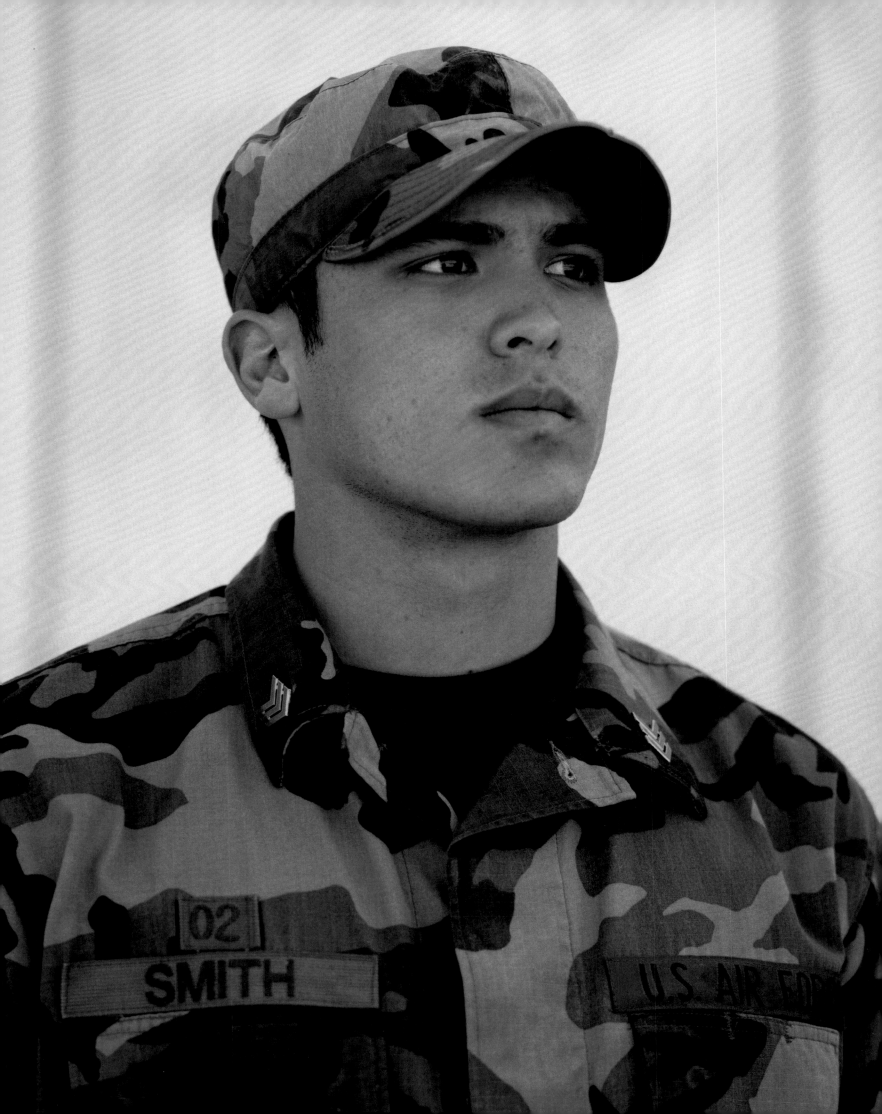

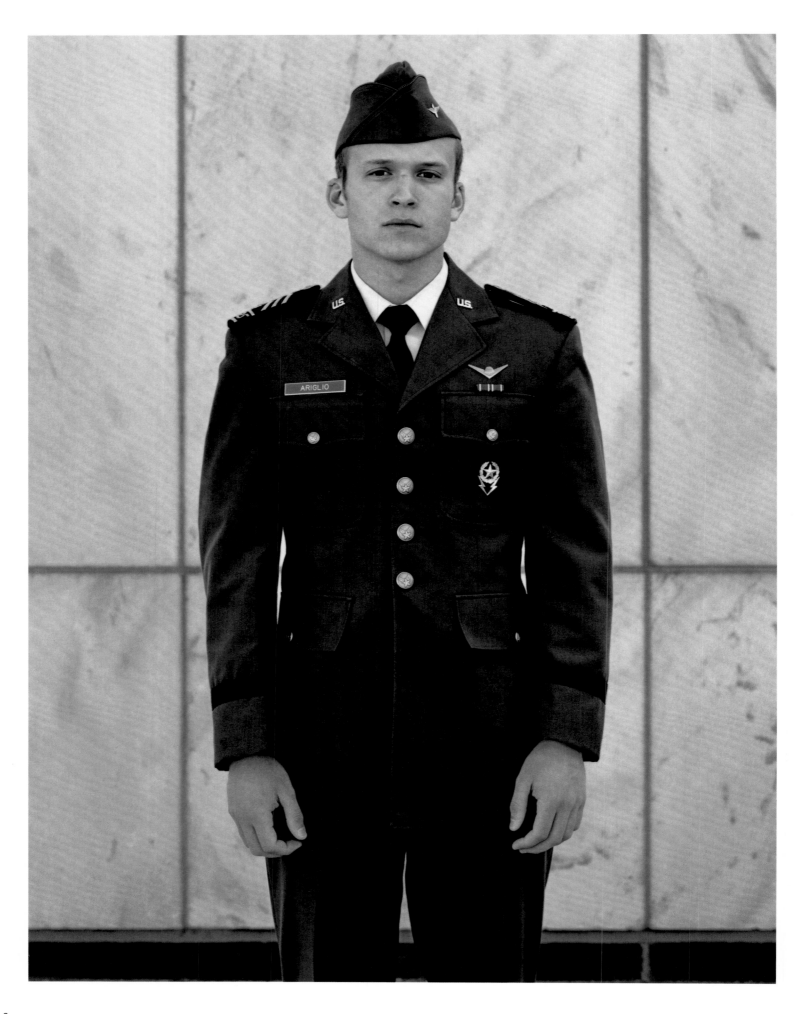

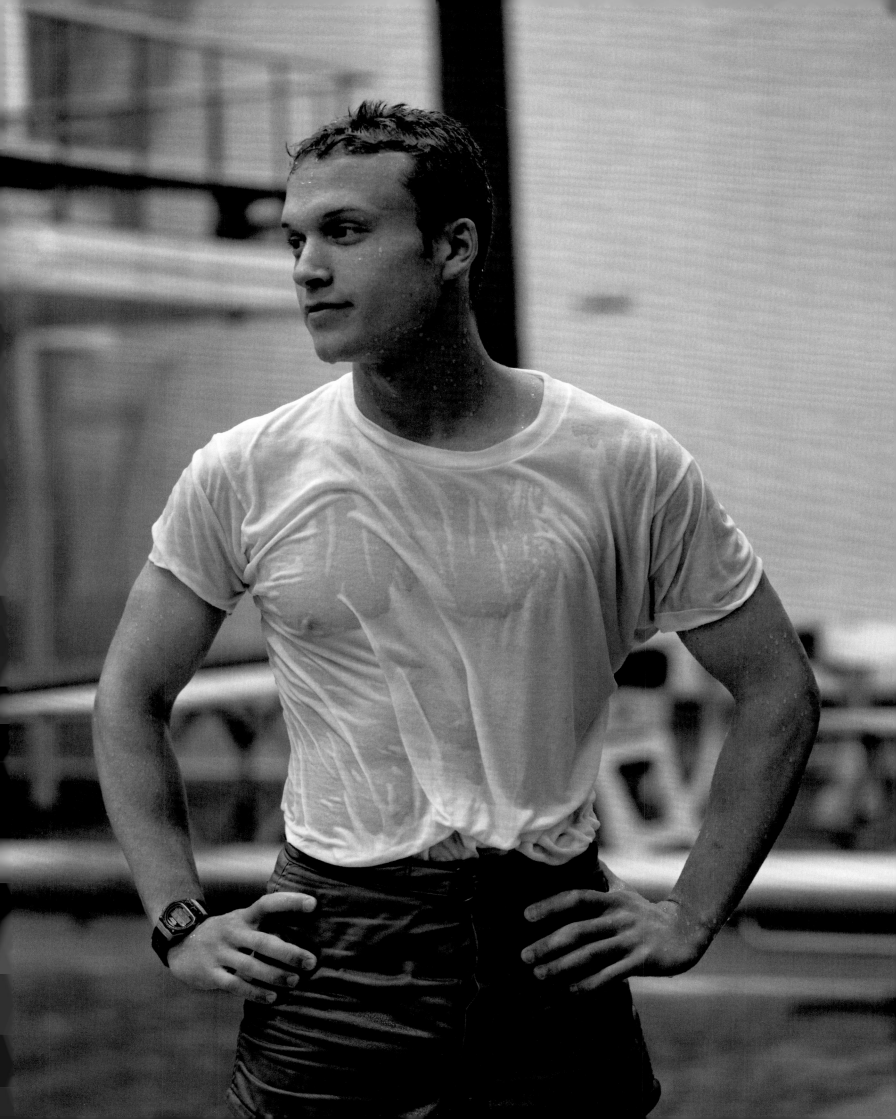

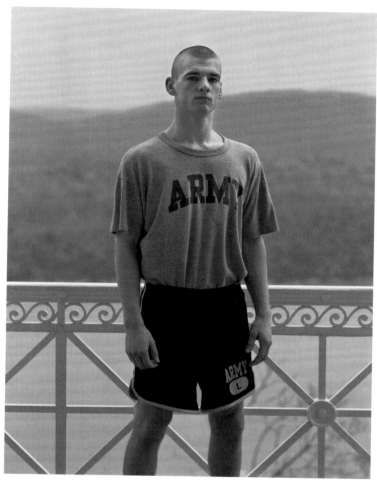
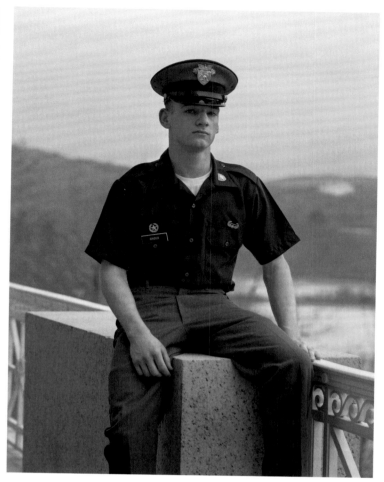
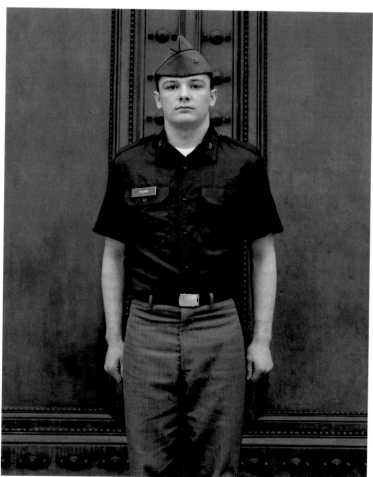
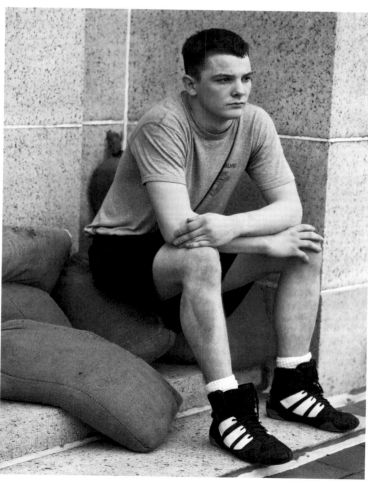

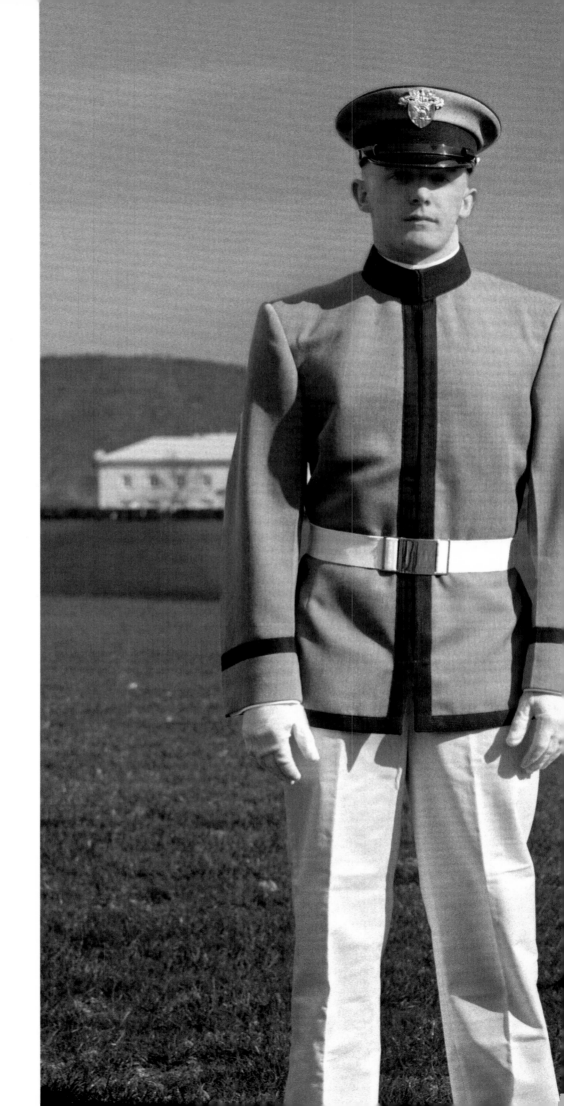

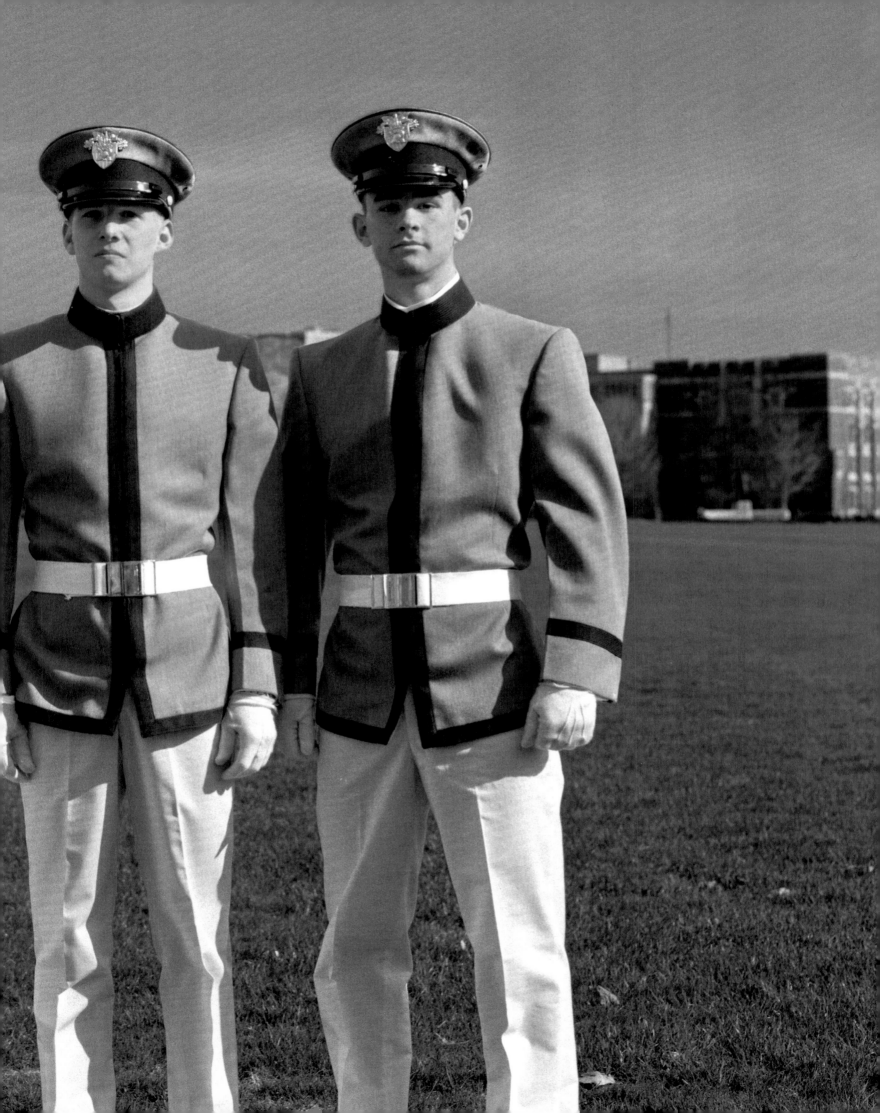

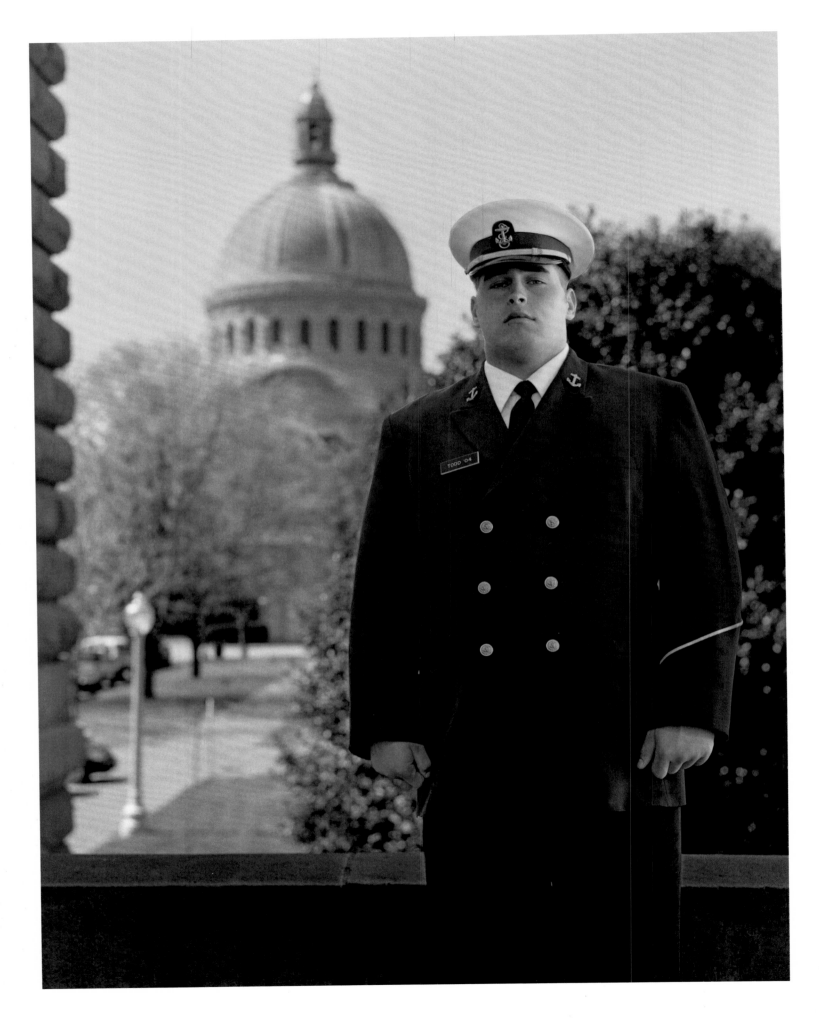

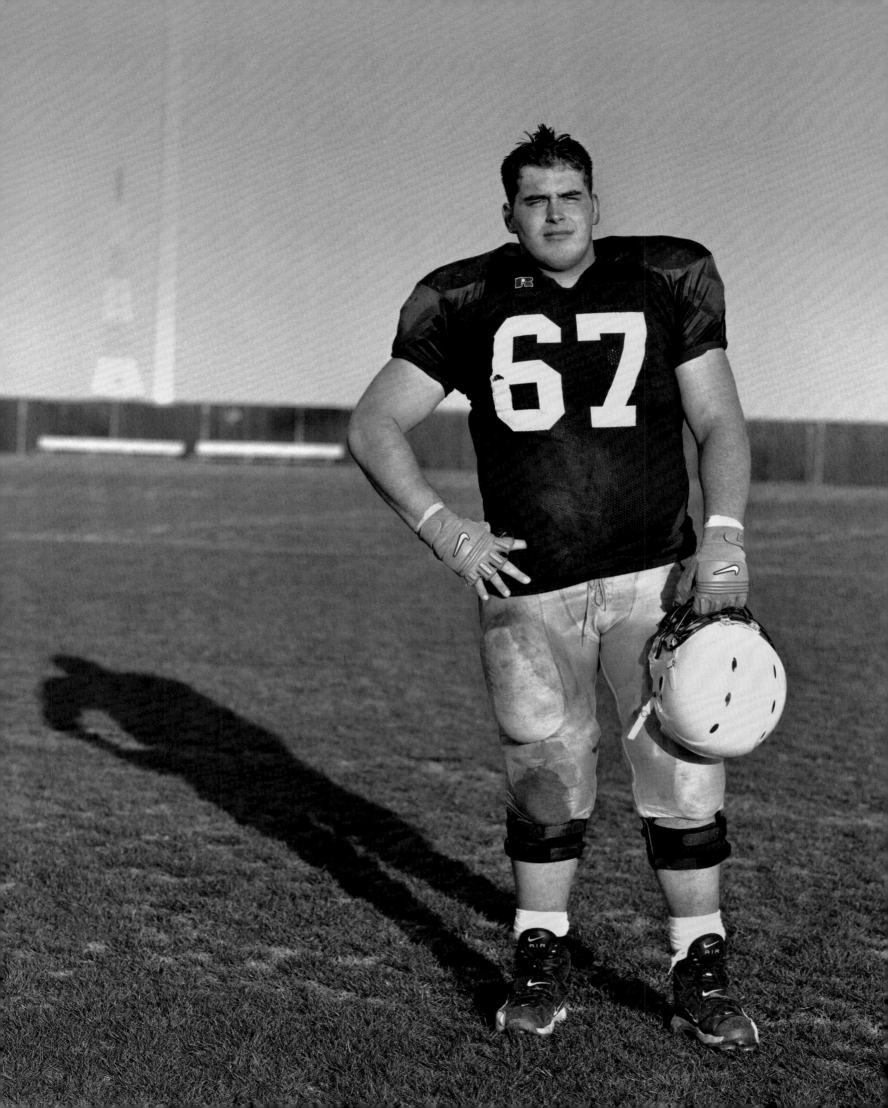

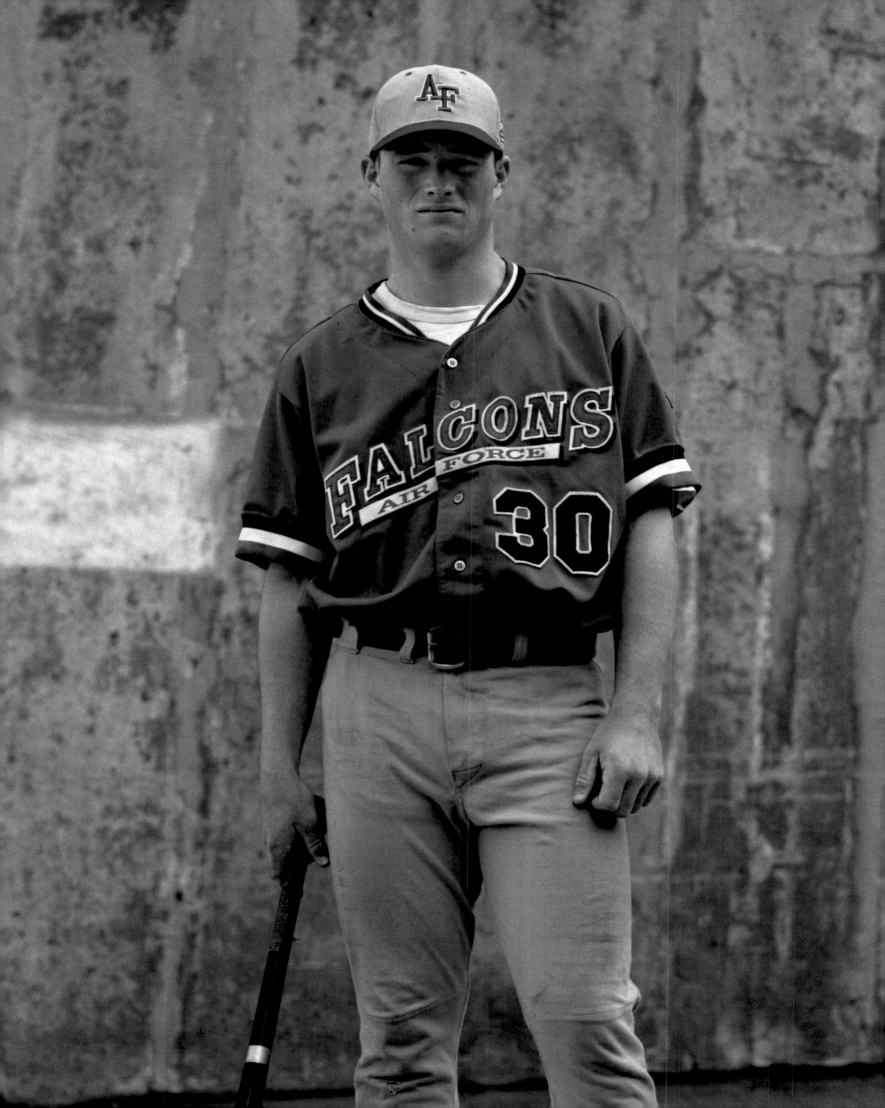

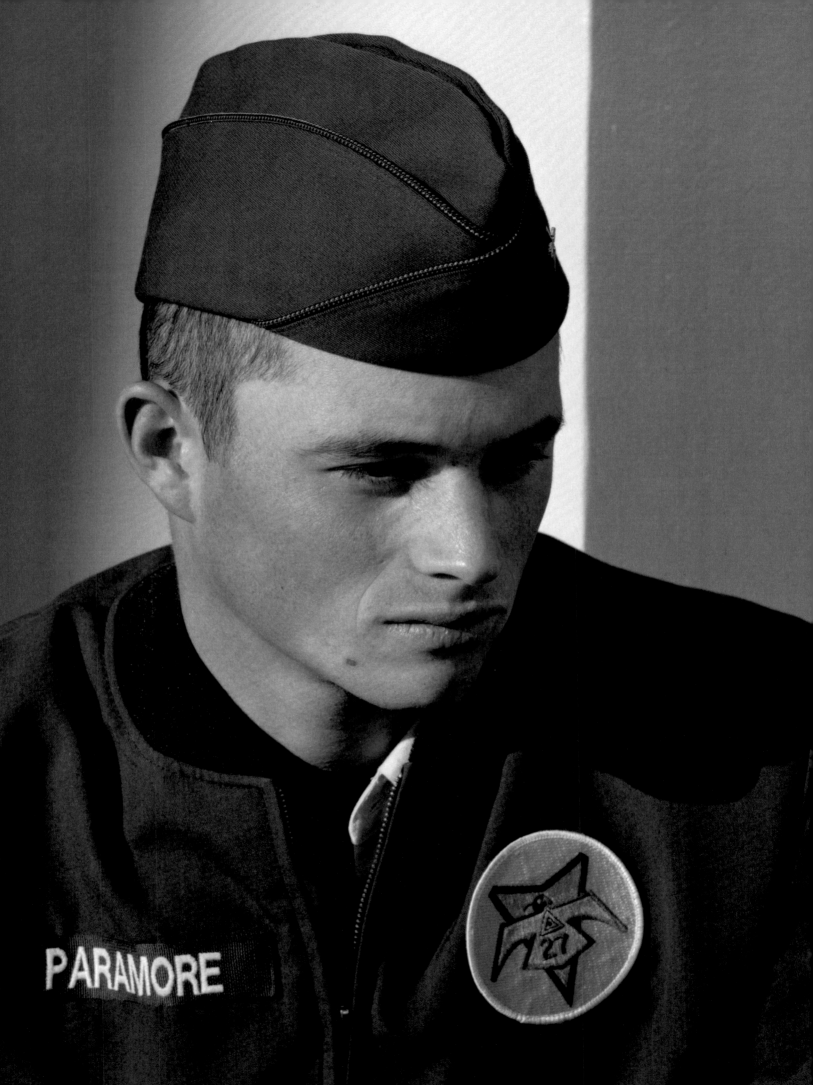

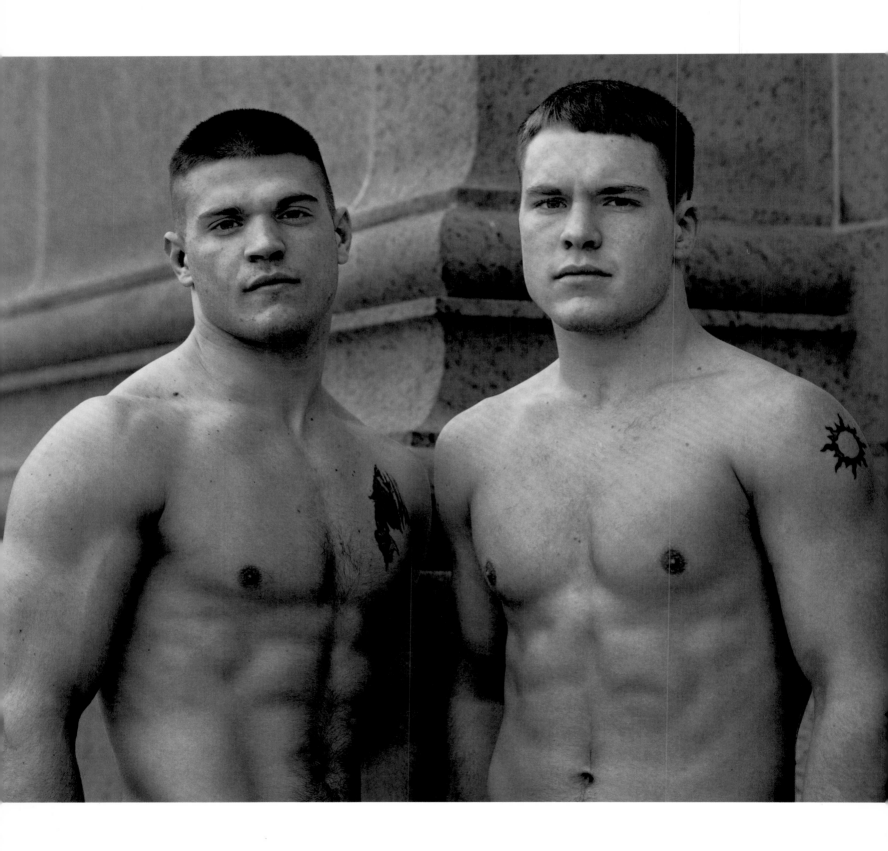

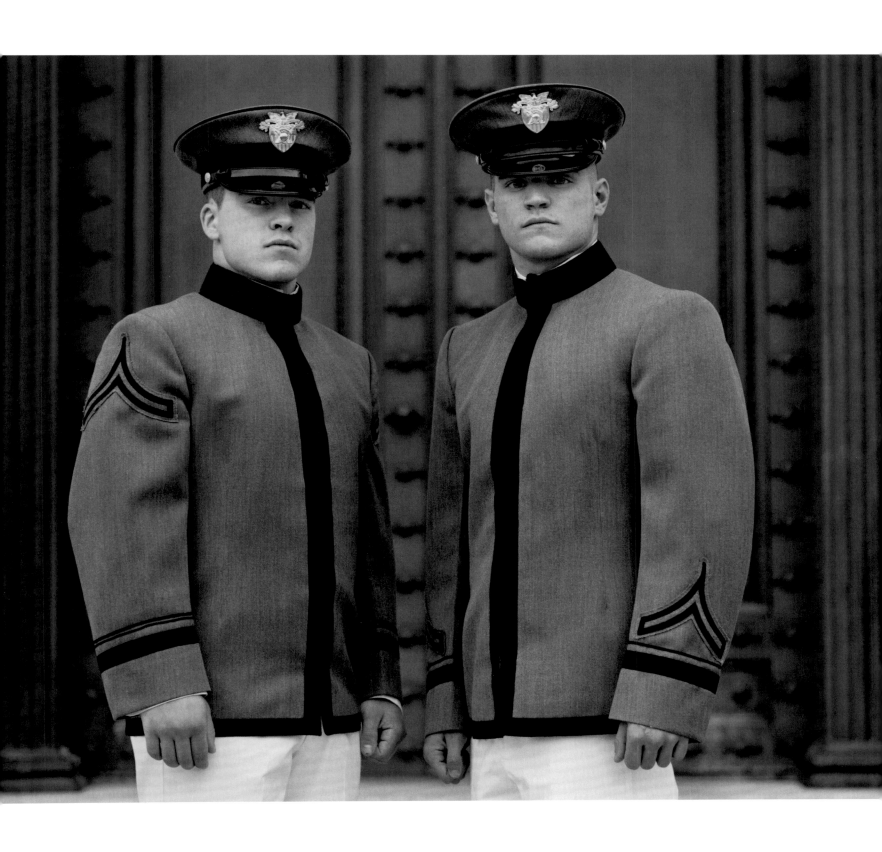

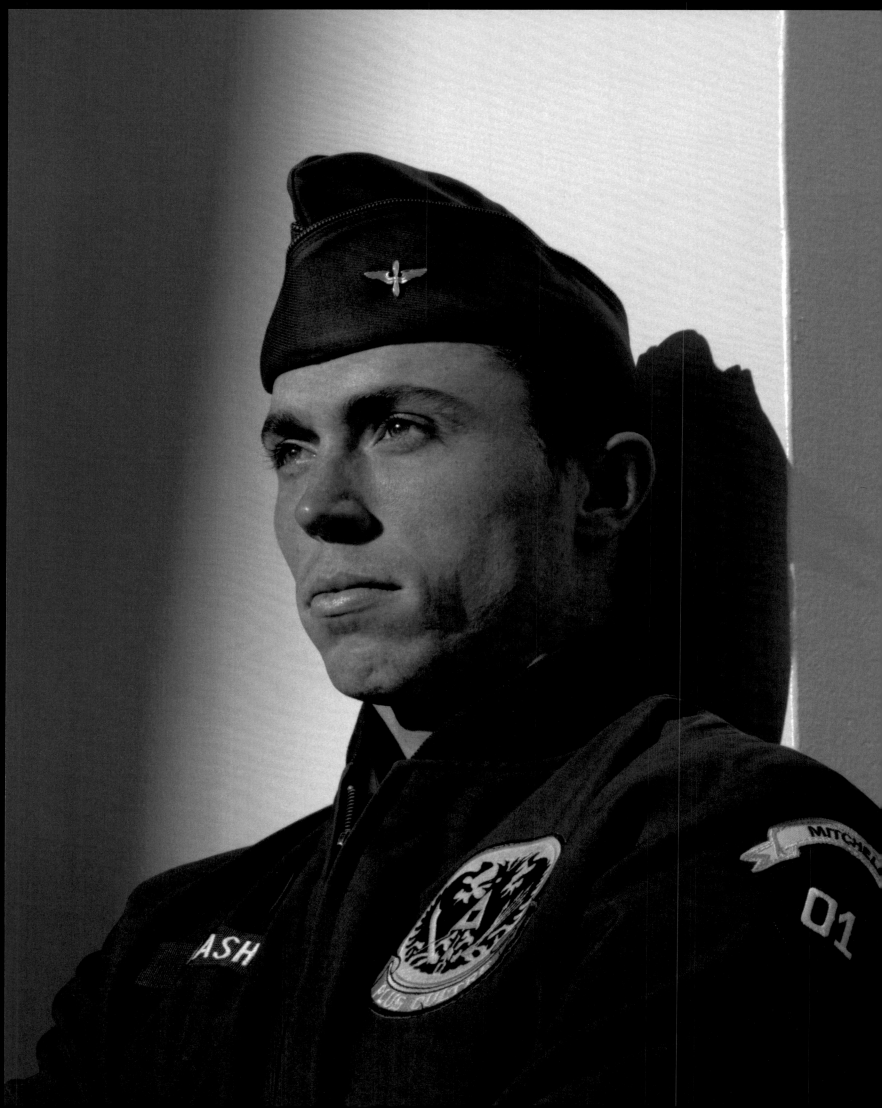

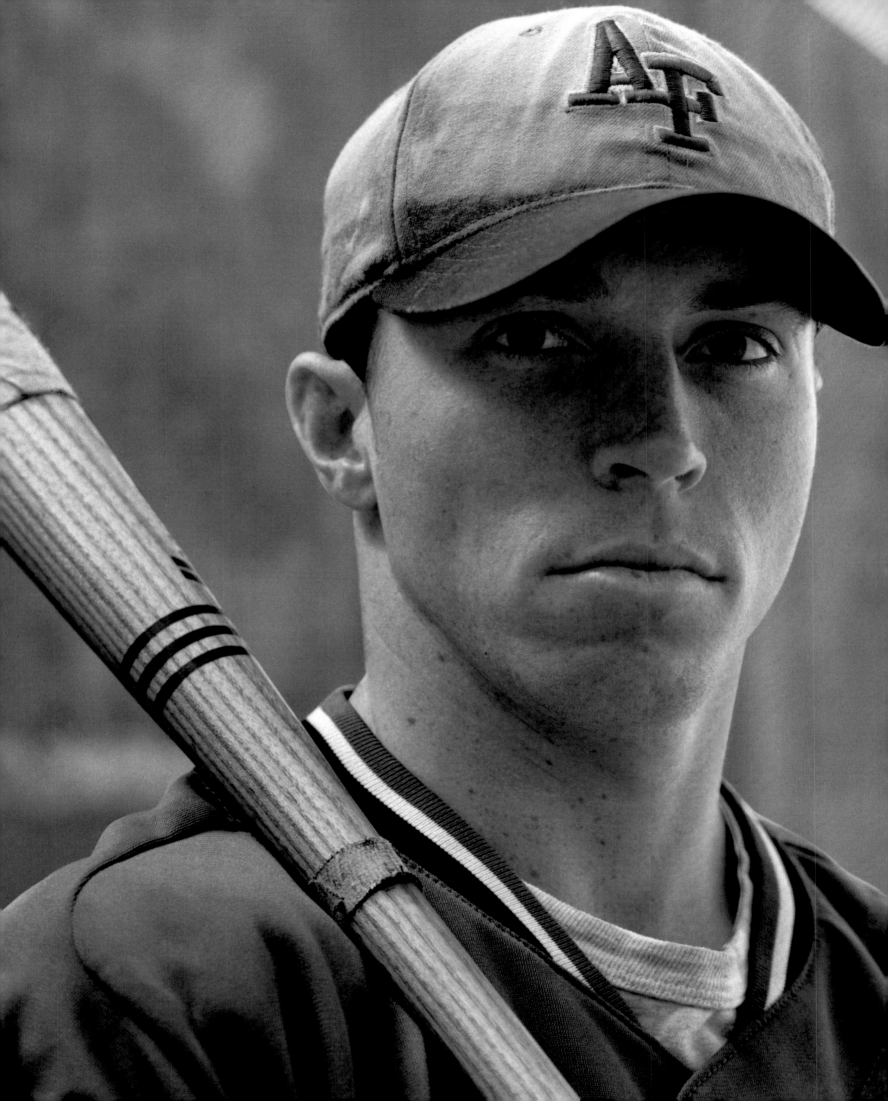

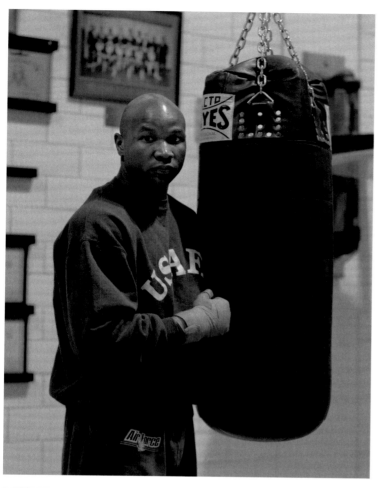
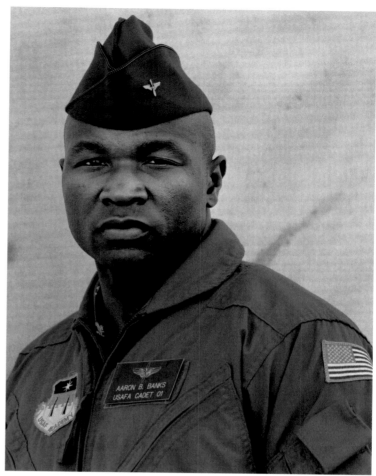
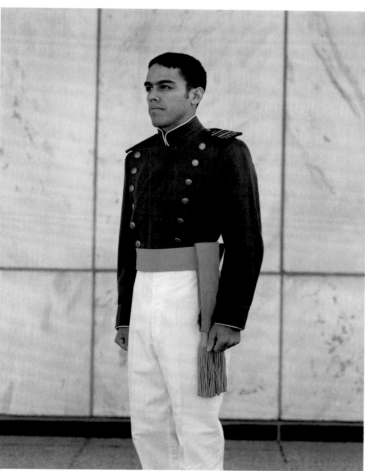
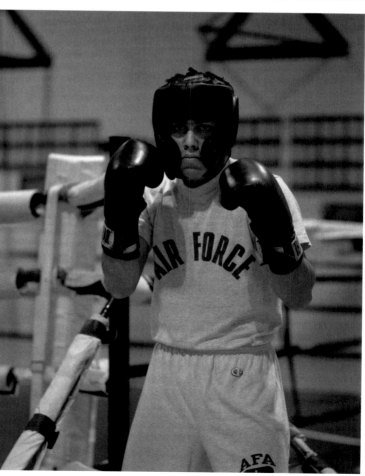

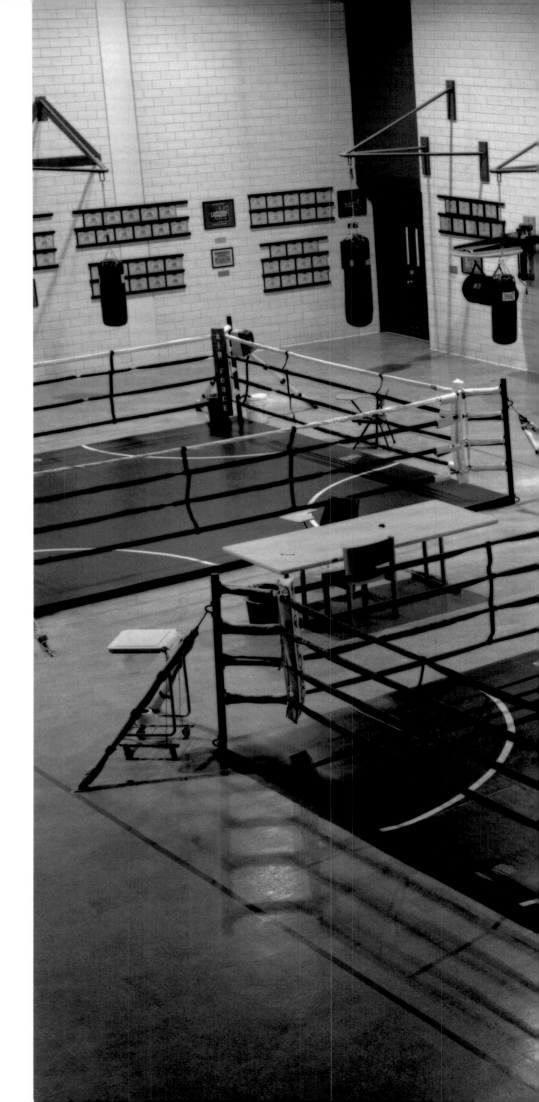

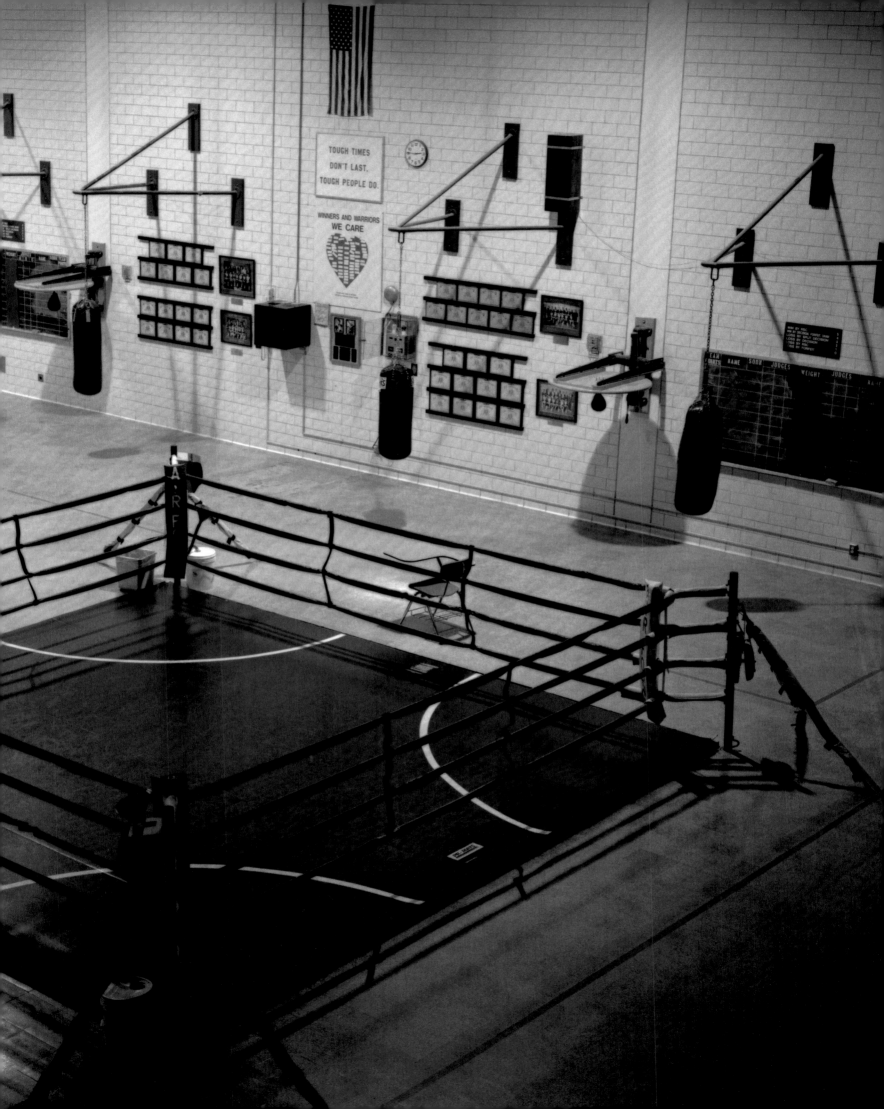

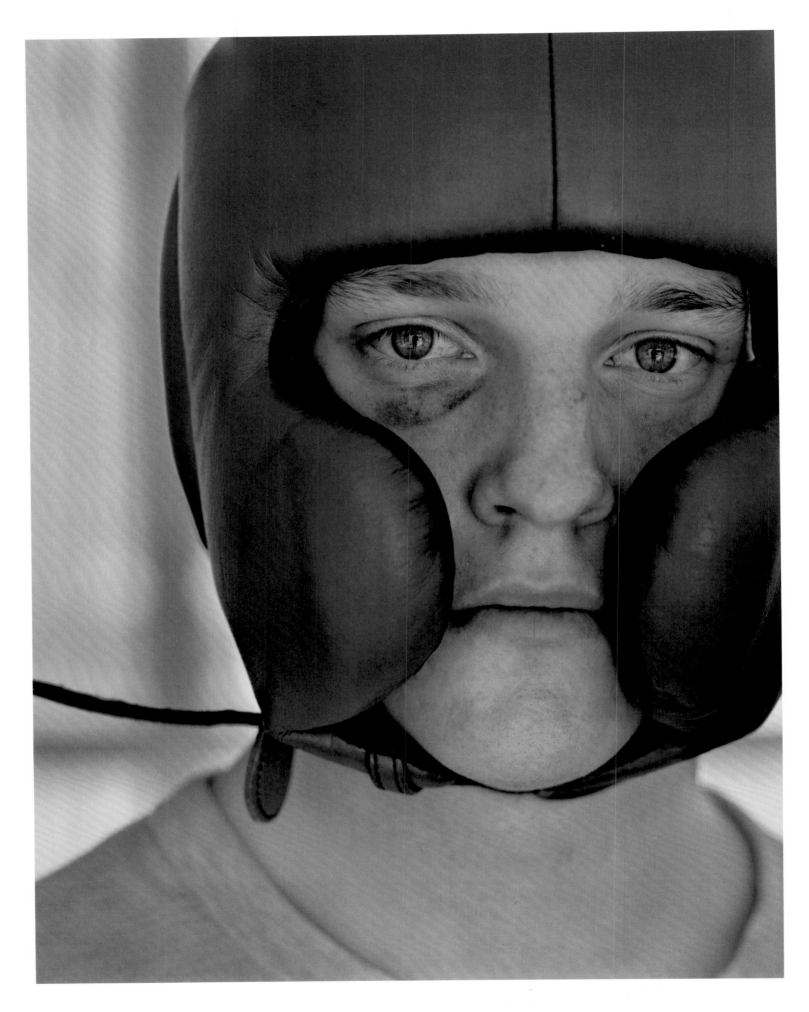

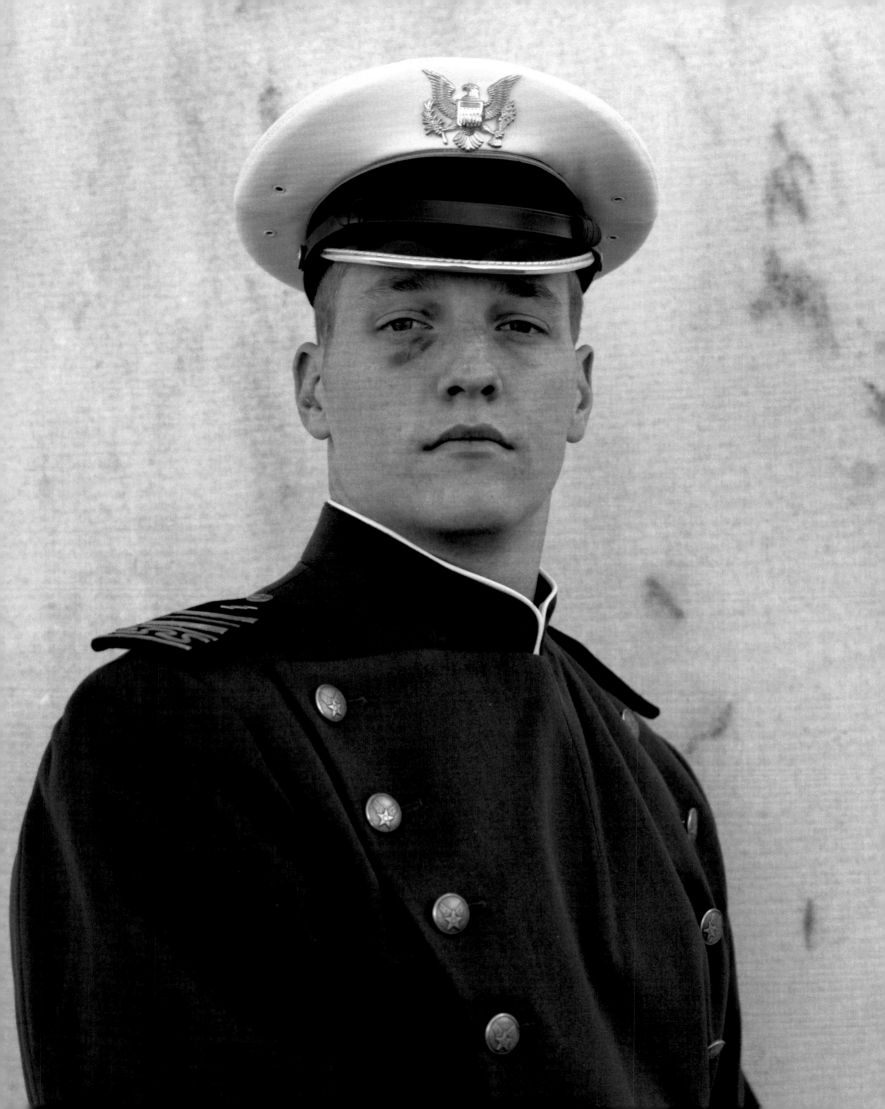

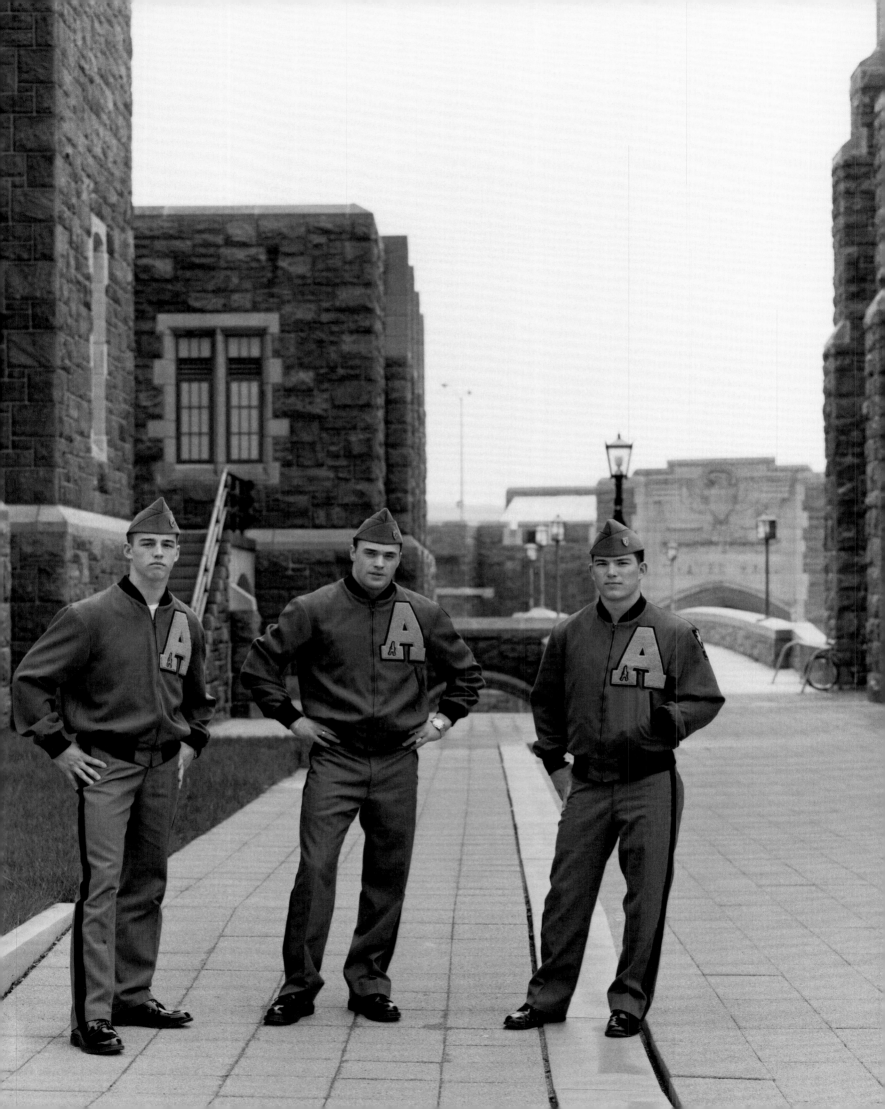

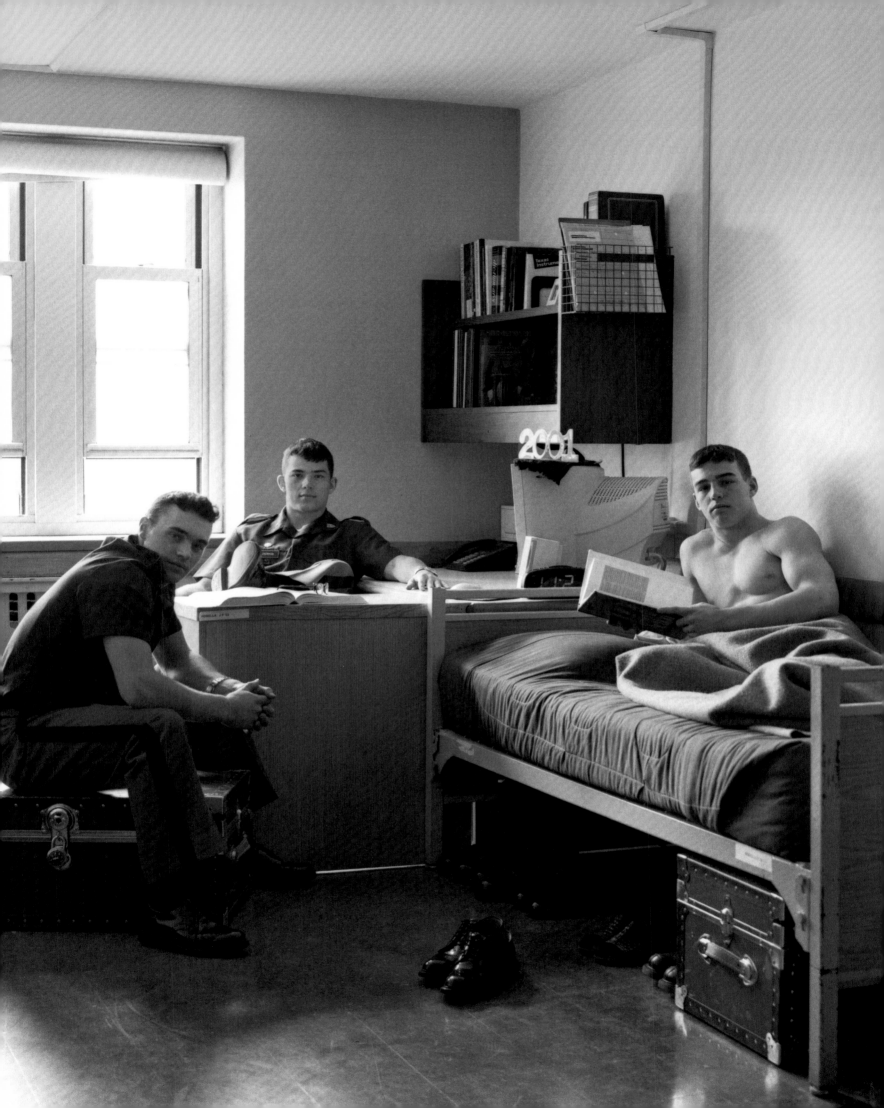

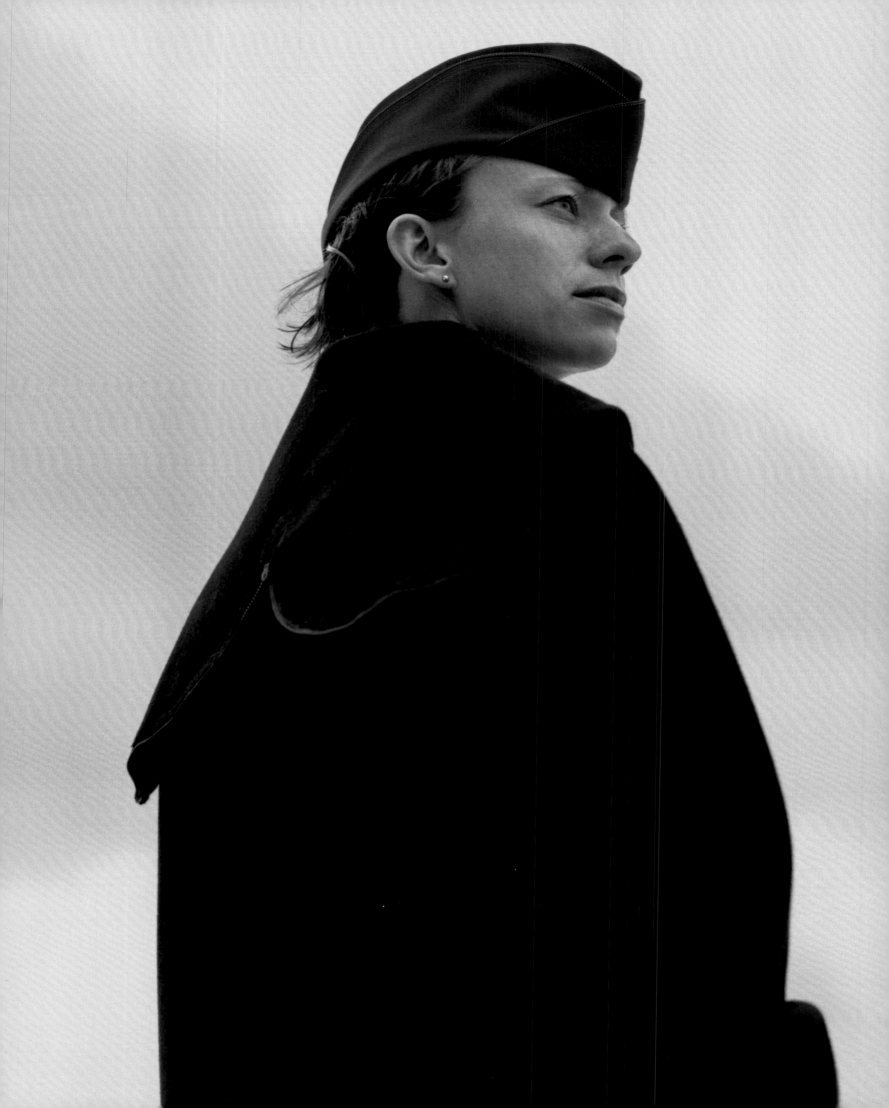

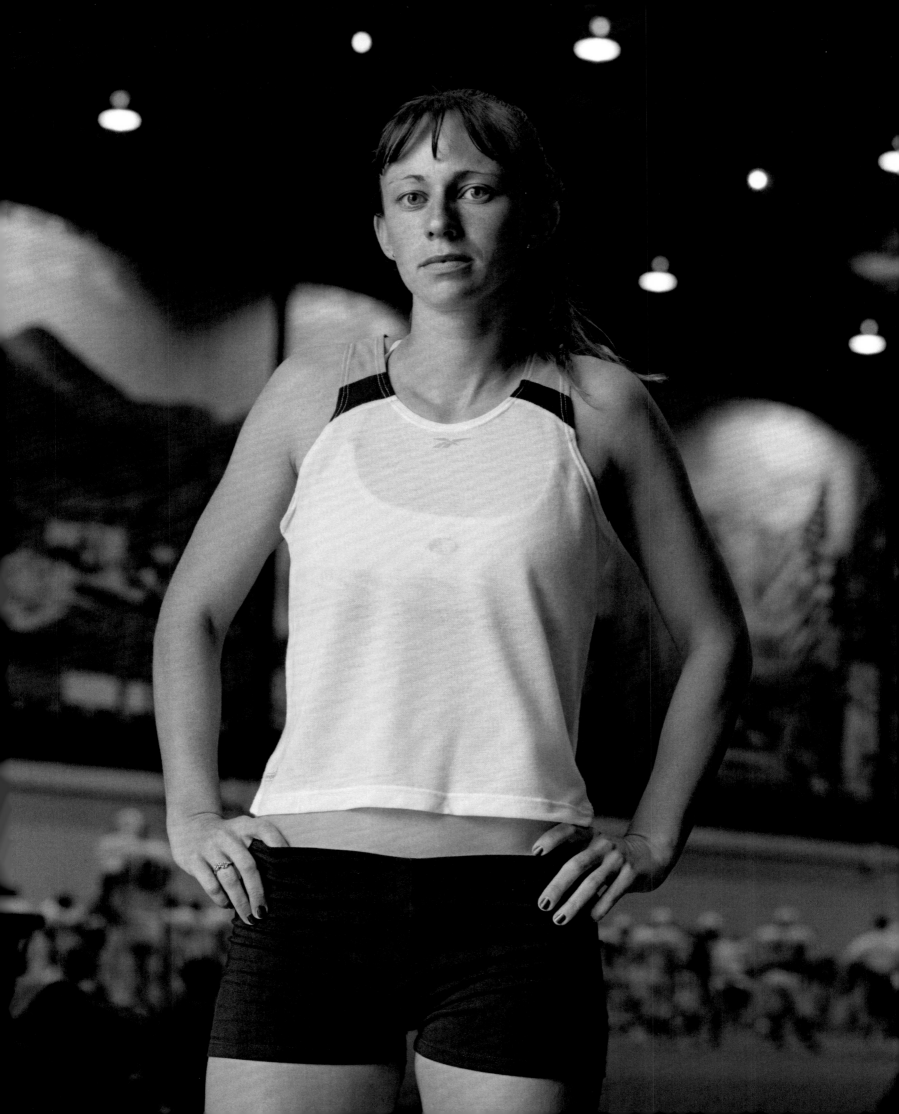

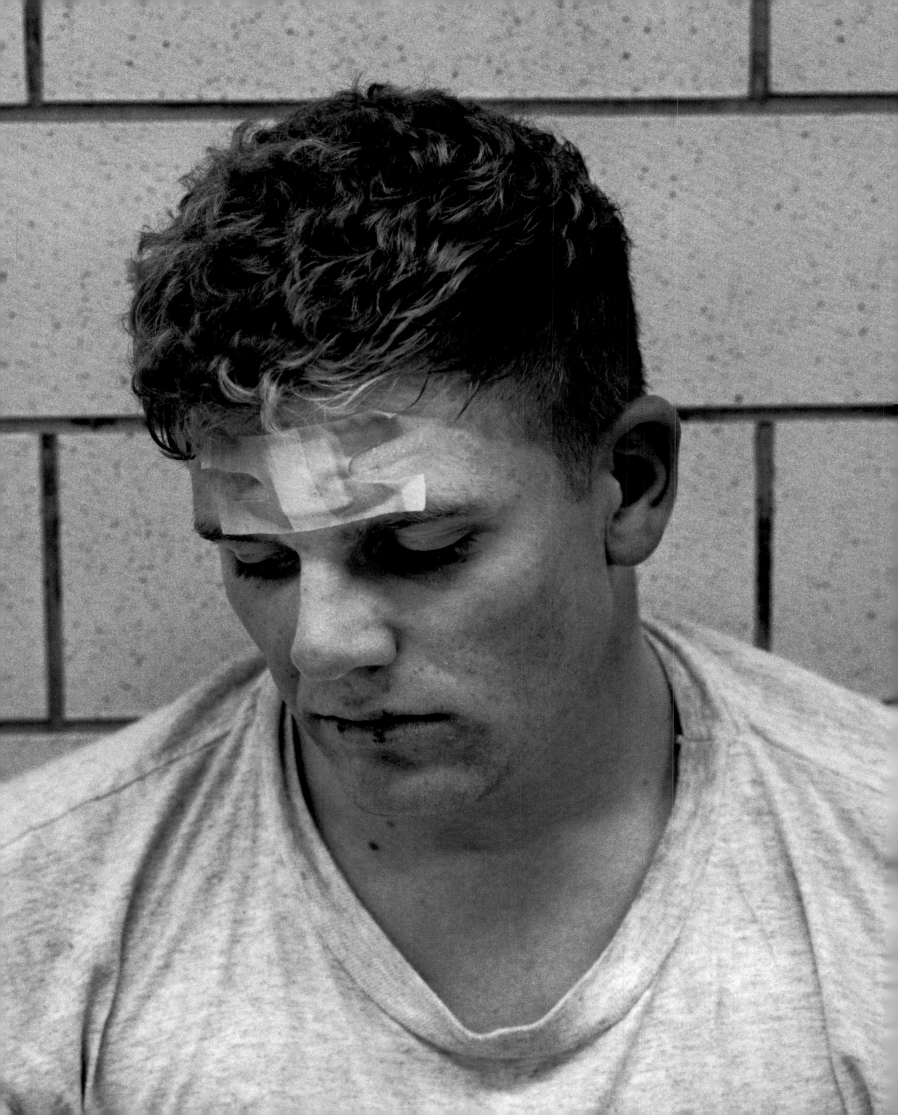

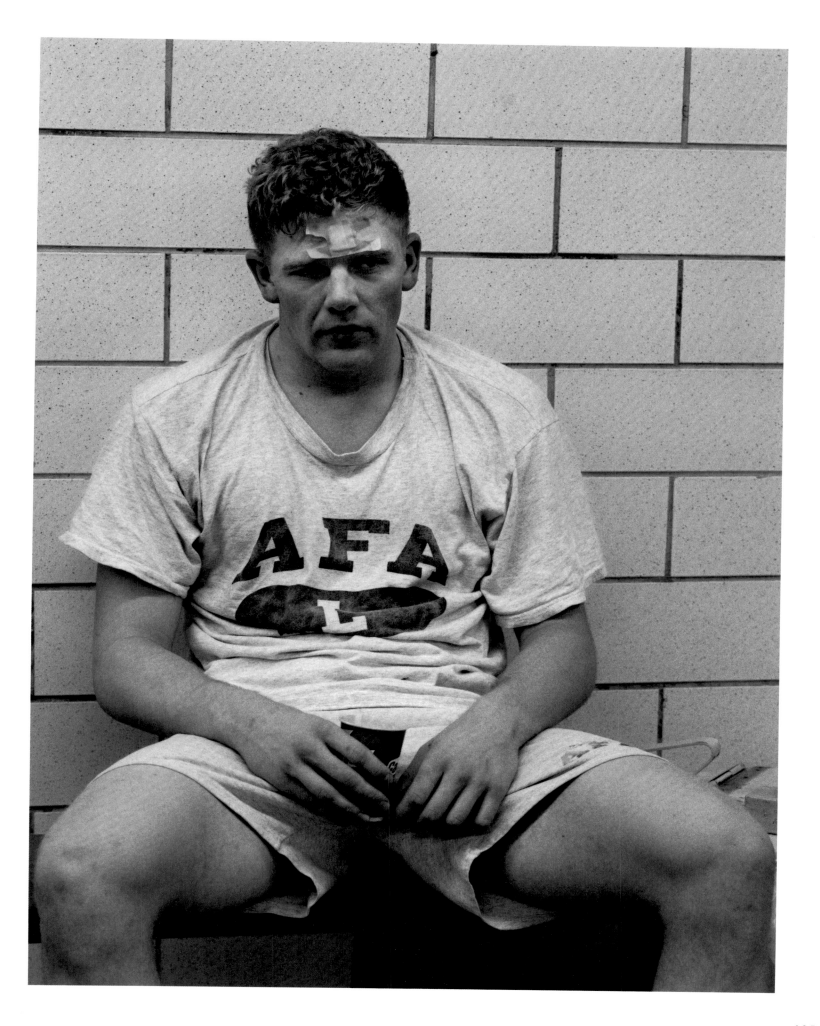

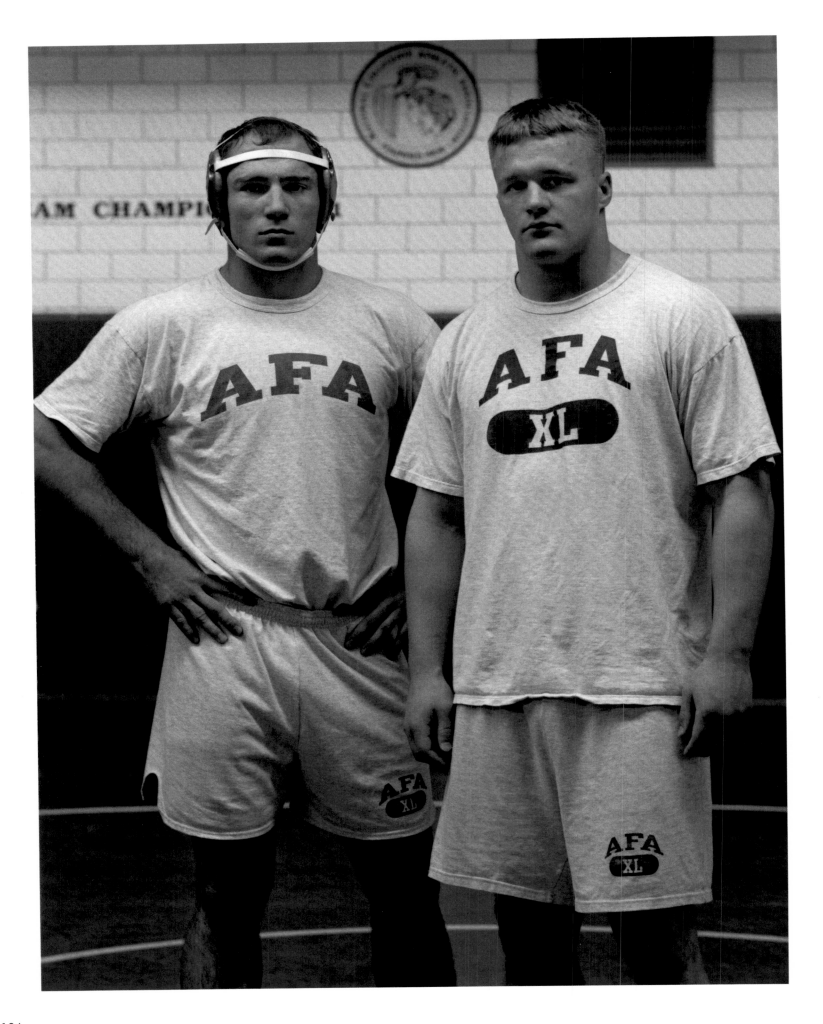

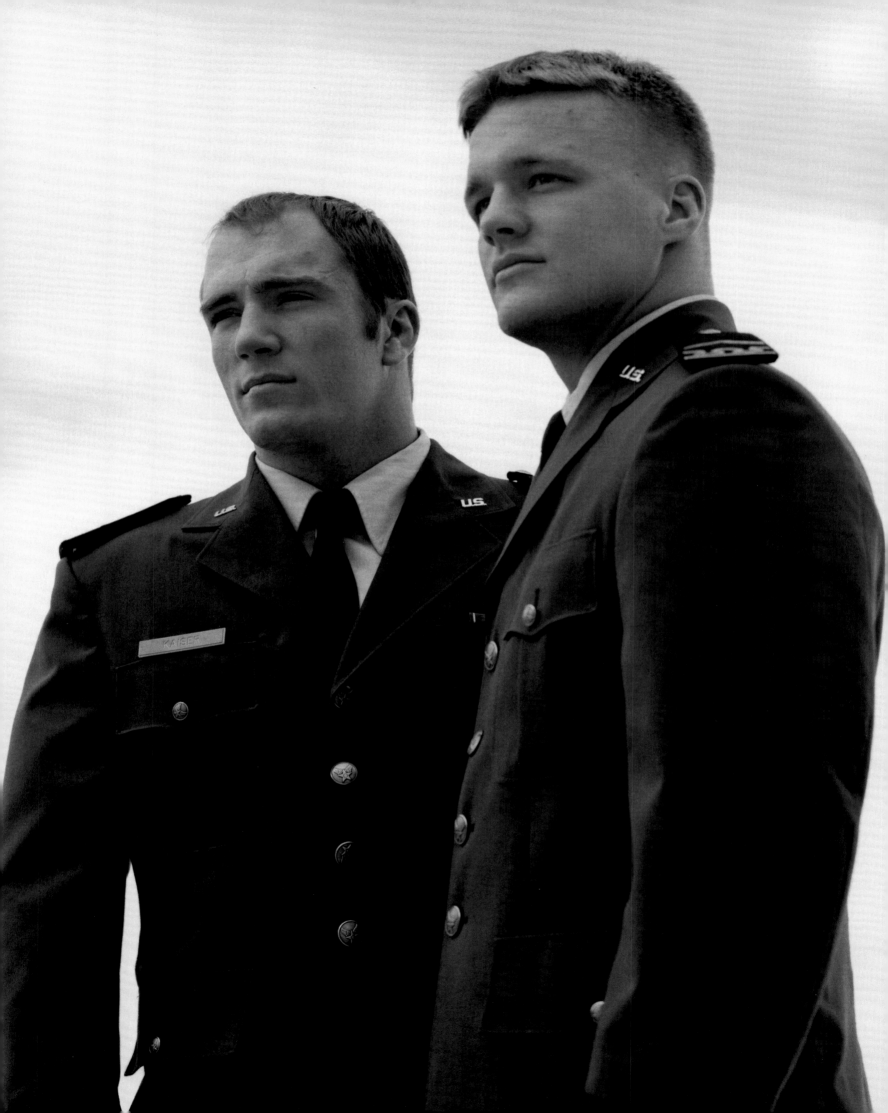

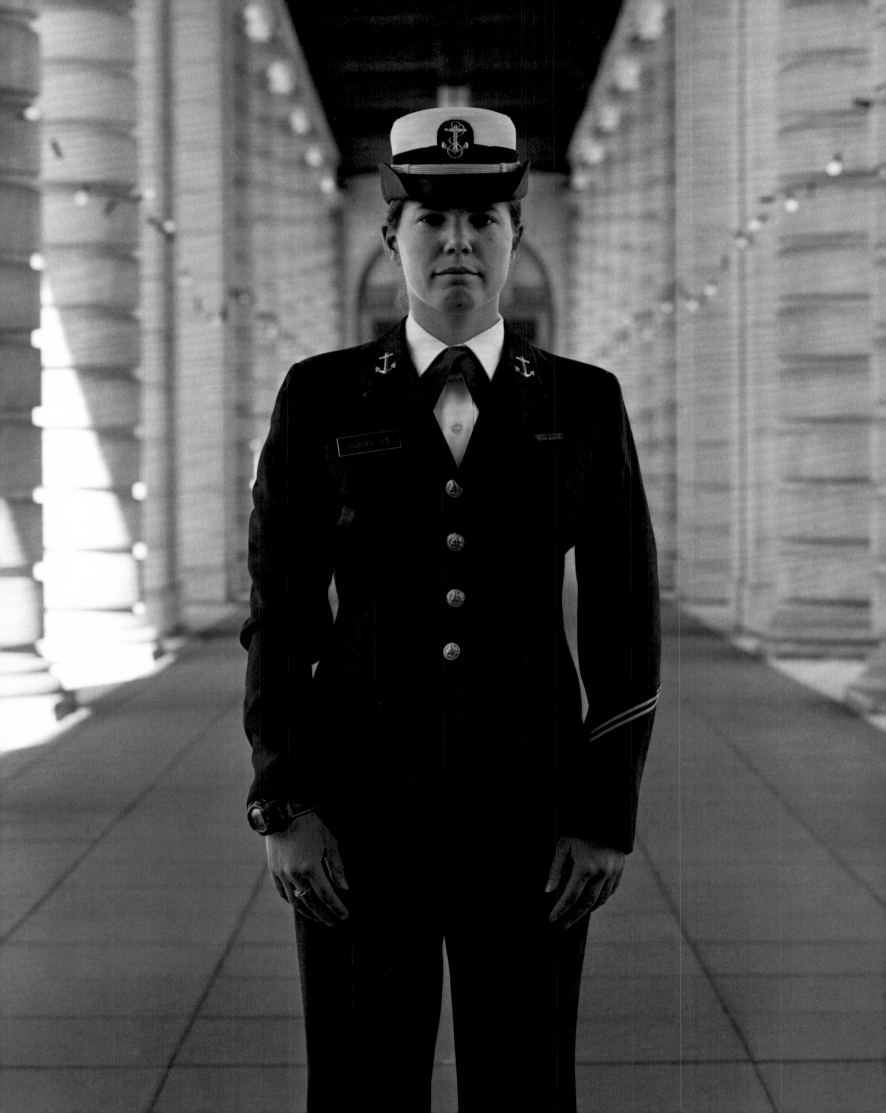

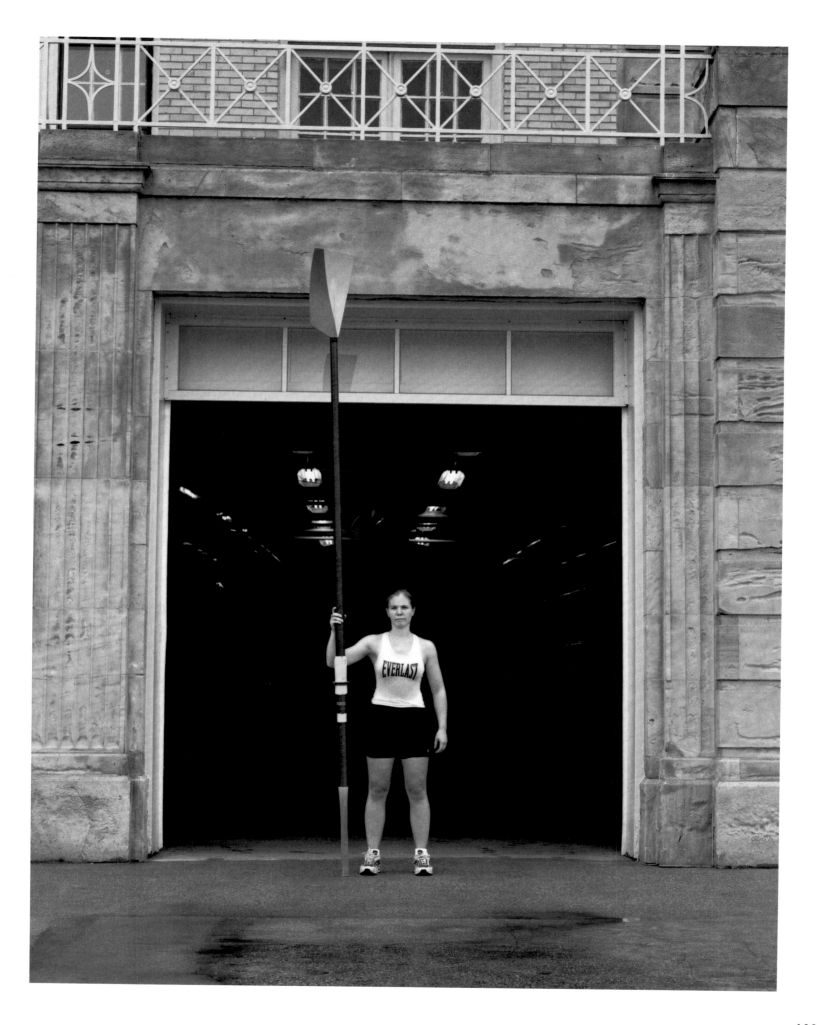

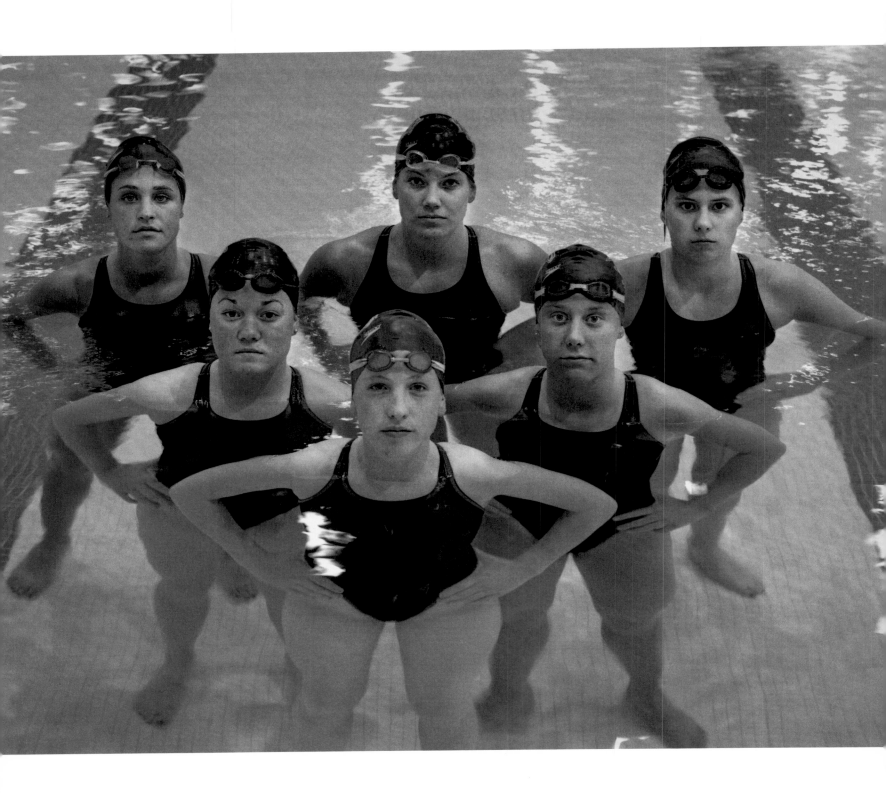

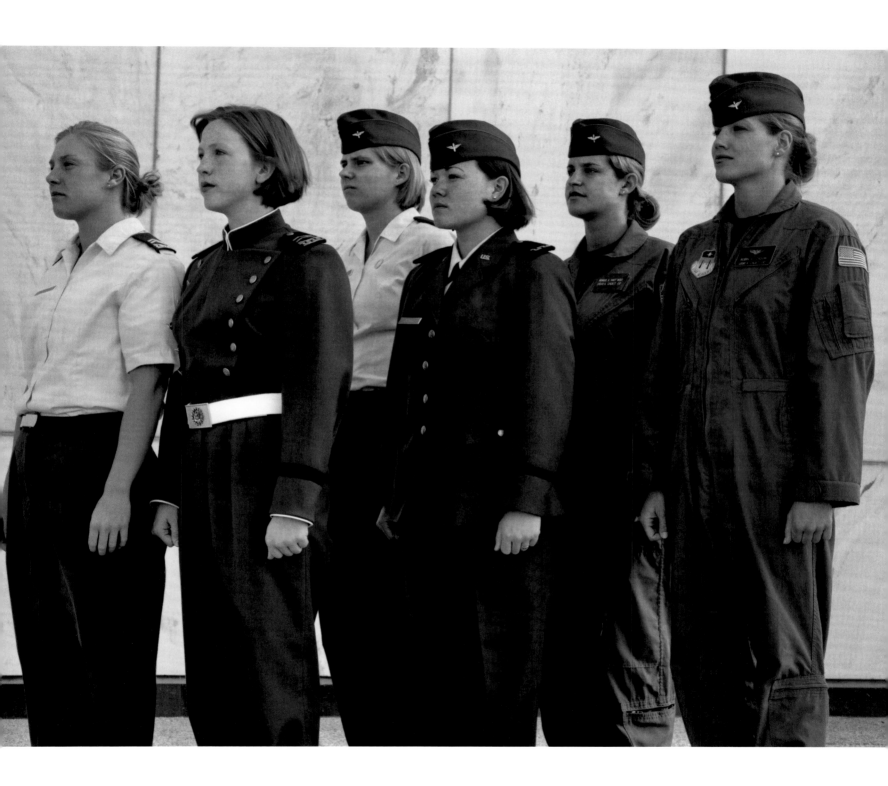

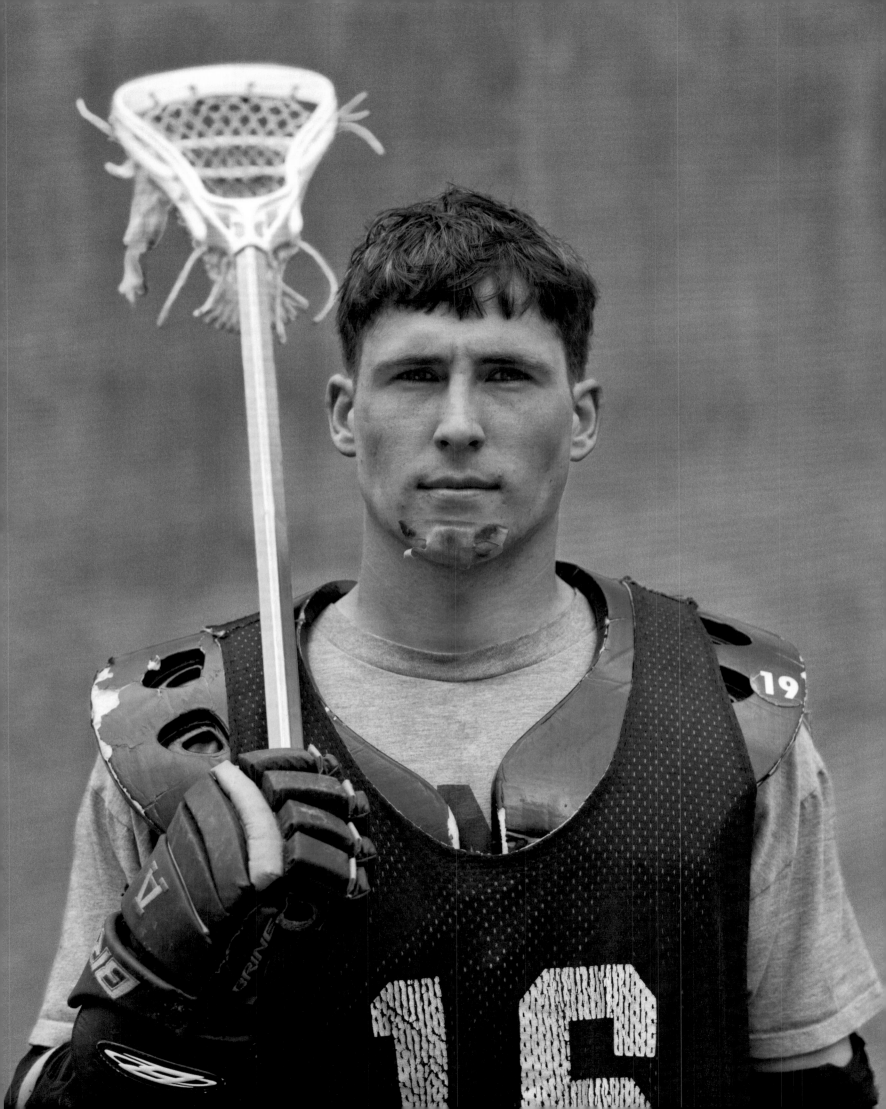

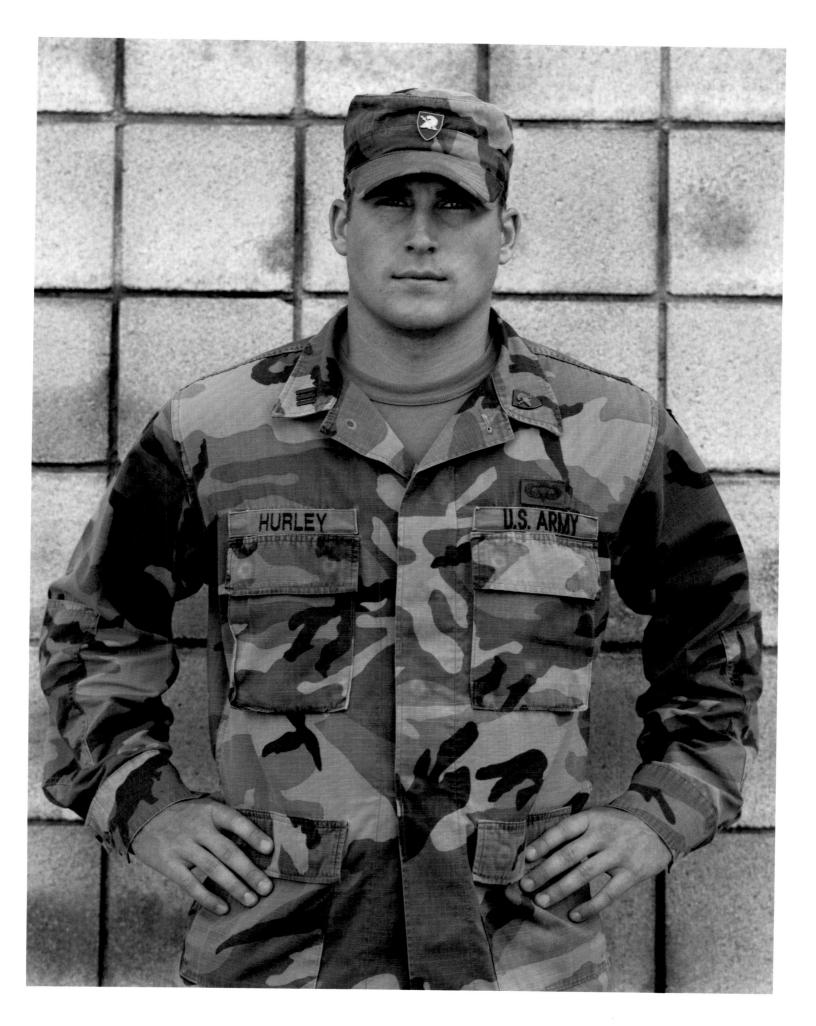

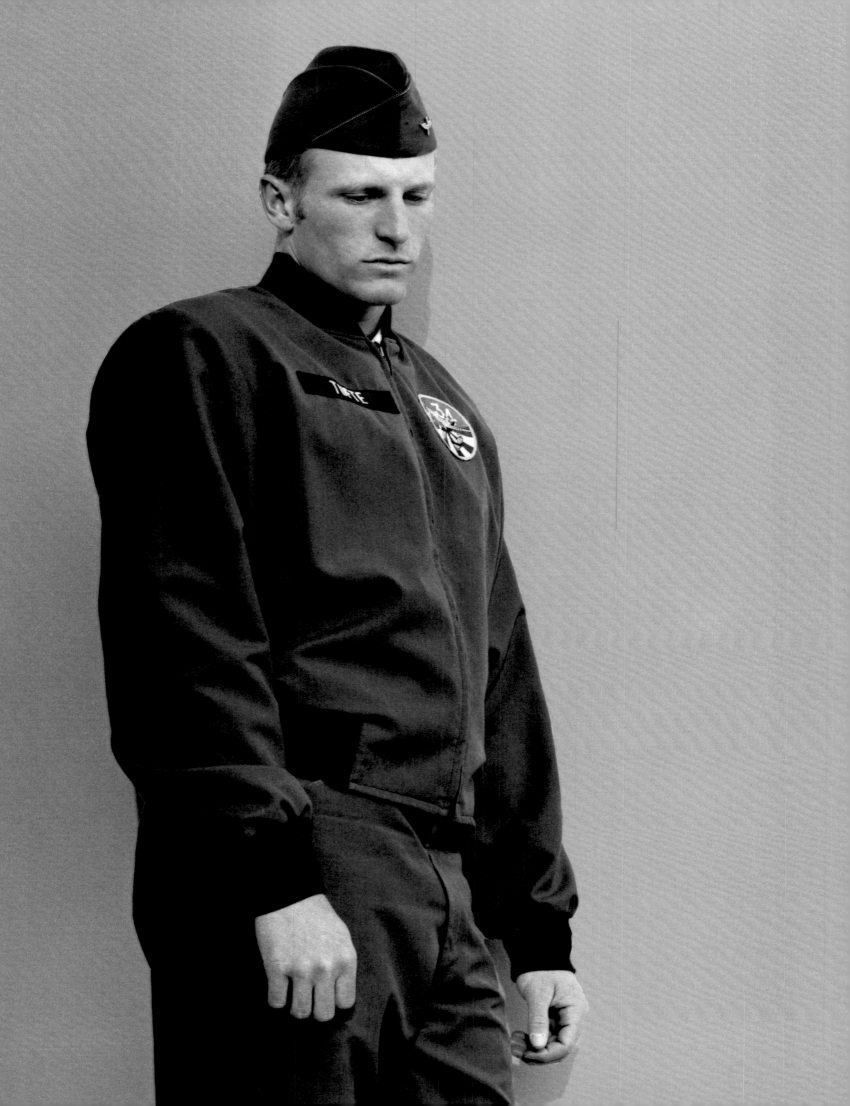

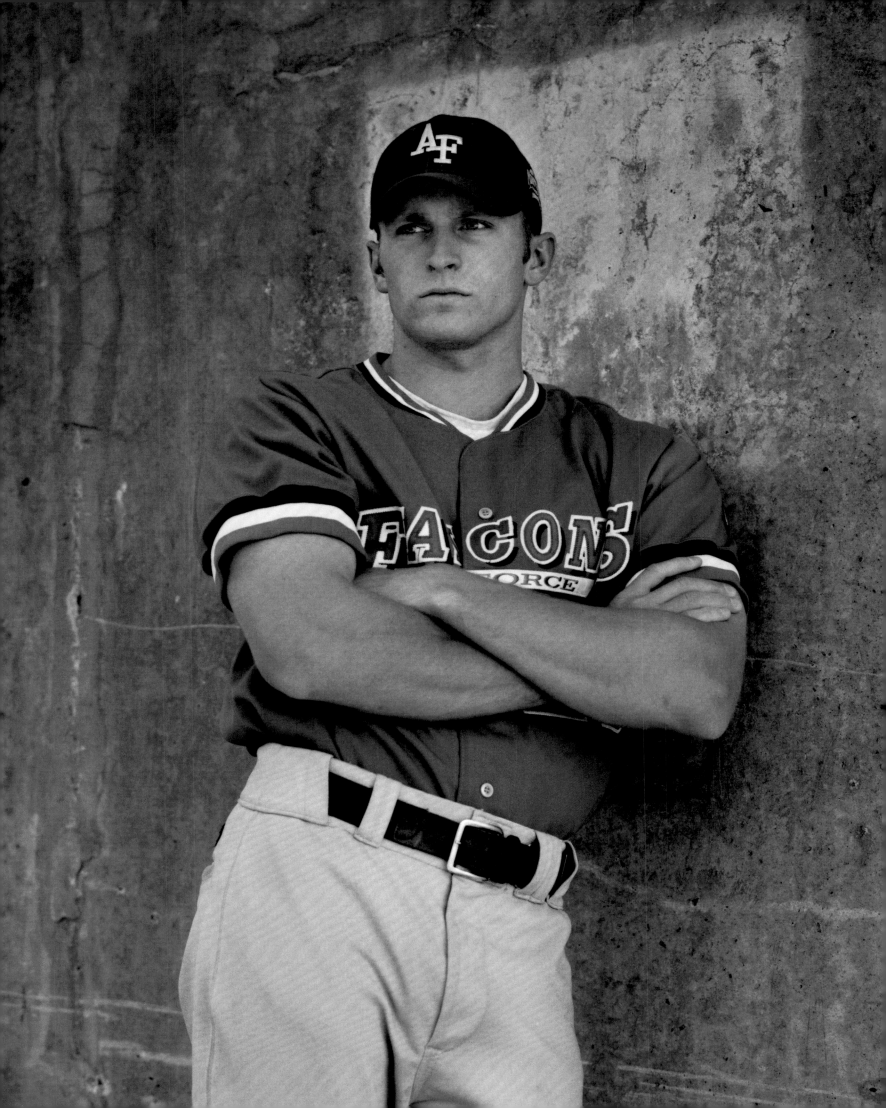

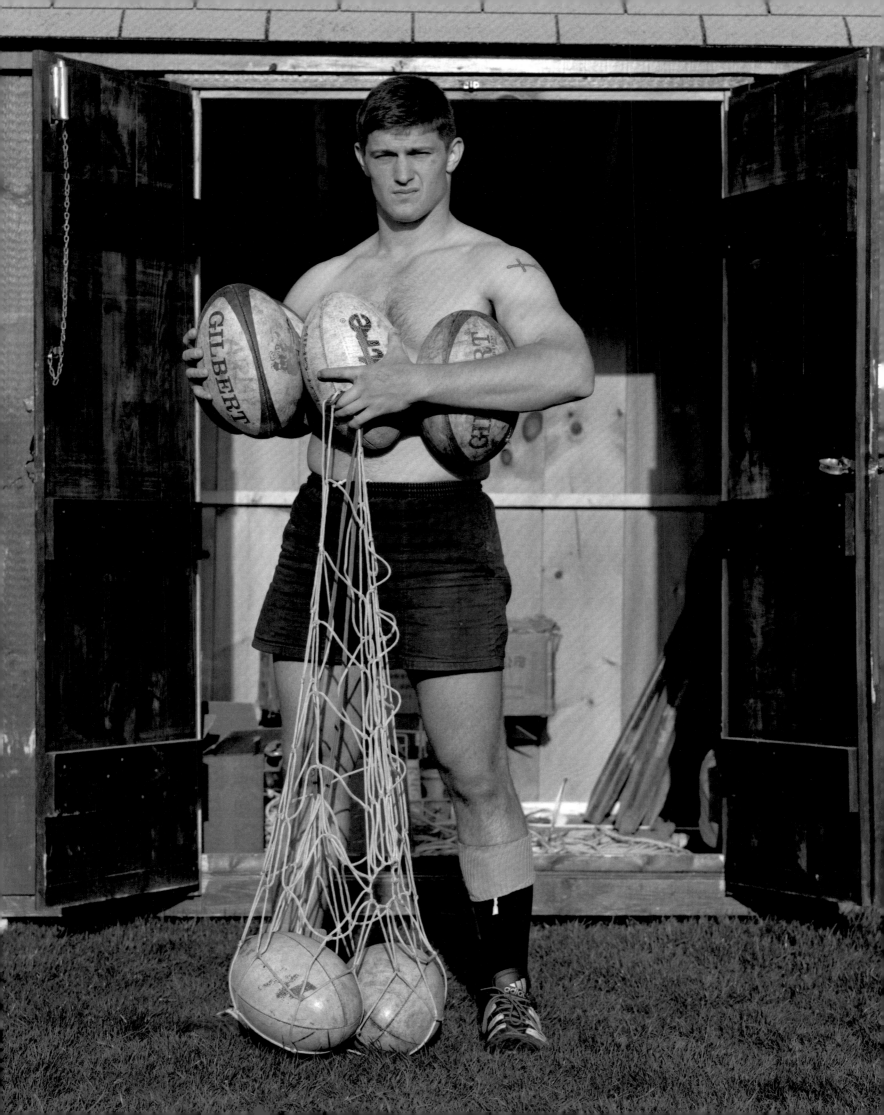

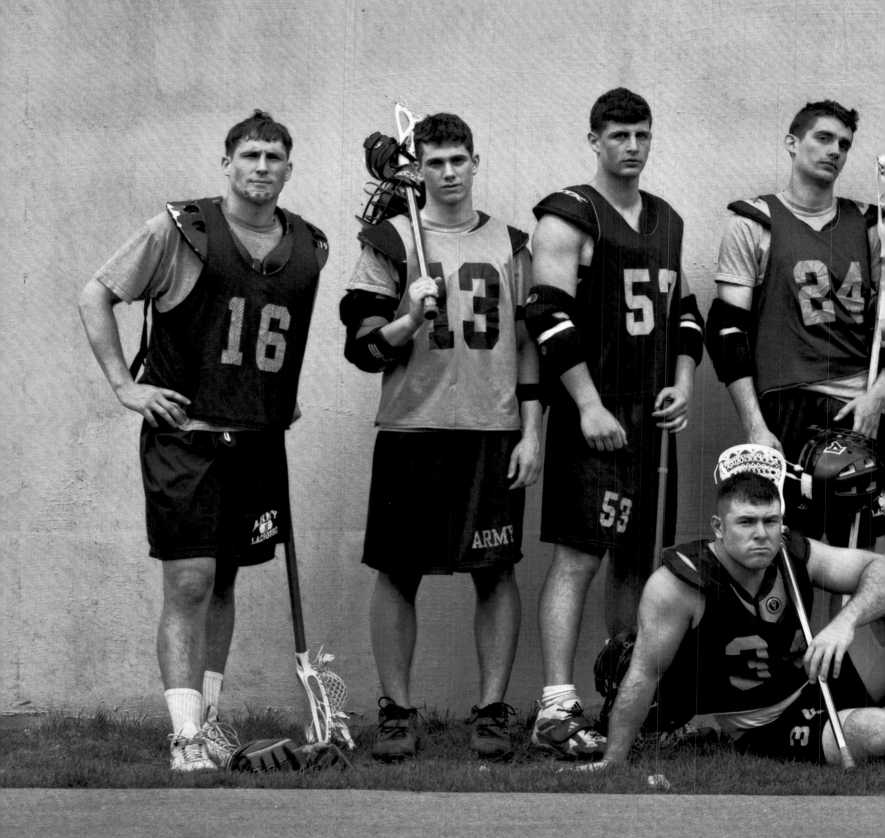

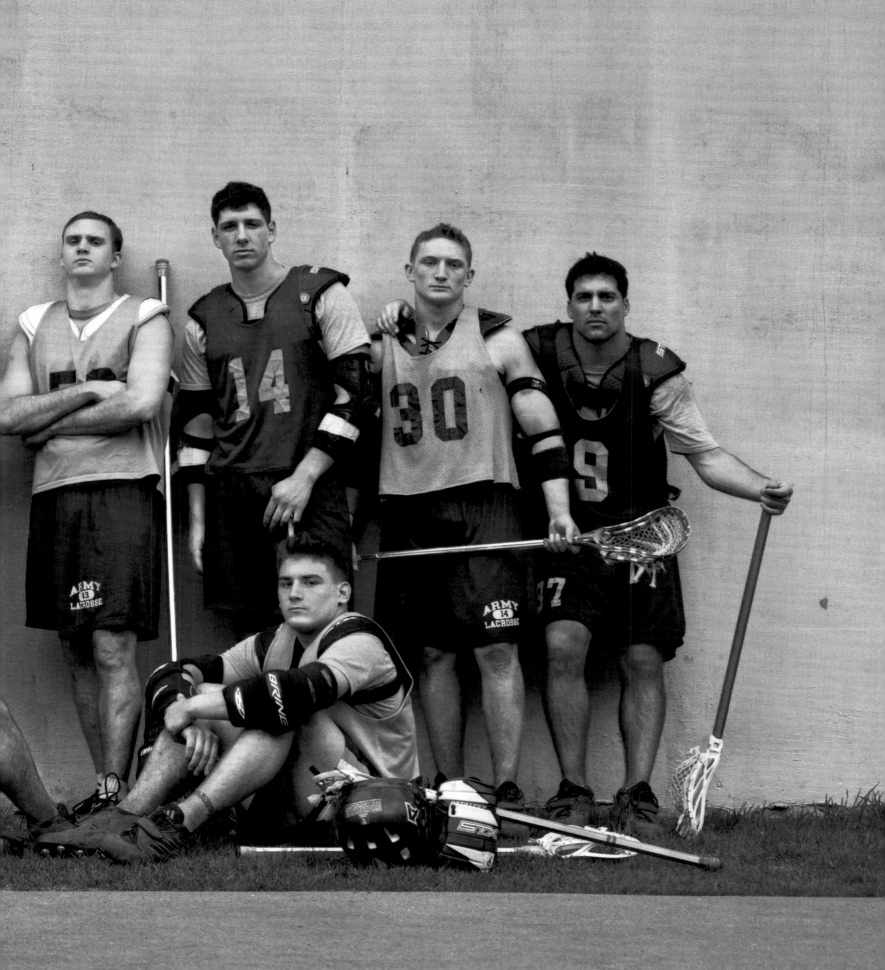

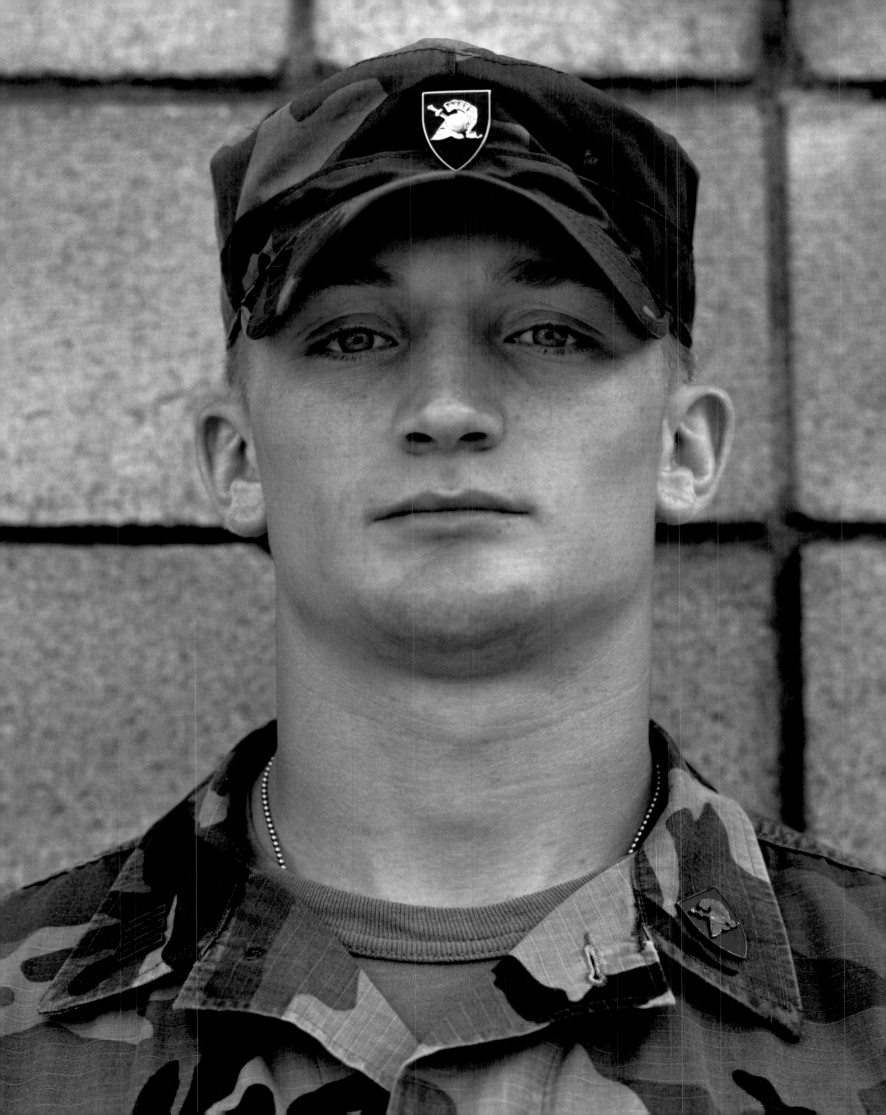

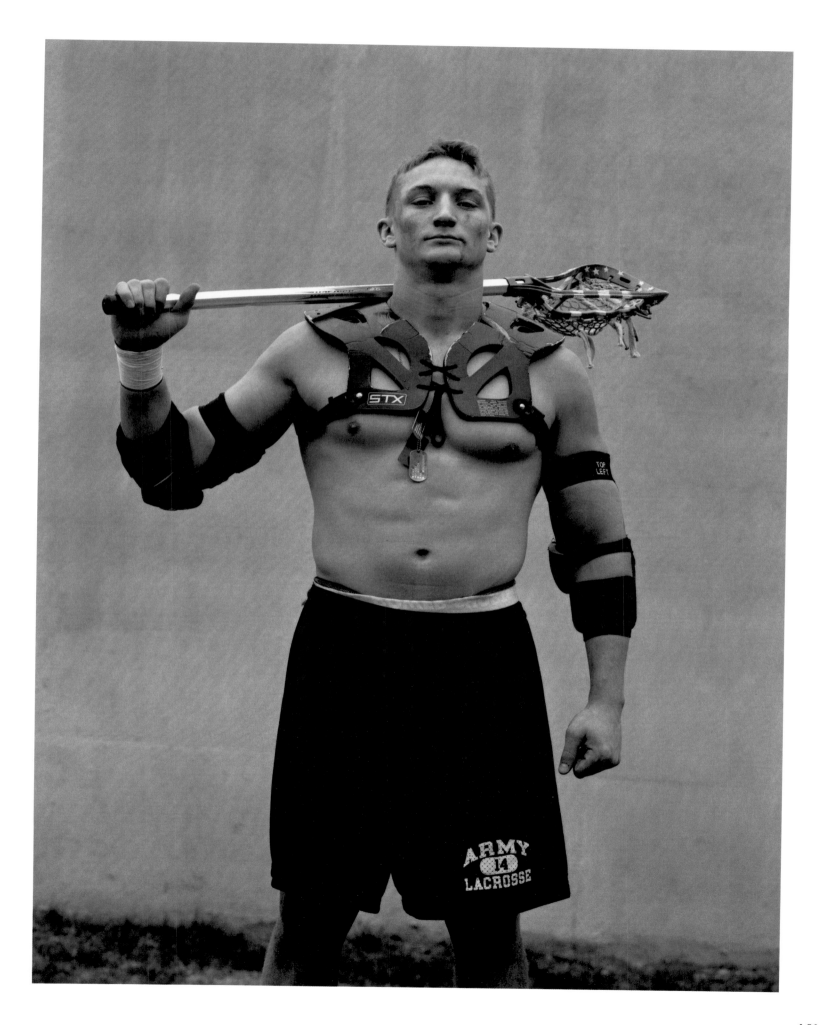

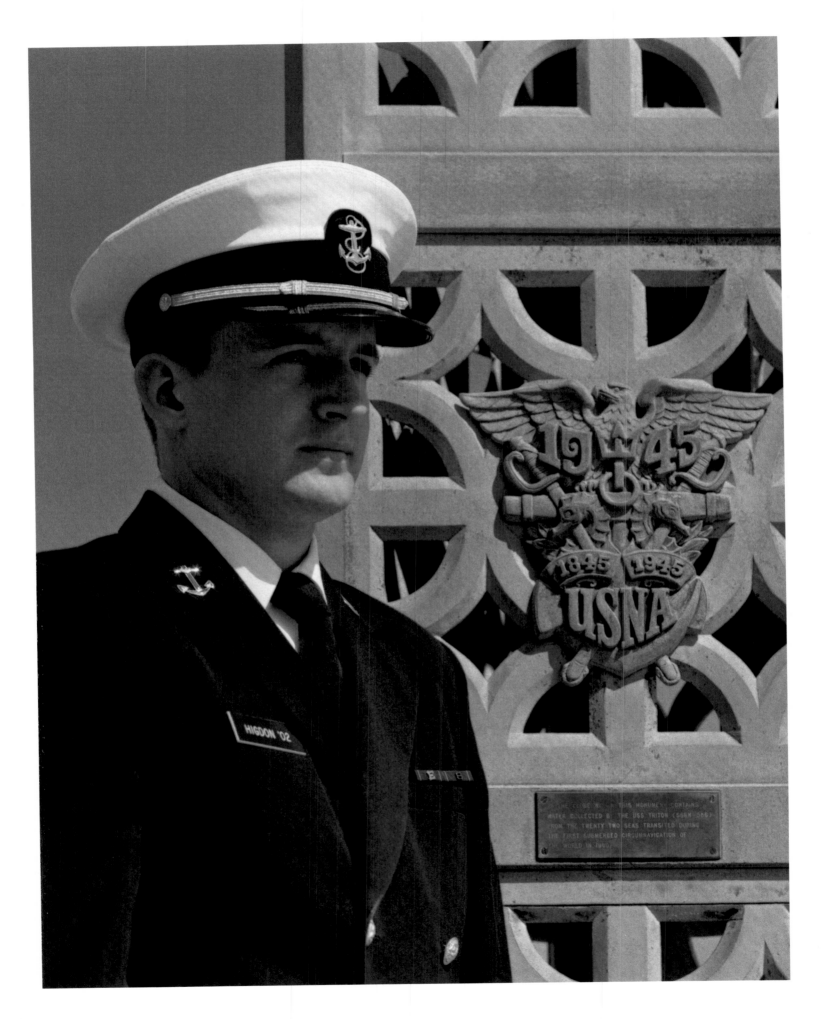

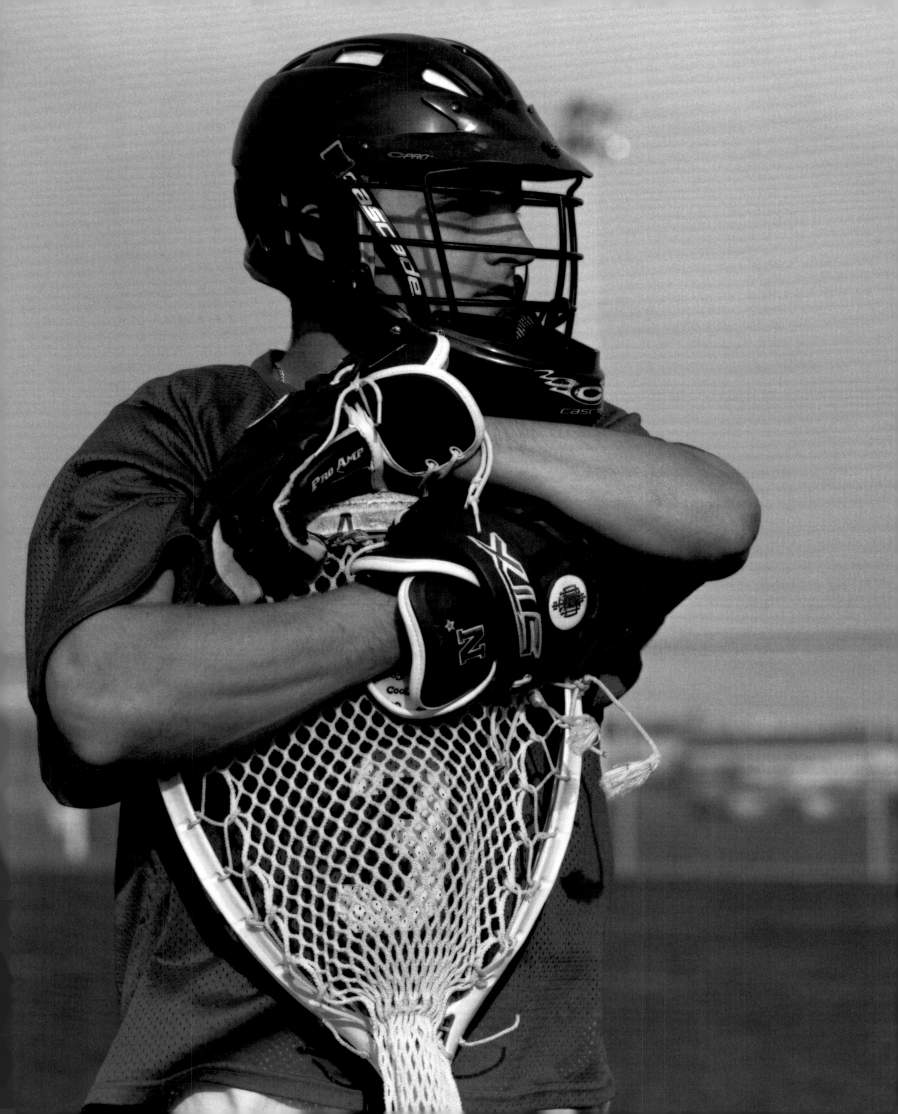

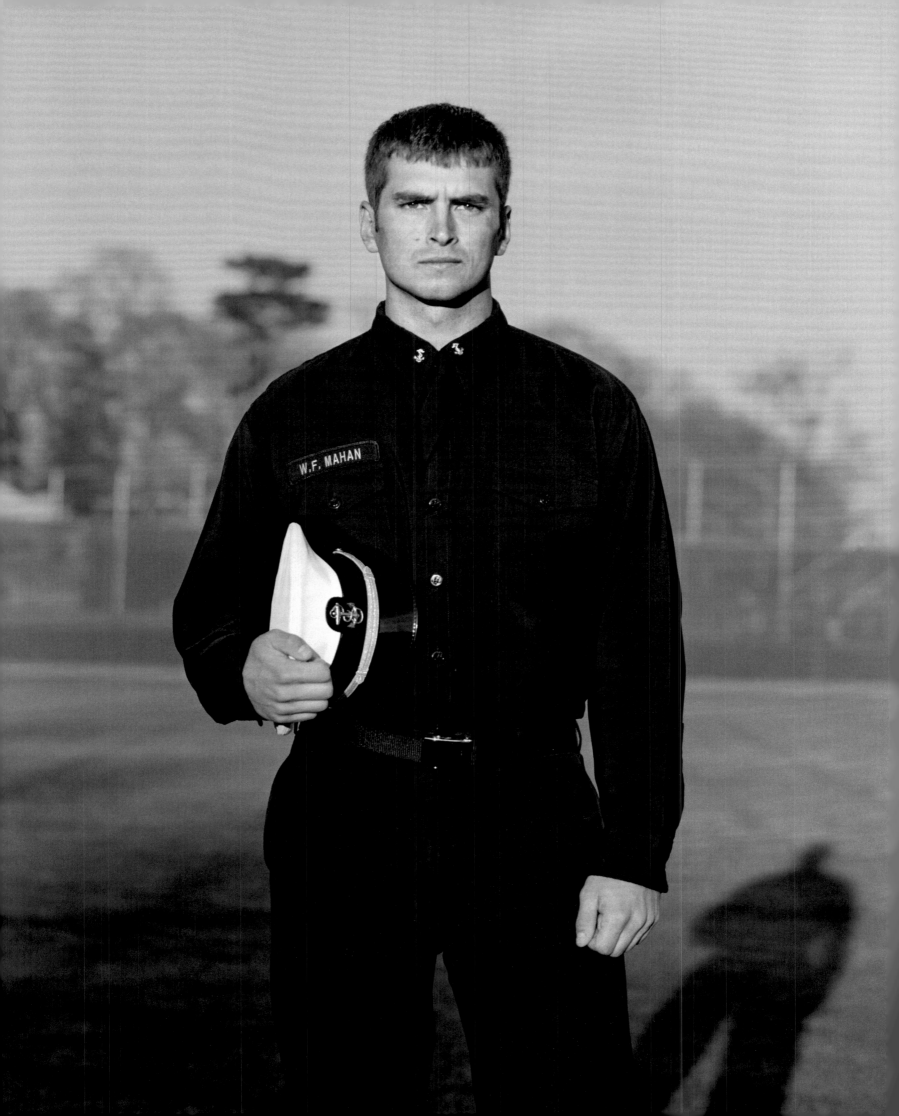

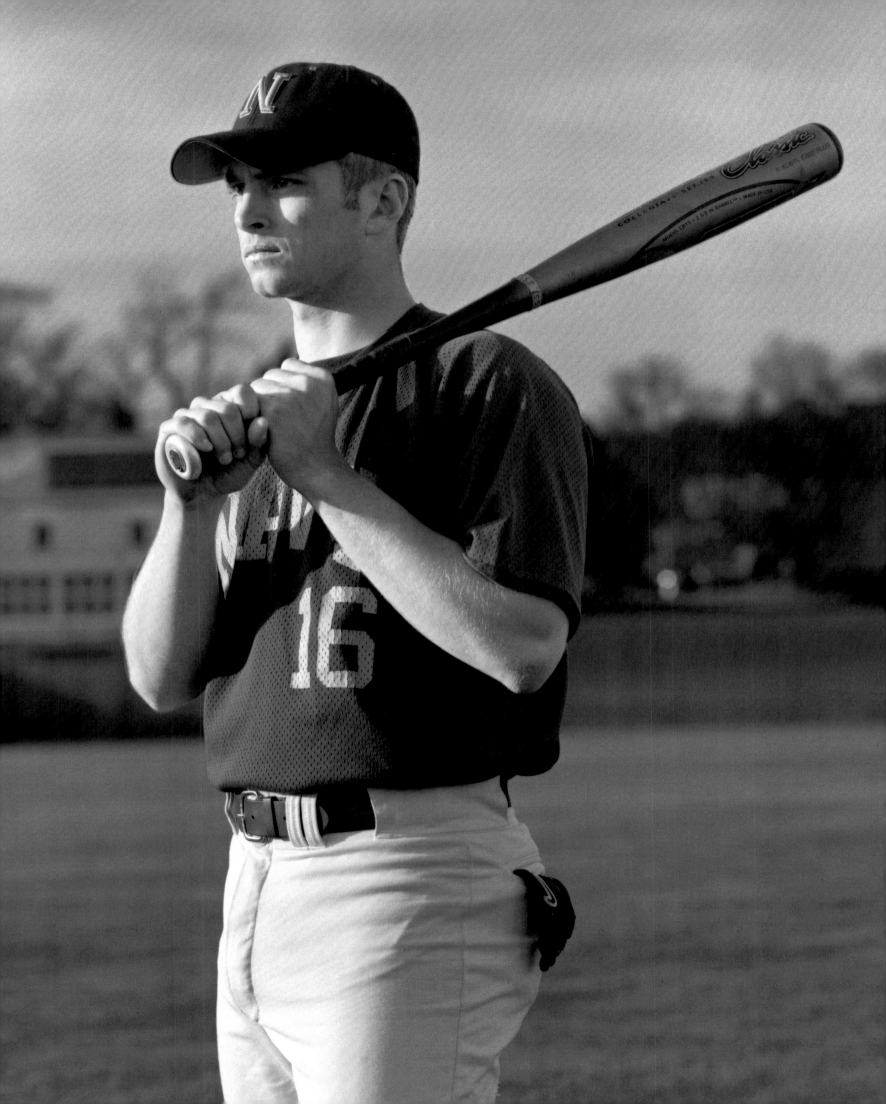

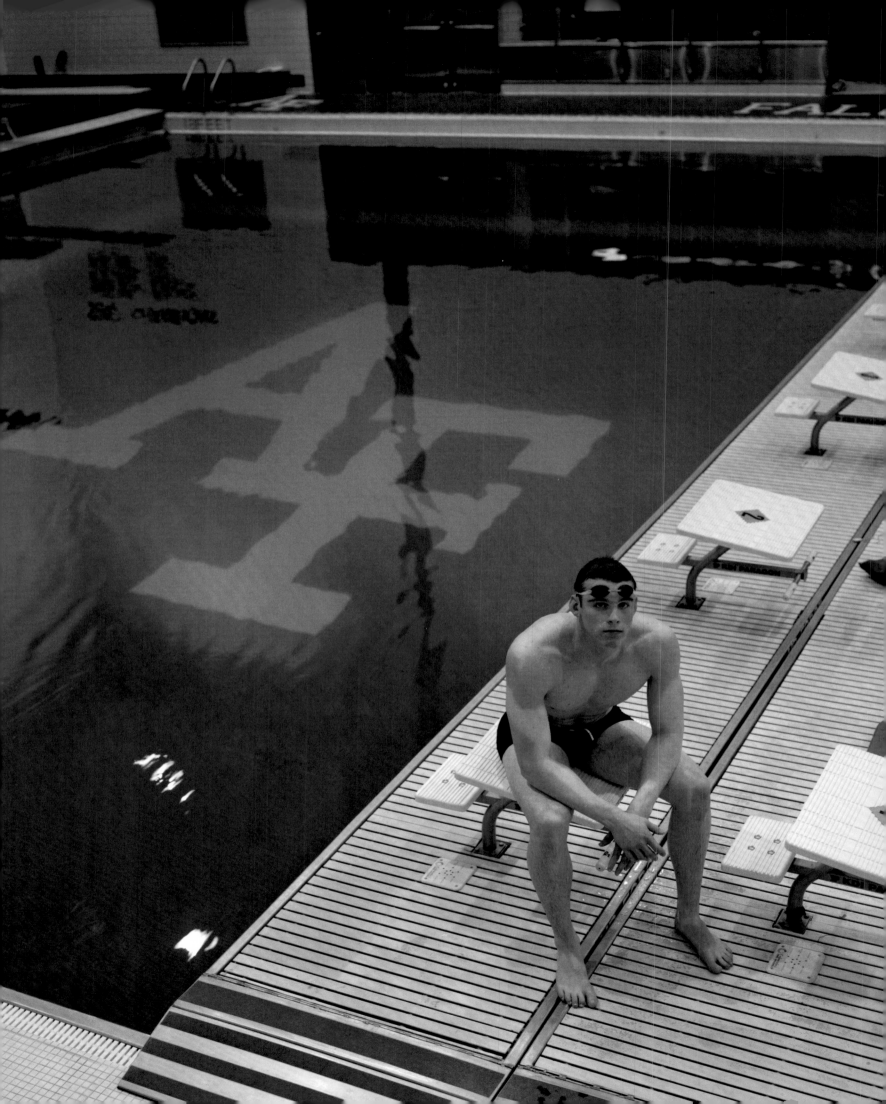

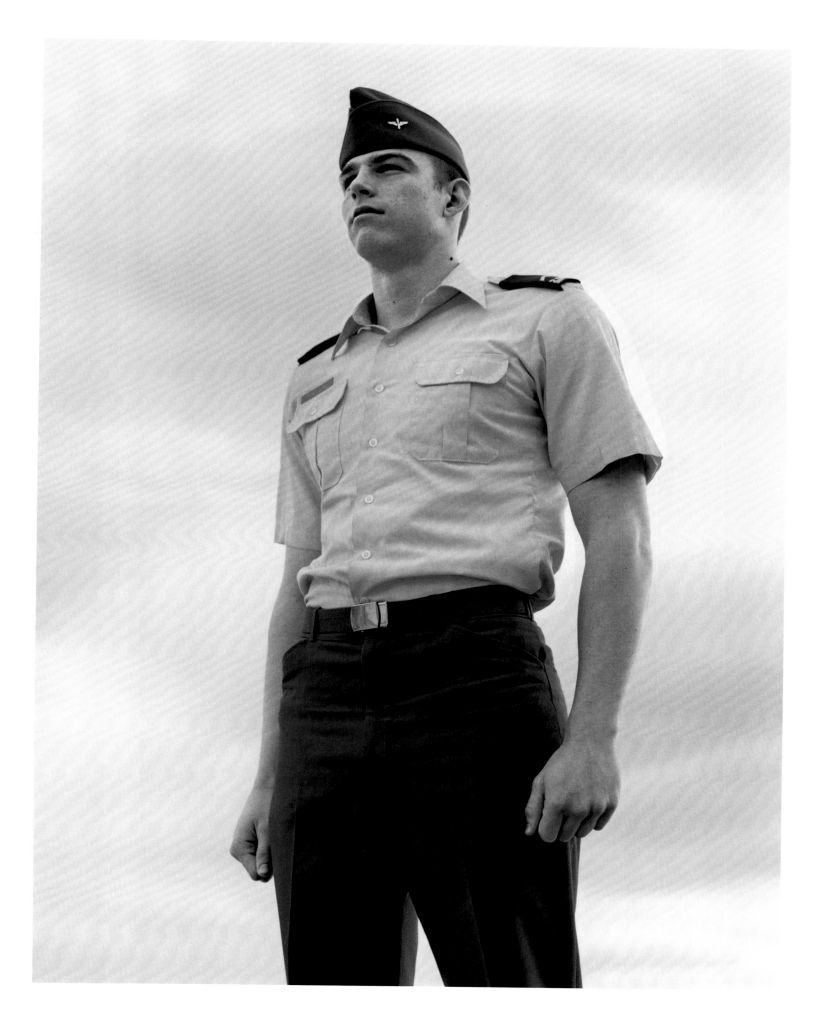

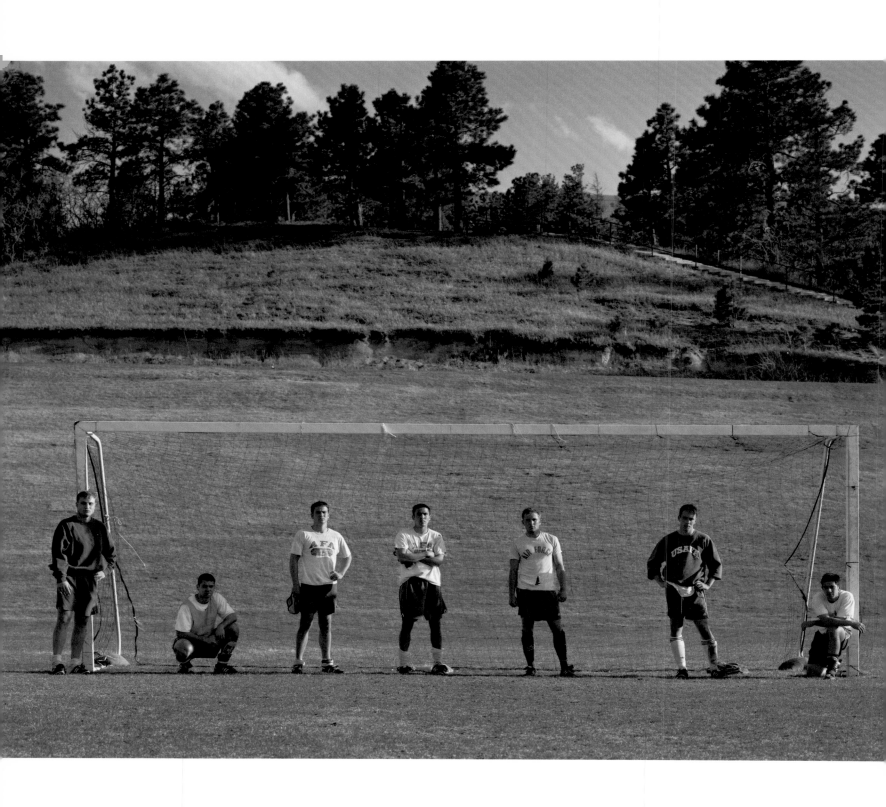

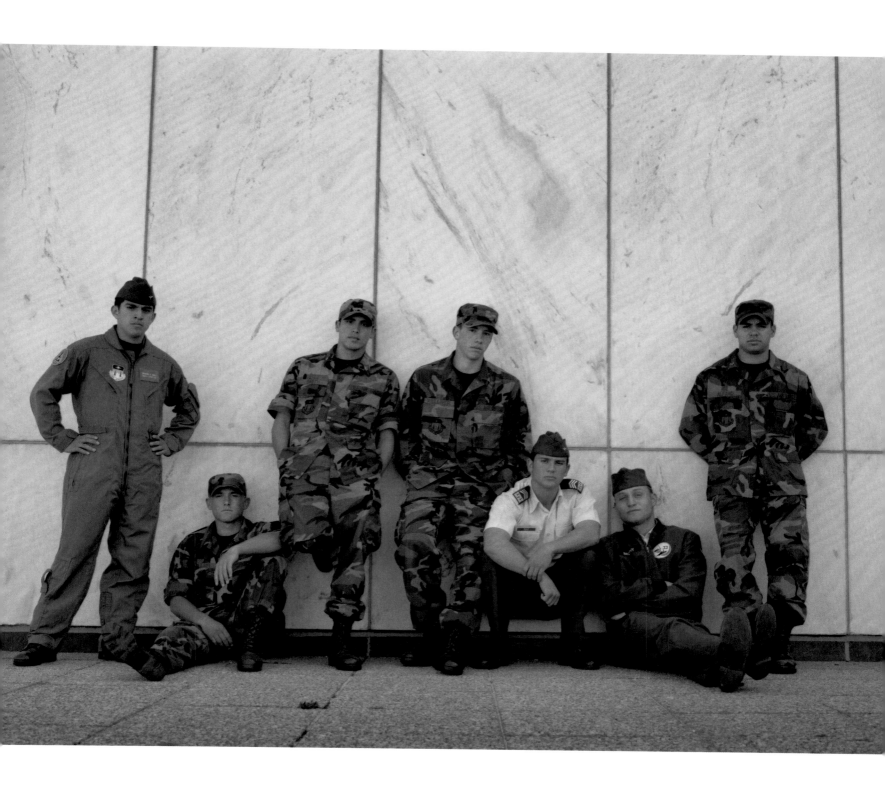

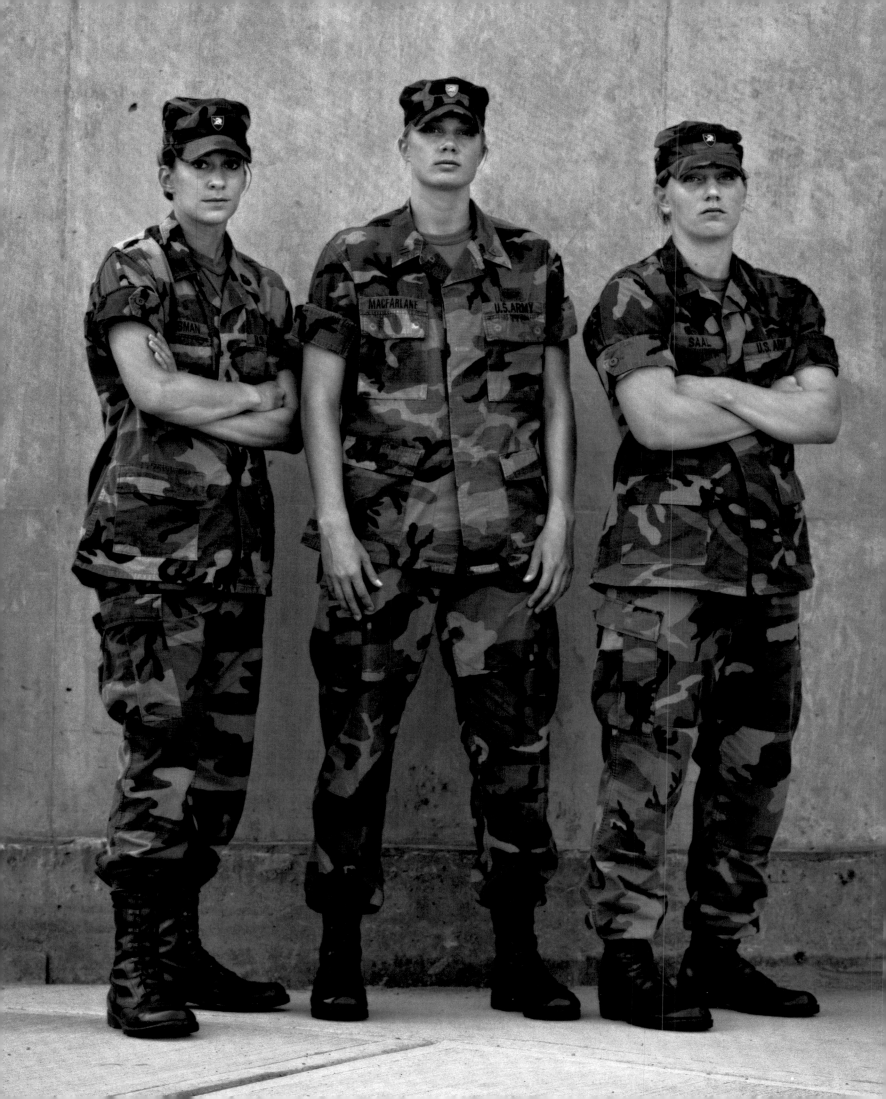

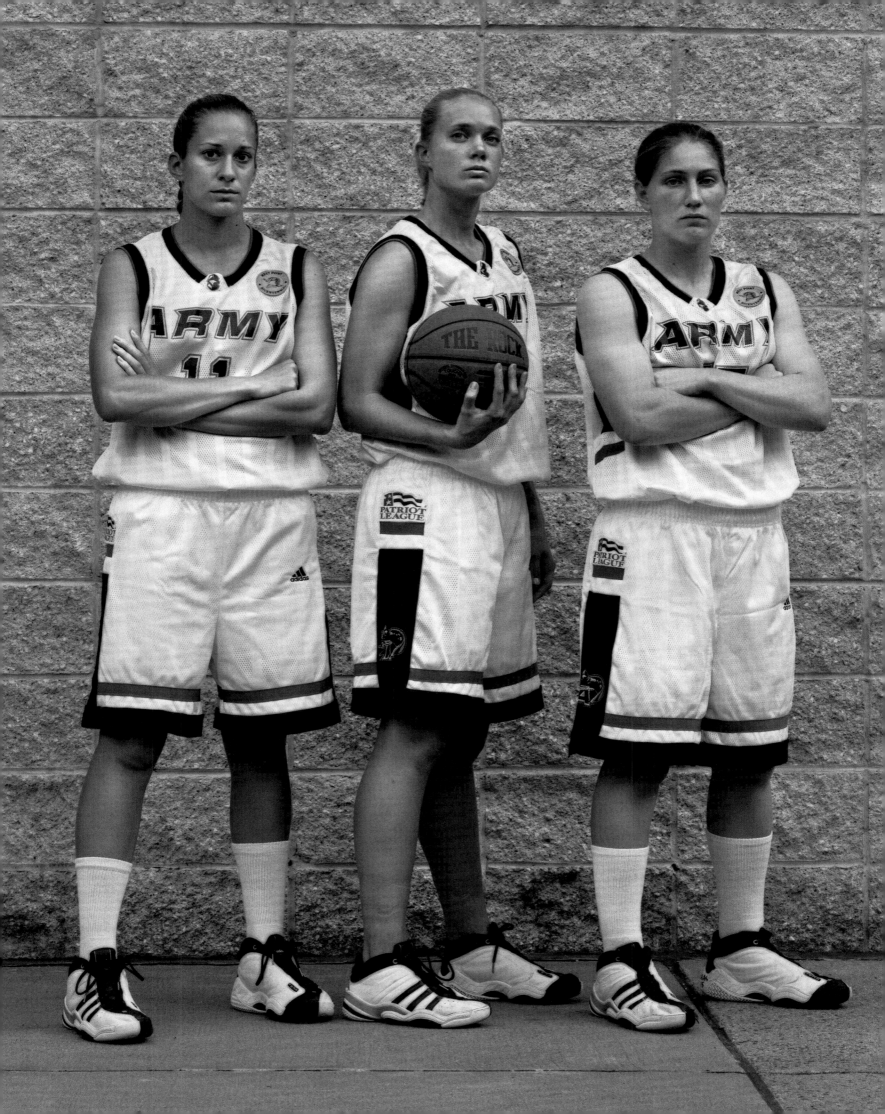

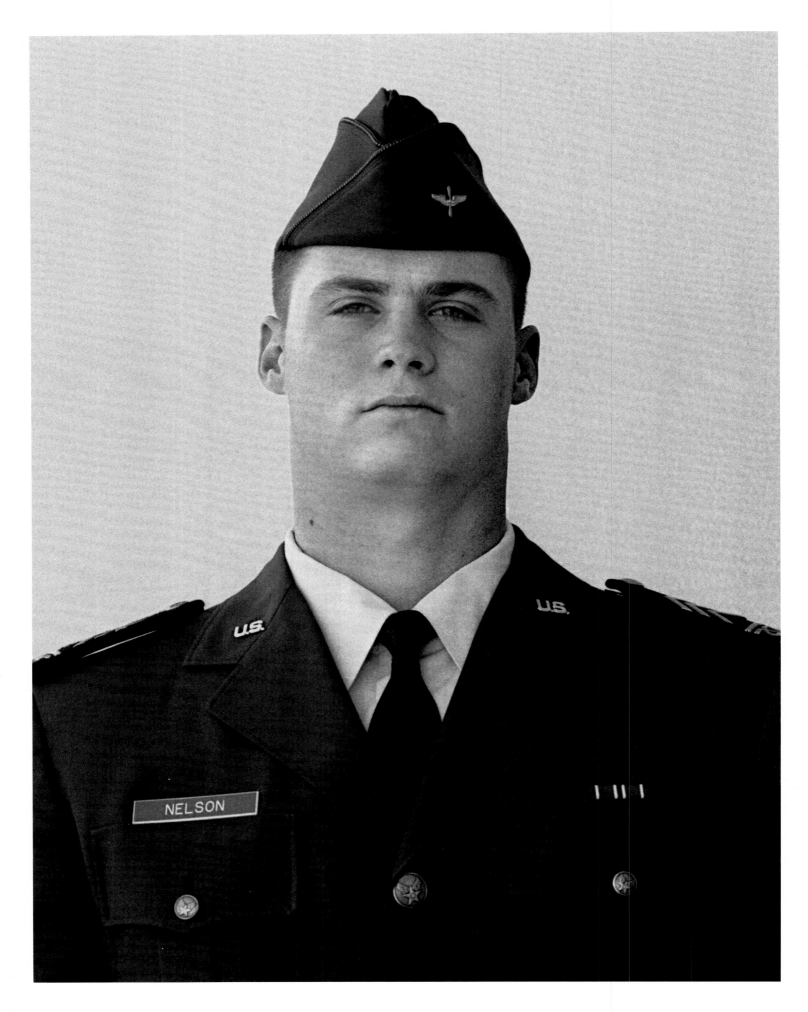

162

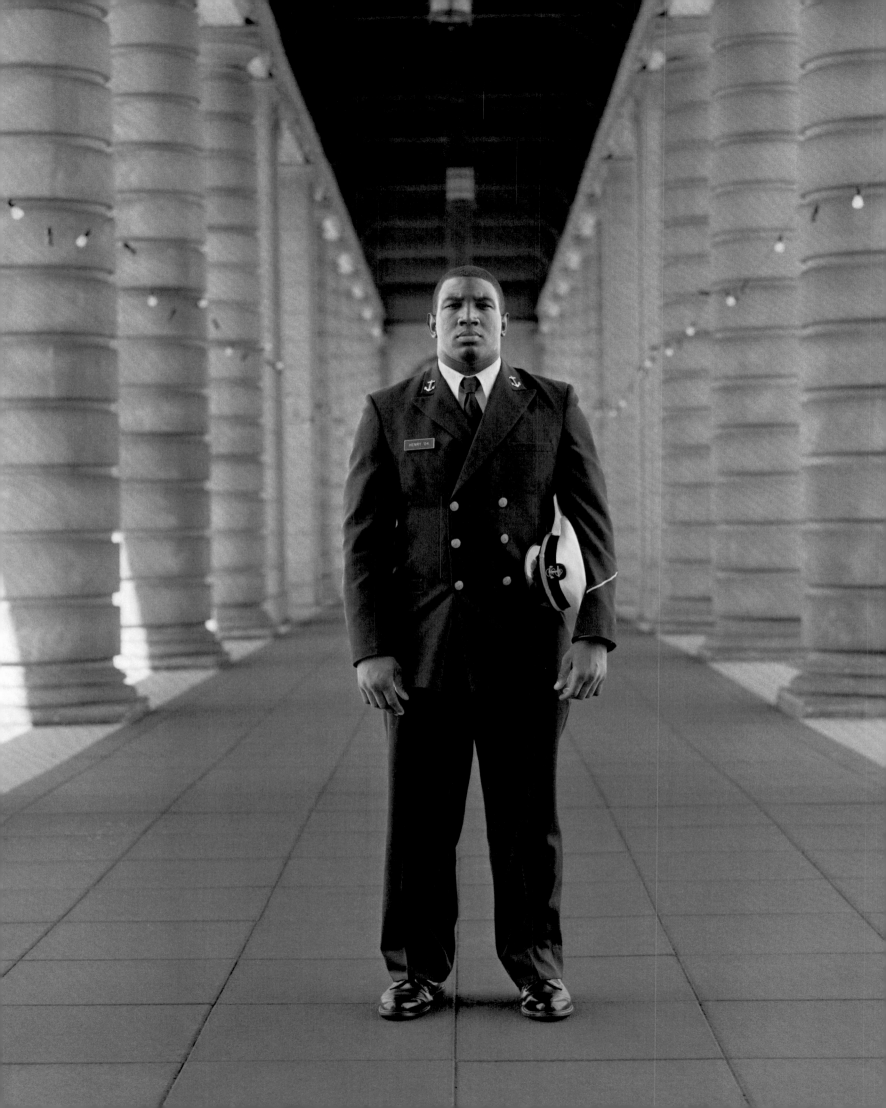

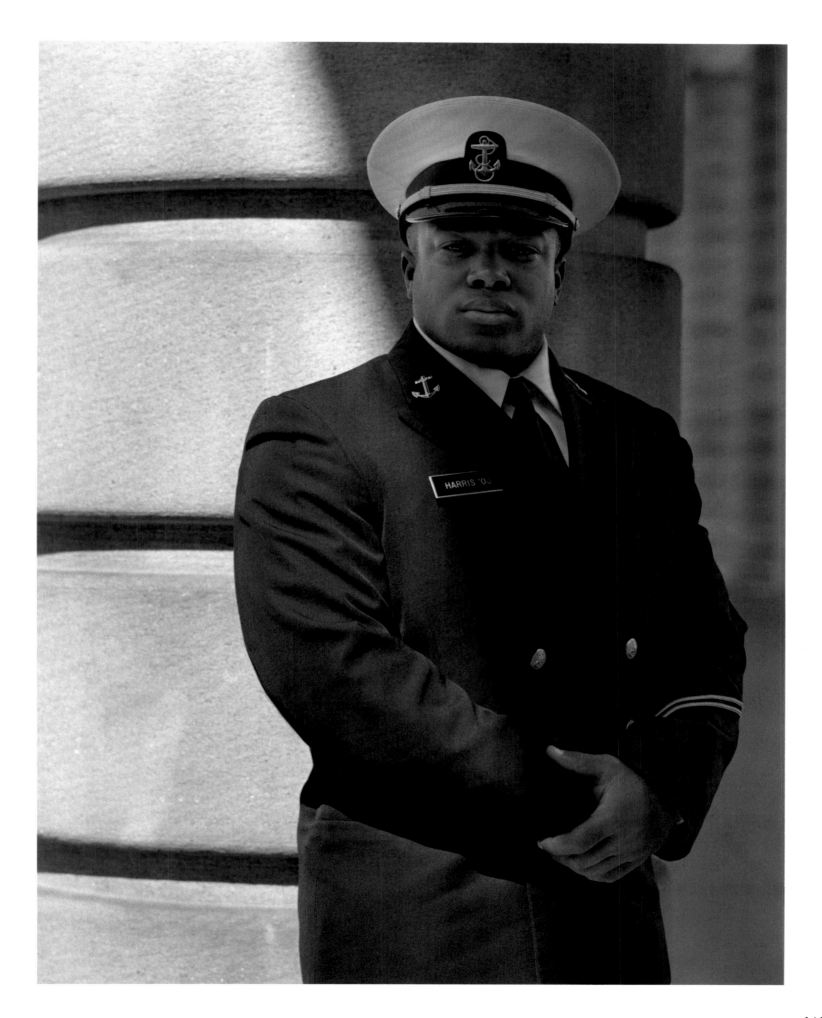

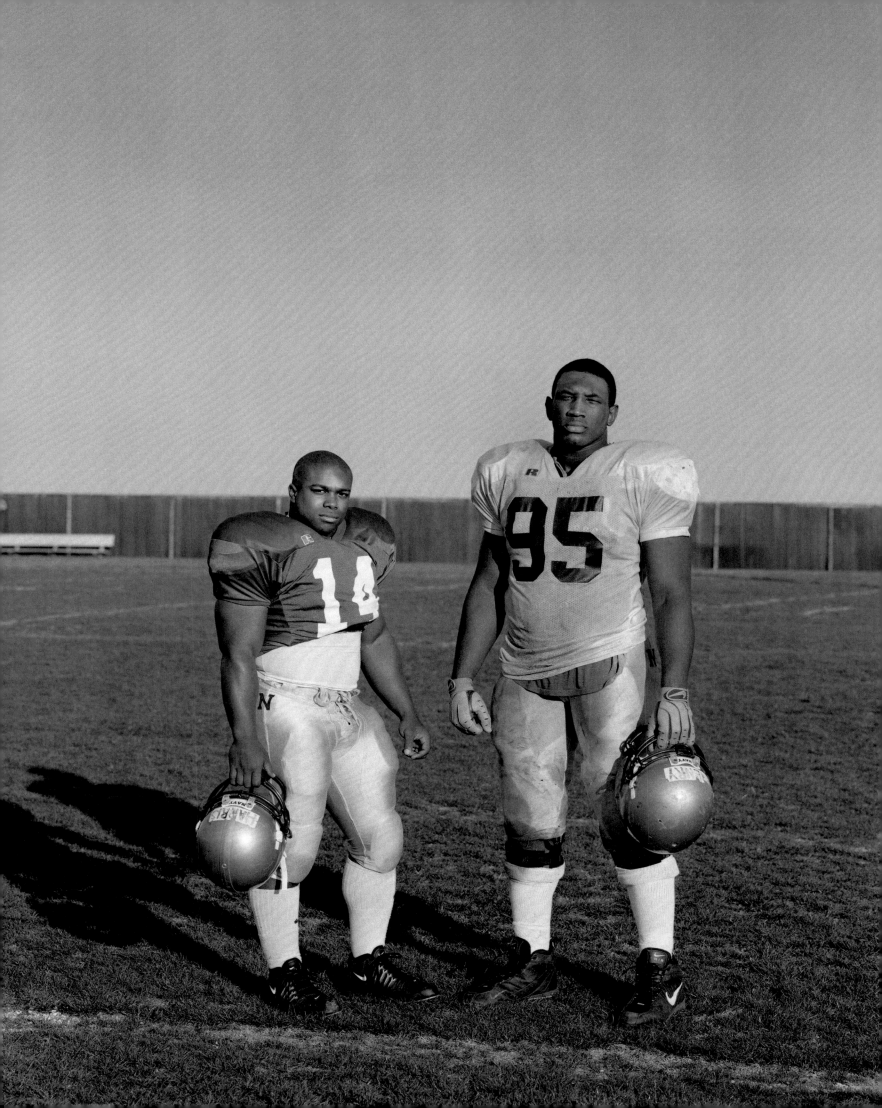

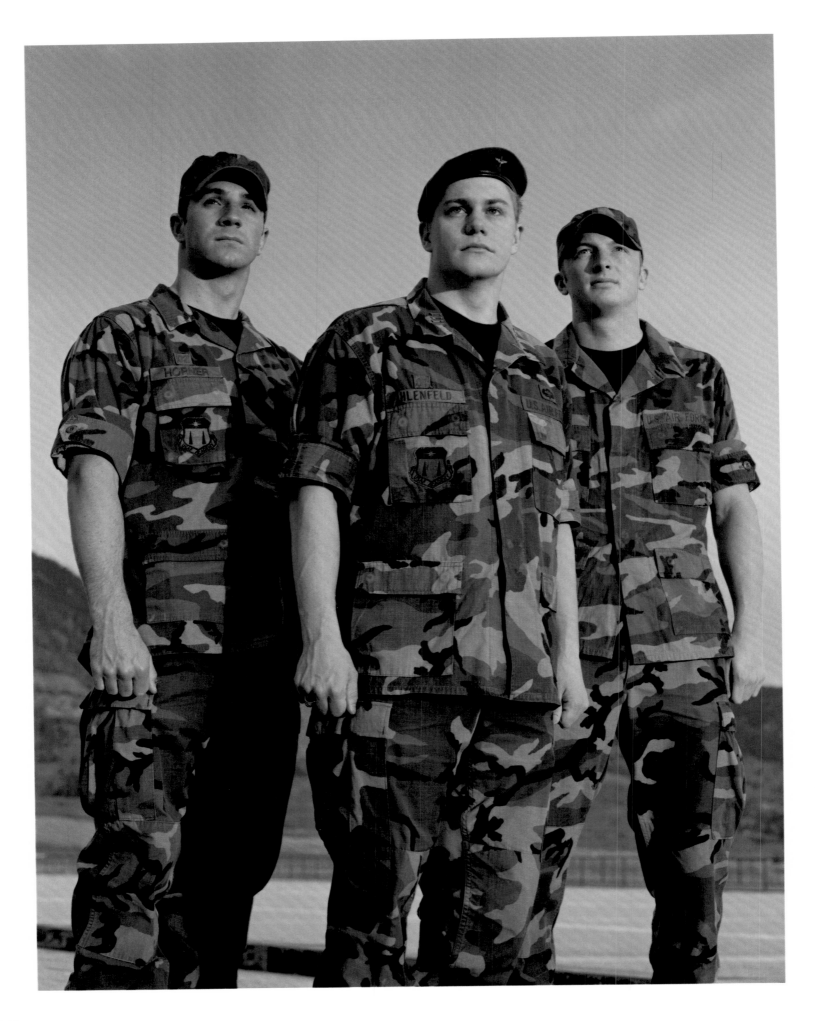

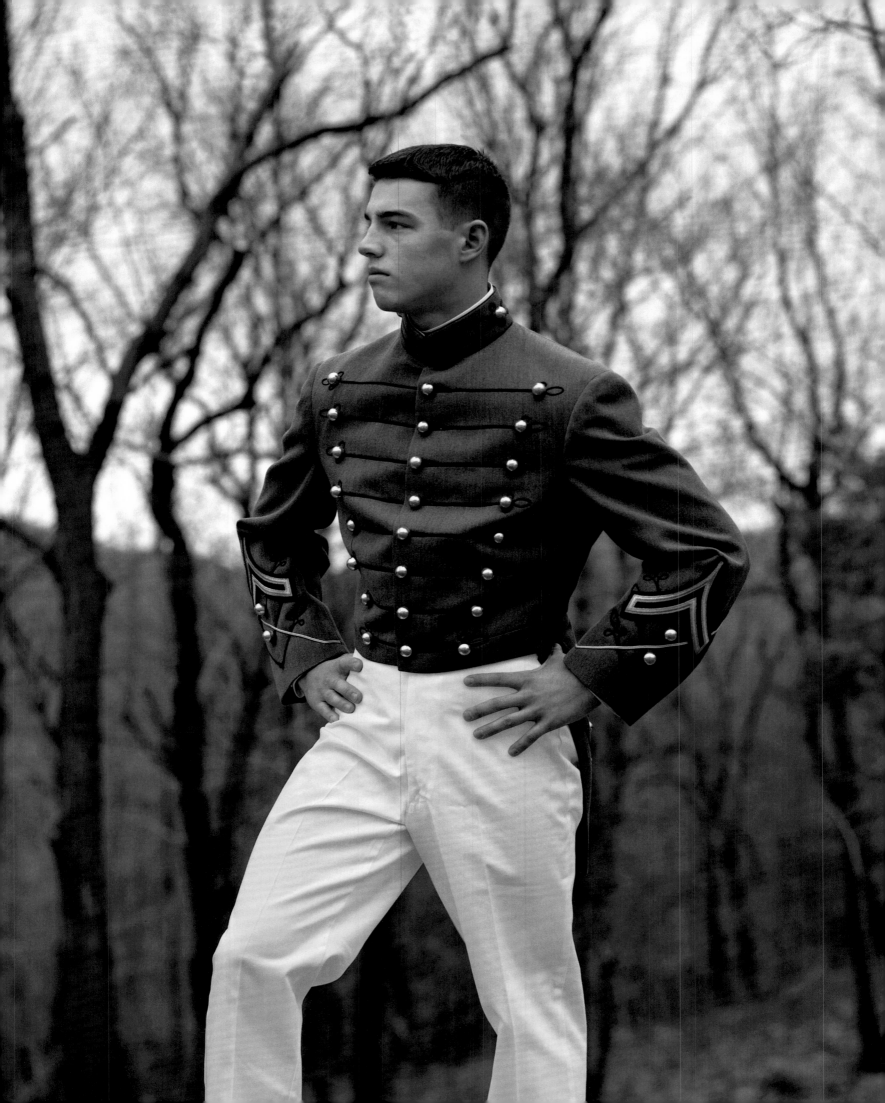

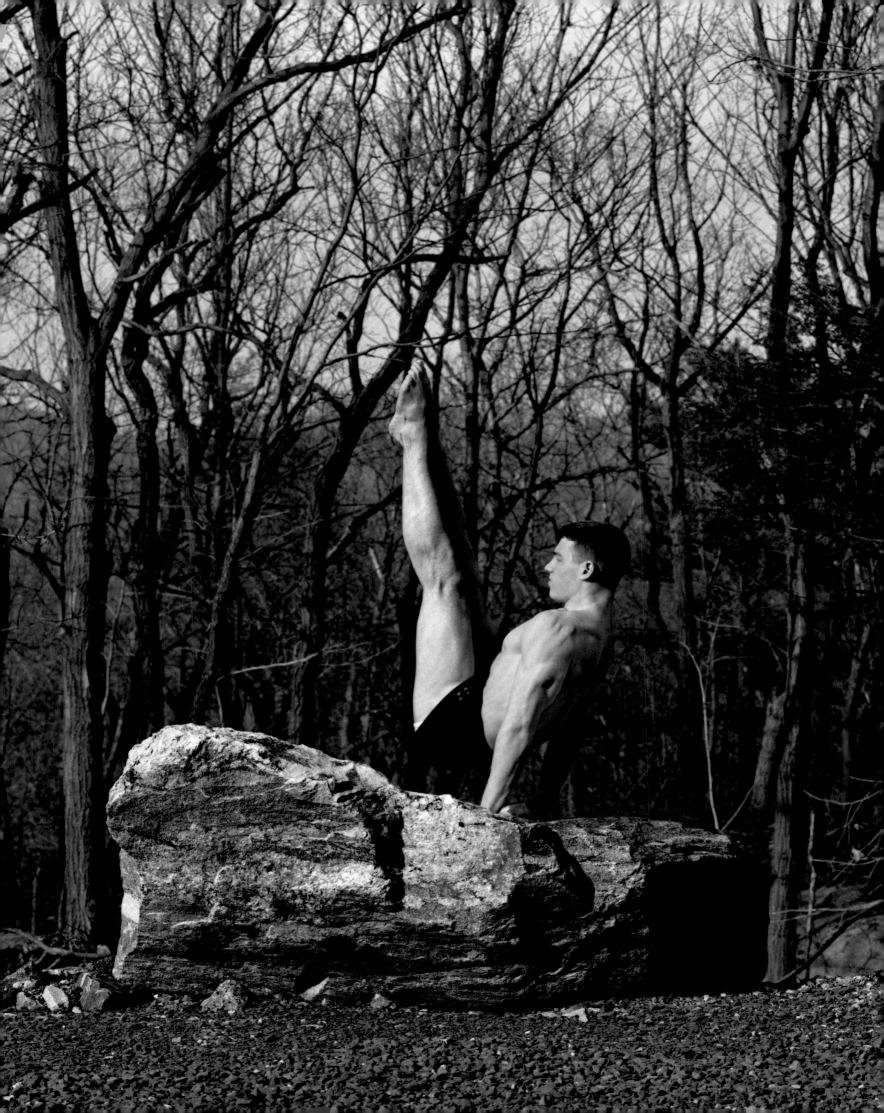

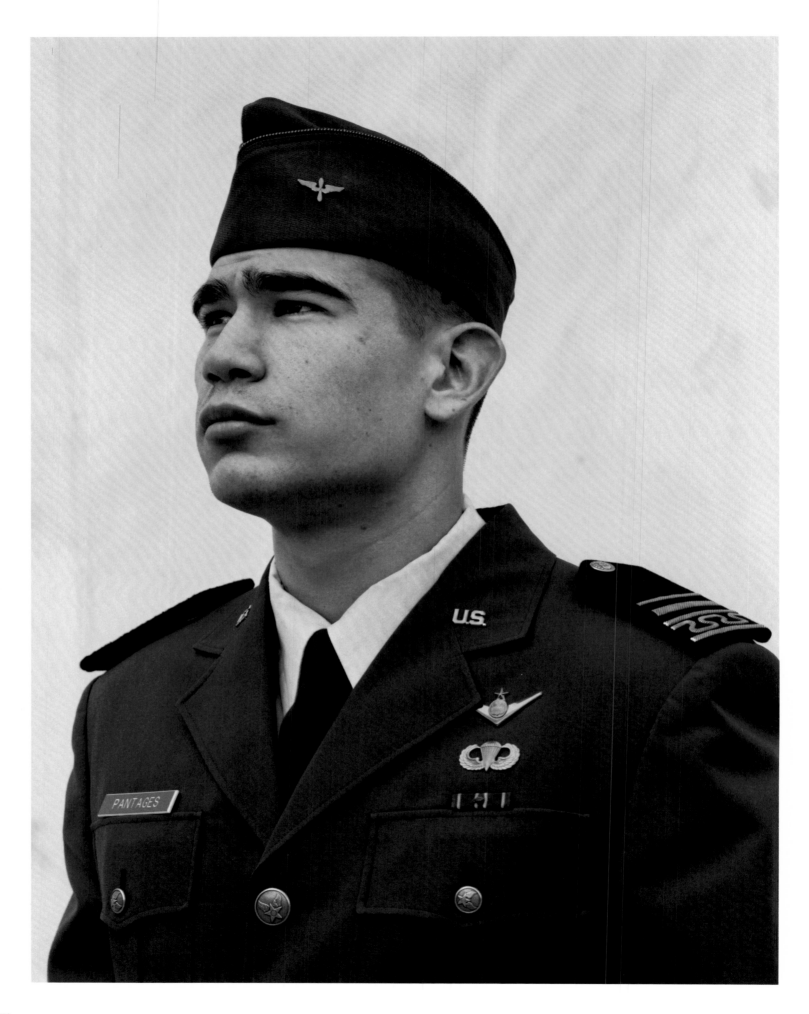

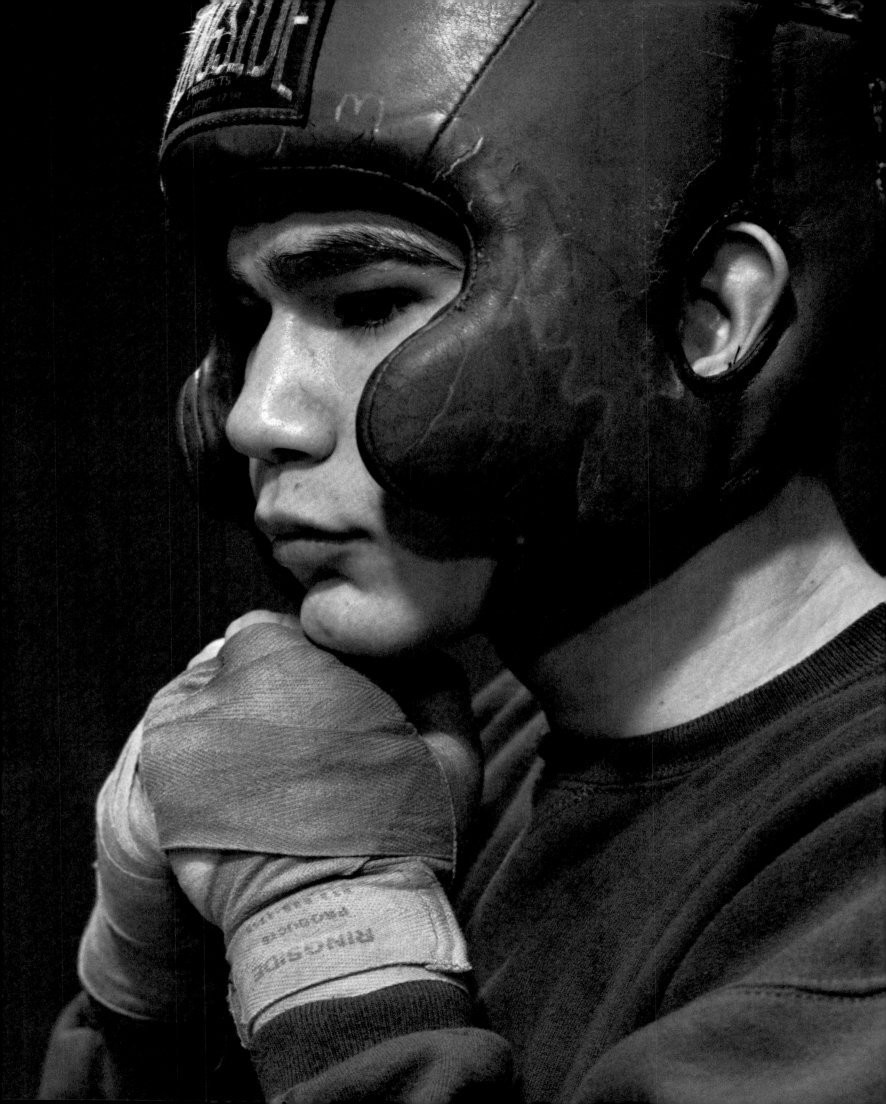

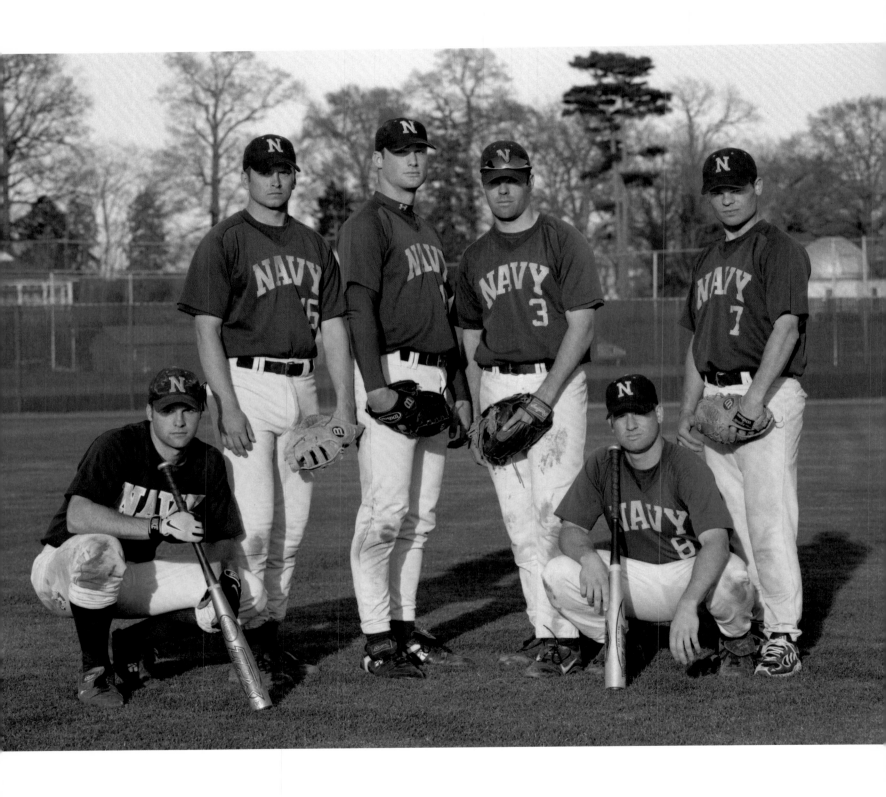

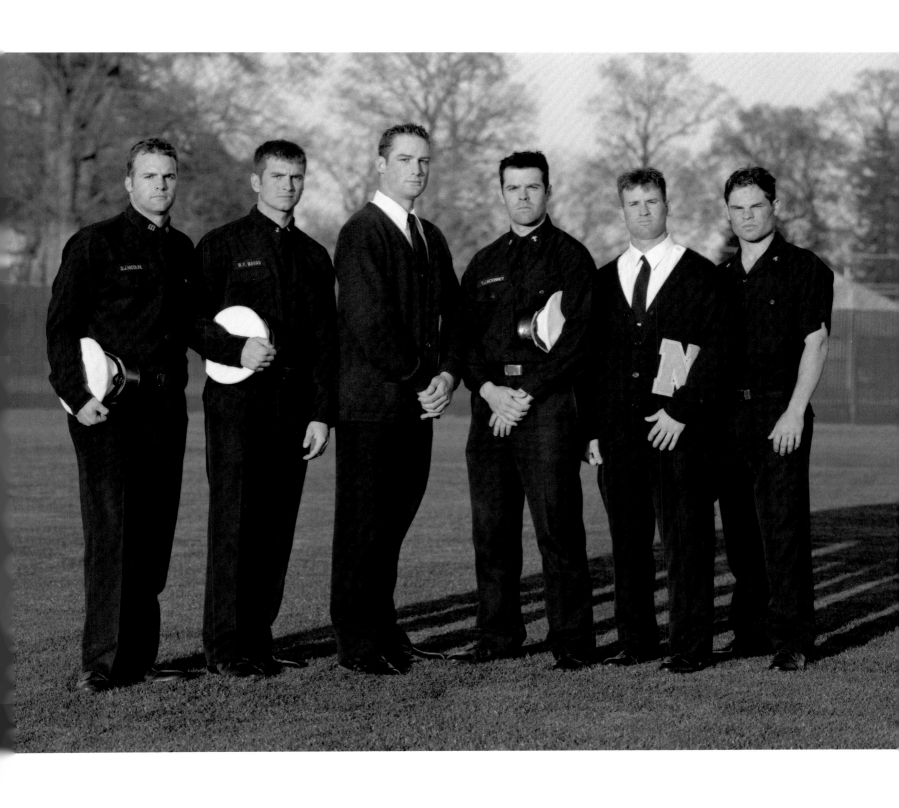

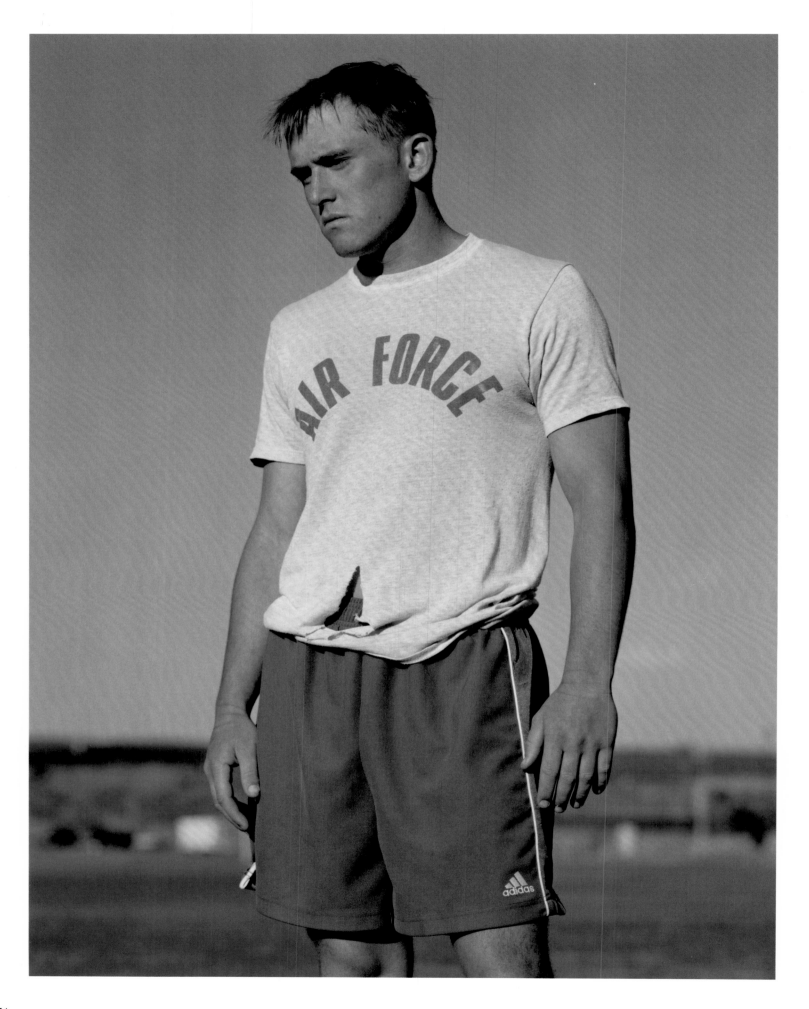

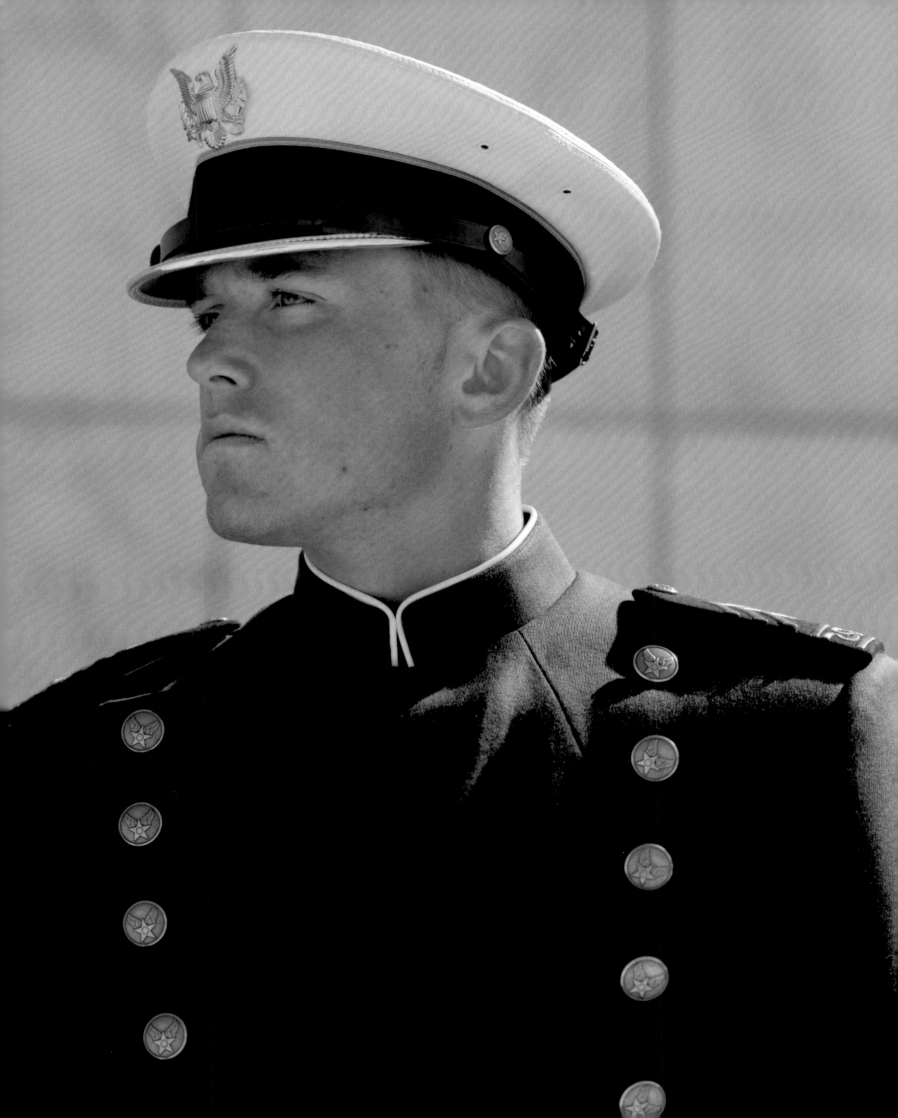

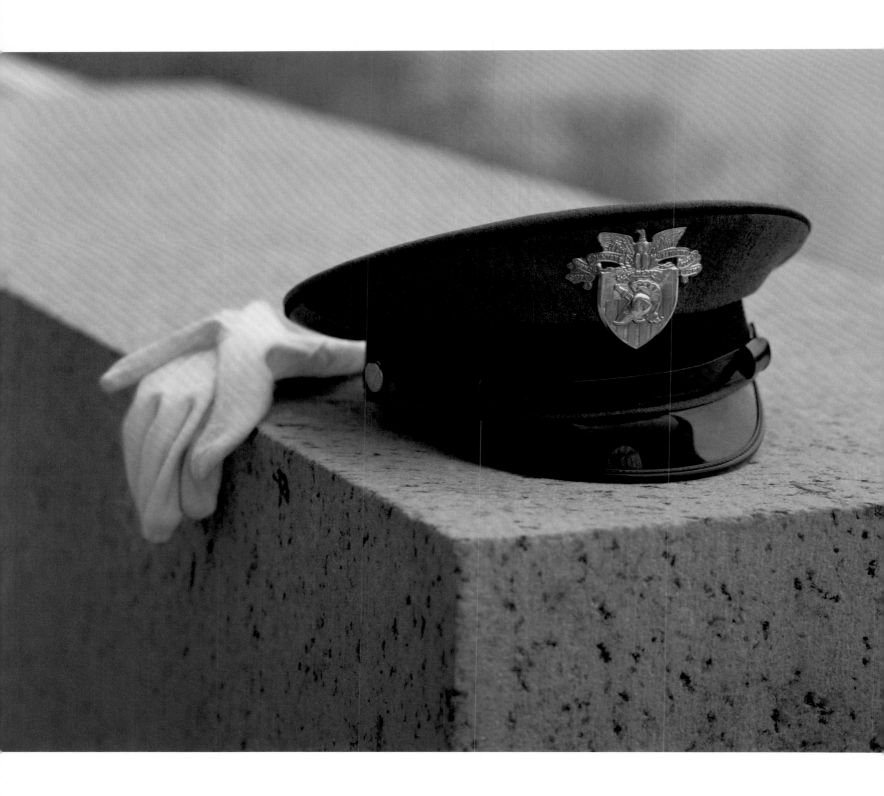

THE PHOTOGRAPHS

Unless otherwise indicated, names are given left to right.

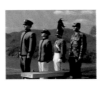

PAGES 2–3
Lucas Meyer, Heidi Brown, John Martinko, and Michael Vahle
Swimmers
US MILITARY ACADEMY

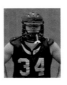

PAGE 4
Nick Bilotta
Lacrosse player
US MILITARY ACADEMY

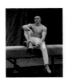 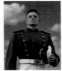 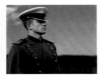

PAGES 10–13
Aaron Jackson
Gymnast
US AIR FORCE ACADEMY

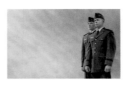

PAGES 14–15
Michael Berry and Noah Rich
Gymnasts
US AIR FORCE ACADEMY

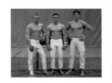

PAGES 16–17
Michael Berry, Aaron Jackson, and Noah Rich
Gymnasts
US AIR FORCE ACADEMY

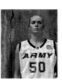 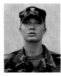 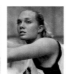

PAGES 18–20
Kathryn MacFarlane
Basketball player
US MILITARY ACADEMY

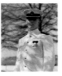 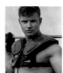

PAGES 22–23
Christopher Dingman
Lacrosse player
US NAVAL ACADEMY

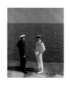

PAGE 24
Thomas Morris and Christopher Dingman
Lacrosse players
US NAVAL ACADEMY

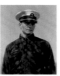 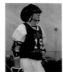

PAGES 26–27
Thomas Morris
Lacrosse player
US NAVAL ACADEMY

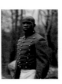

PAGES 28–29
William Reynolds
Gymnast
US MILITARY ACADEMY

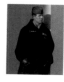 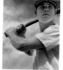 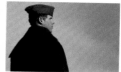

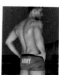 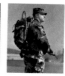

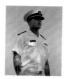 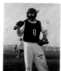 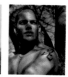

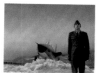 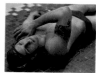

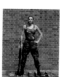 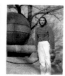

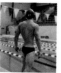 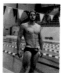 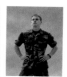

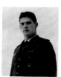 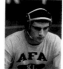

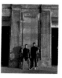 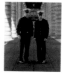

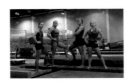

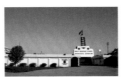

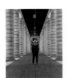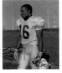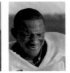

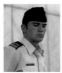

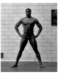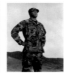

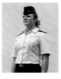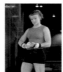

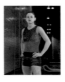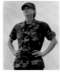

182

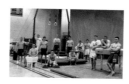

PAGES 76–77
Michael Berry, Justin Jones, William Murphy, Noah Rich, Scott Lewis, James Hayes III, Andrew Fisher, Matt Kenkel, William Hermann, Stephen Sistare, Levi Torkelson, Schan Daniel, and Aaron Jackson
Gymnasts
US AIR FORCE ACADEMY

 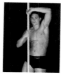 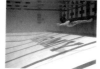

PAGES 78–83
Patrick Schmidt
Swimmer
US MILITARY ACADEMY

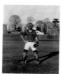 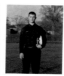

PAGES 84–85
Christopher Pandy
Baseball player
US NAVAL ACADEMY

 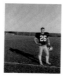

PAGES 86–87
Scott Lieng
Football player
US NAVAL ACADEMY

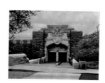

PAGES 88–89
Thayer Hall, West Point
US MILITARY ACADEMY

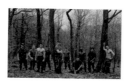 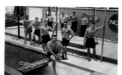

PAGES 90–93
(left to right on pages 90–91) Dunston Greenhill, Scott Harris, Nathan Whitten, Robert Parker, John Robella, Ian Welch, Daniel Helmer, William Reynolds, Troy Pazcoguin, and Daniel Colomb
Gymnasts
US MILITARY ACADEMY

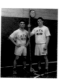 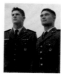

PAGES 94–95
(left to right on page 94) Blaine Brown and Sam Sherertz
Wrestlers
US AIR FORCE ACADEMY

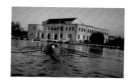

PAGES 96–97
Hubbard Hall Boathouse
US NAVAL ACADEMY

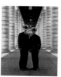 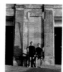

PAGES 98–99
Patrick Anderson and Nicholas Stewart
Crew
US NAVAL ACADEMY

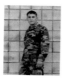 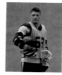

PAGES 100–01
Marko Kostovic
Lacrosse player
US MILITARY ACADEMY

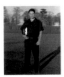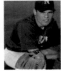

PAGES 102–103
David Woolsey
Baseball player
US NAVAL ACADEMY

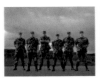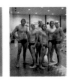

PAGES 104–107
(left to right on page 104) Christopher Smith, David Breitenbach, Derek Argel, Ben Couchman, Charles Horn, and Brian Hasbrouck
Water polo players
US AIR FORCE ACADEMY

PAGES 108–109
Allan Smith
Soccer player
US AIR FORCE ACADEMY

PAGES 110–11
James Ariglio
Minibuds (Special Forces training)
US AIR FORCE ACADEMY

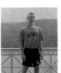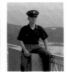

PAGE 113
T.J. Grider
Wrestler
US MILITARY ACADEMY

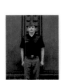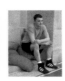

PAGE 113
Christopher Perrin
Wrestler
US MILITARY ACADEMY

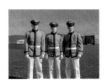

PAGES 114–15
Jeffrey Pardo, Brian Johnson, and Shaun Wild
Cadets on parade duty
US MILITARY ACADEMY

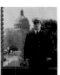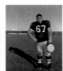

PAGES 116–17
Shane Todd
Football player
US NAVAL ACADEMY

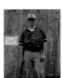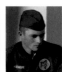

PAGES 118–19
Price Paramore
Baseball player
US AIR FORCE ACADEMY

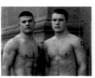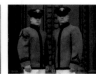

PAGES 120–21
(left to right on page 120) Daniel Ciccarelli and Peter Bakke
Wrestlers
US MILITARY ACADEMY

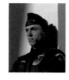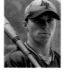

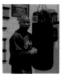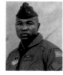

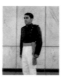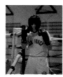

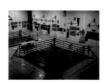

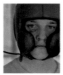

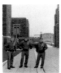

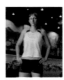

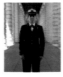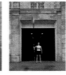

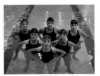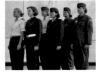

PAGES 140–41

(left to right on page 141) Karley Kroschel, Alexis Ross, Sarah Thilo, Sara Crowell, Monique Van't Wout, and Robin Cadow

Swimmers

US AIR FORCE ACADEMY

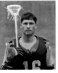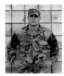

PAGES 142–43

Adam Hurley

Lacrosse player

US MILITARY ACADEMY

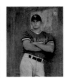

PAGES 144–45

Mike Tufte

Baseball player

US AIR FORCE ACADEMY

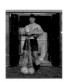

PAGE 147

Adam Martin

Rugby player

US MILITARY ACADEMY

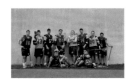

PAGES 148–49

(back row) Adam Hurley, Jeff Bryan, Gregory Bartolotta, Chris Roberts, Andrew Kuen, Douglas Bartolotta, John Ryan, Michael Kamon; (foreground) Nicholas Bilotto and Marko Kostovic

Lacrosse players

US MILITARY ACADEMY

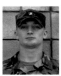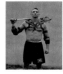

PAGES 150–51

John Ryan

Lacrosse player

US MILITARY ACADEMY

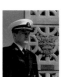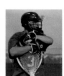

PAGES 152–53

Jonathan Higdon

Lacrosse player

US NAVAL ACADEMY

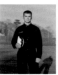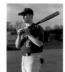

PAGES 154–55

Rusty Hearn

Baseball player

US NAVAL ACADEMY

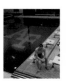

PAGES 156–57

John Dayton

Swimmer

US AIR FORCE ACADEMY

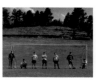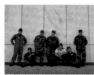

PAGES 158–59

(left to right on page 159) Brandon Jones, Britton Miller, Allan Smith, Terrence Welliver, Armando "A.J." Ruiz, Michael Brophy, and Mike Alfaro

Soccer players

US AIR FORCE ACADEMY

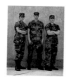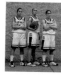

PAGES 160–61

Christine Gassman, Kathryn MacFarlane, and Amy Saal

Basketball players

US MILITARY ACADEMY

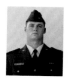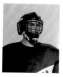

PAGES 162–63

Brad Nelson

Ice hockey player

US AIR FORCE ACADEMY

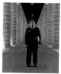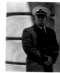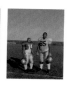

PAGES 164–67

(left to right on page 167) Ralph Henry and Charles "Cee" Harris II

Football players

US NAVAL ACADEMY

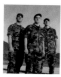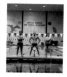

PAGES 168–69

(left to right on page 168) Matthew Horner, Matt Ihlenfeld, and Charles Toth

Swimmers

US AIR FORCE ACADEMY

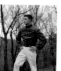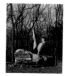

PAGES 170–71

John Robella

Gymnast

US MILITARY ACADEMY

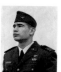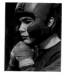

PAGES 172–73

John Jason Pantages

Boxer

US AIR FORCE ACADEMY

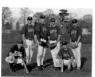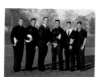

PAGES 174–75

(left to right on page 175) Dominic Nicolini, Rusty Hearn, Matthew Foster, Todd McKinney, John Cocca, and David Woolsey

Baseball players

US NAVAL ACADEMY

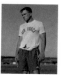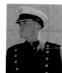

PAGES 176–77

Britton Miller

Soccer player

US AIR FORCE ACADEMY

PAGE 178

Hat and gloves

US MILITARY ACADEMY

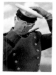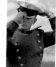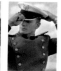

PAGES 190–91

Aaron Jackson

Gymnast

US AIR FORCE ACADEMY

ACKNOWLEDGMENTS

Anderson & Low would like to thank the following people and organizations for their generous support, help, and assistance:

United States Air Force Academy
United States Military Academy
United States Naval Academy
United States Olympic Committee
El Pomar Foundation

Erica Hutchinson
Sir Elton John
William Hybl
Thayer Tutt
Neal Posey
Sherry Von Reisen
John Dauth
Paul Mellor
Woody Brooks

Lou Burkel
Casey Converse
Jeff Ehrlich
Eddie Weichers Jr.
Lisa Woody
Luis Sagastume
Arianne Babcock
Rob Clayton
David Kellogg
Wayne Baughman
Reed Peters

Dr. Doug Van Everen
Bob Beretta
James Zuhlke
Scott Felix
Shannon Felix
Jack Emmer
Joe Sottolano
Sherri Abbey-Nowatzki
Susan Lintemann
Deborah McKeon-Pogue
Bill Yost
Thomas Endres
Daniel Zupan

Scott Strasemeier
Stacie Michaud
Justin Kischefsky
Rick Clothier
Mike Hughes
Dale Hurley
Charlie Weatherby
Richard Meade

Bob Gambardella
Hernando Madronero
Kurt Kumukawa
Al Larson

Chris Taylor
Aurora Rodriguez
Ulrike Rosser
Katie O'Byrne
Margaret Johnson
Rick Minor

Michael Tang
Chris Trenholme
John Robella
Daniel Colomb
Christopher Smith

James Lucas
Simon Cashman
David Whittall
John Neville
Panykos Camberis
Alex Stout
Adele Hodges
Brad Eagle

Andy Garcia
Lawrence Payne
Brendon McMullan
Eamon Donohoe
Naz Siddiqui
Alan Benson
Bob Ridgewell
Peter Donoghue

Alan Woolmore
Peter Gardener
Ray Derrick
Kathy Mellor
Kevin Furr
Kapil Amin
Bindi Amin
Sucharita Anand
Jane Nunn
Chris Clark

Tom Southall
Shelley Lawrence
David Barenholtz
Kathleen Ewing
John Stevenson
Michael and Jane Wilson
Paul Wombell
Nicki Michelin
Jane Jackson
Anna Walker Skillman
Terence Pepper
Bill Hunt
John Bennette

Charles Cowles
David Knaus
Violet Hamilton

Piet Defossez
Paul McDermid
Panos Galanopoulos
Joseph Alfieris
Martin Davies
Simon Anderson
Rodney Engen
Malcolm Hillier
Keir McGuinness
Tim Fetherston-Dilke
Solimar Marquez
Laurent Girard
Hugh Merrell

Andrew Sie
Steve and Debbie Anderson
Clare Hansen
Philip Polivchak
Alden Kamikawa
Susan Pomerantz
John and Brenda Hartness
Alden O. James
Adam Stoltman
Jeremy Peterson
Konrad and Stefanie Ribeiro
Eric Daigle
Brad West
Steven Borsuk

George and Perry Packard
Vincent Cianni
Cliff Carpenter
Aaron Butler
Richard Rambuss
Charles O'Boyle
Sally Packard
Dinah Reath
Philip Caggiano
Daile Kalpan
Donna Hennes
Loke He Yin
Philip Moeller
Paul Muniz
Satoshi Tomiie
Stefan Stein
Henning Meisner
Jorge Desormaux
Paul Nyame
Patti Robinson
Danny Espaniola
Theresa Guerrero

Kirsten Whatson
Cameron Johnston
Enzo Junior
Jack Hagstrom
Bill Kappy
Anne Skeffington
Joyce Baker
Dieter Jaschik
Derek Lam
Steve Crook
Robert Zublin

Carol Richenberg
Catherine and Ramli Ismail
Tim and Bärbl ffytche
Anna and Aaron Chuang
Susy Phillips
Michael Ginessi
Gianfranca D'Ignazio
Anthony Eden-Brown
Alan Wickes
Gwen Thomas
Jackie Kelly
Gavin Blyth
Anna Roberts
Linda Checkley
Sung Ma
Annick Wolfers
Sam Christmas
Julian Anderson

Adrian and Kathy Chong
Lim Bee Ling
Nadia Stopnicer
Mario M. Ramos
Charlene Franklin
Sylvia Hendricks
Shevon Moore
Stan Anderson
Tyson Boehme
Dawn Sumner
Simon Bainbridge
Diane Smyth
Laura Noble
Katrina Moore
Emma Brogi
David Low
Bill Hicks
Bill Sadler
Nicola Bailey
Michelle Draycott
Sam Wythe
Marion Moisy
Emily Sanders
Paul Shinn

Lexington Labs, New York, USA
Wyndham Midtown Atlanta, USA
Wyndham Colorado Springs, USA
The Hertz Corporation
United Airlines

Apex Fine Art,
 Los Angeles, USA
Kathleen Ewing Gallery,
 Washington, D.C., USA
Jackson Fine Art,
 Atlanta, USA
John Stevenson Gallery,
 New York, USA
High Museum of Art,
 Atlanta, USA
Arnott Museum,
 New York, USA
Birmingham Museum of Art,
 Alabama, USA
George Eastman House,
 New York, USA
National Arts Club,
 New York, USA
Tulla Booth Gallery,
 Long Island, USA
National Portrait Gallery,
 Canberra, Australia
National Portrait Gallery,
 London, UK
The Photographers' Gallery,
 London, UK
The Association of Photographers,
 London, UK
Merrell Publishers

Athletes, coaches, and all the
staff at the US Air Force, Military,
and Naval Academies

The staff at US Olympic Visitor
Center, Training Center, and
Canteen, Colorado, USA

The staff at the Admagic Group,
Powerprint and Panther Imaging,
London, UK

Our families

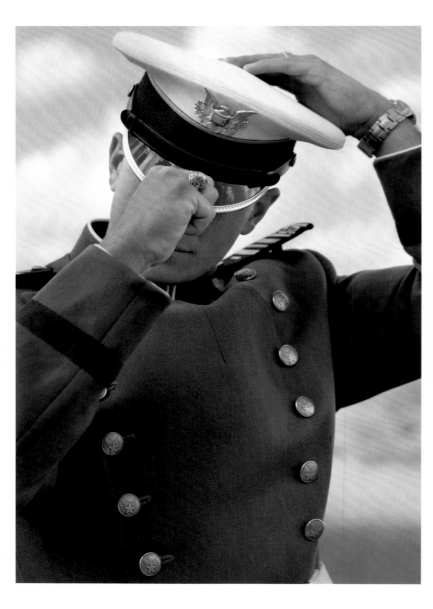
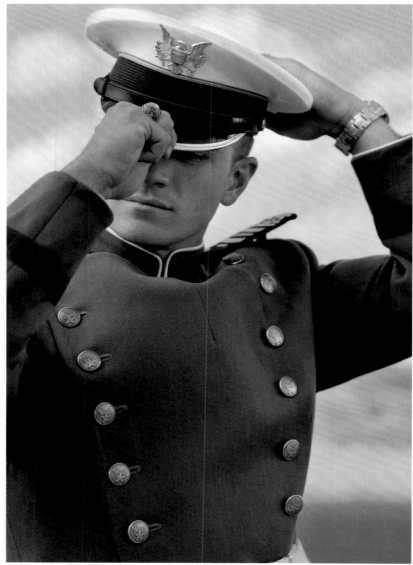

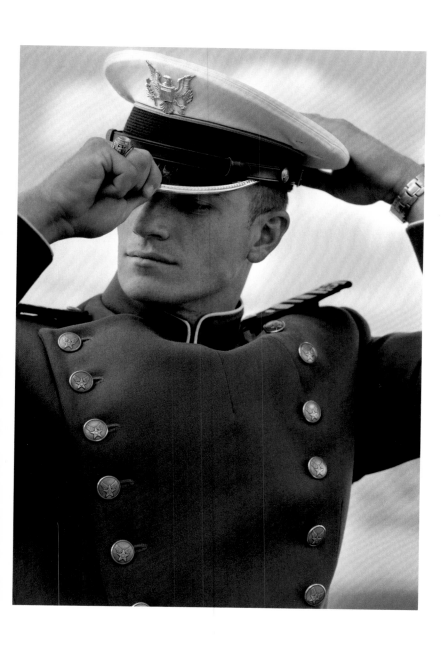

First published 2005 by Merrell Publishers Limited

Head office
42 Southwark Street
London SE1 1UN

New York office
49 West 24th Street, 8th floor
New York, NY 10010

www.merrellpublishers.com

Publisher Hugh Merrell

Editorial Director Julian Honer

US Director Joan Brookbank

Sales and Marketing Manager Kim Cope

Sales and Marketing Executive Emily Sanders

Managing Editor Anthea Snow

Editor Sam Wythe

Design Manager Nicola Bailey

Junior Designer Paul Shinn

Production Manager Michelle Draycott

Production Controller Sadie Butler

British Library Cataloguing-in-Publication Data:
Athlete/warrior
1.Military cadets – United States – Portraits 2.Athletes – United States –
Portraits 3.Photography, Artistic 4.Portrait photography
I.Anderson & Low
779.9'35533'0973

ISBN 1 85894 291 8

Original book design and layout concept by Edwin Low, Jonathan Anderson,
Piet Defossez, Paul McDermid and Panos Galanopoulos

Proof-read by Barbara Roby

Printed and bound in Italy

FRONT AND BACK JACKET
Aaron Jackson
Gymnast
US AIR FORCE ACADEMY